PHILOMENA KEET photography by YURI MANABE

Tokyo Fashion City

A Guide to Tokyo's Trendiest Fashion Districts

TUTTLE Publishing

Tokyo | Rutland, Vermont | Singapore

Contents

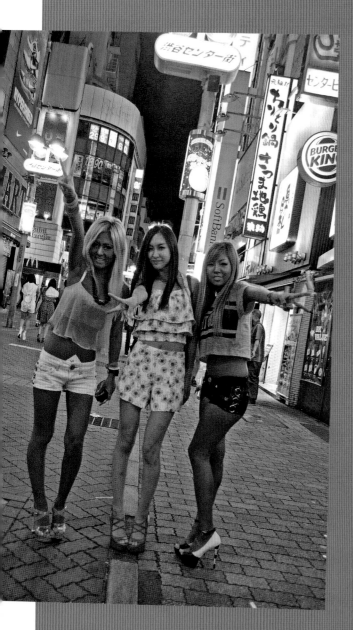

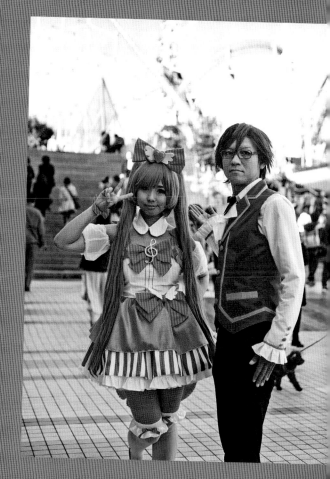

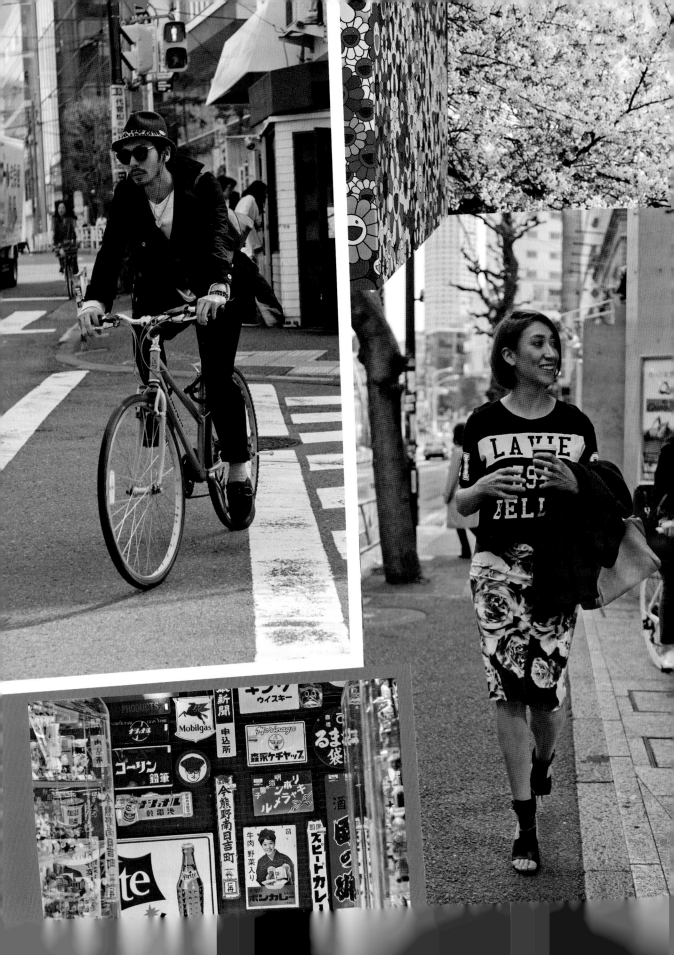

Fashion City

All big cities have many faces that they present to their inhabitants and visitors: culinary, architectural; commercial, traditional; old, new; rich, poor. For Tokyo, the sprawling yet dense megacity at the heart of Japan, fashion is one of the most alluring and expressive of these faces, changing as one moves through the urban jungle from chic to outrageous, well-heeled to bohemian. Where else in the world could one so openly and unashamedly dress in anything from the pretty and innocent frills of the Bo-Peep or Victorian-doll Lolita style to the sharp suits, pointy shoes, and long, feminine hair of the nightclub host—not to mention the exuberant outfits of Harajuku fashionistas? In Tokyo, one can bask in looks ranging from the mundane to the extravagant without fear of drawing public criticism or unwanted attention.

Tokyo's cacophony of styles has long provided a source of fascination to those perusing images from afar, whether on blogs or in the pages of magazines and photo books. But its urban fashions have an important and complex relationship to the urban jungle that surrounds them—one which is impossible to grasp from afar and difficult to properly navigate on the ground.

Each style has a Tokyo neighborhood or two in which it feels most at home, thrumming in its cafés, shops, and bars; adorning its streets; and complementing its architectural backdrop. Tokyo's fashion people are to its streets what accessories are to outfits, both embellishing and complementing the underlying fundamentals. Together they make Tokyo Fashion City, which this book will present in all its glory.

NEIGHBORHOOD GUIDE

Each of the eight chapters covers a geographic location within Tokyo with its own distinctive sartorial landscape. Chapter 1 introduces what is perhaps Tokyo's most famous fashion spot, Harajuku—known for its outlandish street fashion—along with its more sophisticated neighbors, Omotesando and Minami-Aoyama. We move down the road in chapter 2 to Shibuya, where fast fash-

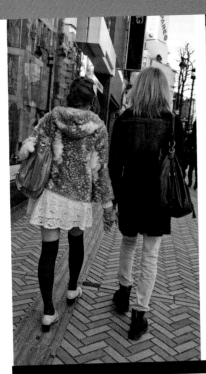 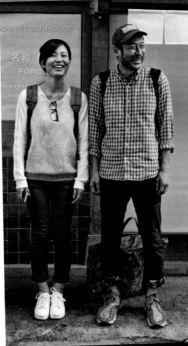 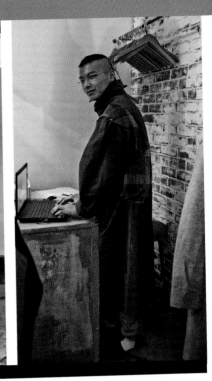

ion meets youth culture in the fashion mecca for Japan's trendsetting *gyaru* "gals." In chapter 3 we head to Shinjuku and Ikebukuro, mini-cities in themselves, with world-class department stores and a legendary fashion college as well as underground offerings. Chapter 4 takes us into the alternative and vintage warrens of Koenji, Shimokitazawa, and Nakano, only to emerge in the urban chic of Daikan-yama and hipster central Nakameguro in chapter 5. We hop over to the east side of Tokyo from chapter 6 onward, starting with the swanky shopping and business districts of Ginza and Marunouchi. Heading north into less salubri-ous territory in chapter 7, we explore the geek culture of Akihabara and venture into an intriguing arcade nestled under the railway tracks. Finally, we ride further out to the more traditional neighborhoods around Asakusa in the east of the city, including a visit to the new city icon, Tokyo Skytree.

Tokyo is a city of diversity and change; accordingly, it is hard to pin down on paper. This book could not cover the many intriguing outlier fashion shops that pepper the expansive urban sprawl, nor every single stylish neighborhood. For example, Roppongi—with its two luxe mega-malls, Tokyo Midtown and Roppongi Hills—and Jiyugaoka—a chic and charming town in the western Tokyo suburbs—are both worth visiting, but they are not as rich in distinct looks, unique shops, and hidden gems as the areas introduced in the following pages. An additional caveat: diversity begets constant change, so it is possible that some shops and places mentioned have relocated or closed down since the time of writing.

The first few pages of each chapter welcome the reader into the area with some evocative images of its streets and buildings, a map showing many of the fashion hot spots mentioned in the pages that follow, and an introductory text giving a short history and overview of the place.

The bulk of each chapter consists of spreads covering various themes related to the fashions of the area, wheth-er about one particularly famous or important shop, such as Shinjuku's Isetan department store; a type of fashion, like traditional festival style in East Tokyo; or a wider topic, like the importance of street snaps in Japanese fashion media (for this, see the section covering Harajuku, the hot spot for such snaps).

STREET SNAPS

From the Sartorialist website to Japan's very own *Fruits* magazine, the street snap is everywhere—and for good reason: it locates a particular outfit in time and space, and literally allows us to "put a face" to the featured garments. No self-respecting tome on the current fashion of a city would fail to include photos of the inhabitants themselves going about their business. Every spread in this book

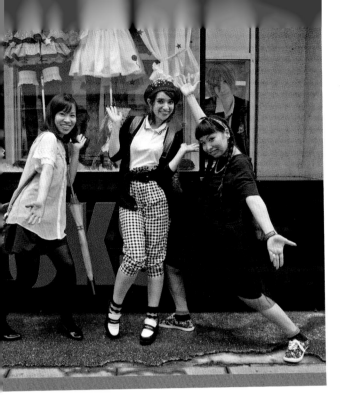

appropriate. These will help to give a better picture of the social and cultural context in which the various styles featured are located. The weary wanderer is encouraged to refresh and replenish in the places mentioned, from cafés hosted by maids in Akihabara to bars in trendy Nakameguro.

JUMP IN!

This is not just another book on Tokyo fashion, nor is it just another Tokyo guidebook: it is both. There should be plenty of interest in the following pages for those who are planning a trip to Tokyo, actually wandering its streets and diving in and out of shops, or just curious to pore over images of Tokyo's fashion denizens from afar. Avid shoppers, keen fashionistas, inquisitive armchair travelers, and Nipponophiles alike, you are all warmly invited to immerse yourselves in Tokyo, fashion city.

features photos of stylish Tokyo characters—and their clothes—representing the topic or area being discussed. The photo captions provide context for the look in question or offer personal trivia or anecdotes.

MORE THAN JUST FASHION

Some chapters cover a wider area than others: while Shibuya—arguably the epicenter of Japan's youth culture—gets a chapter to itself, the final chapter addresses the whole of East Tokyo, reflecting the density of interesting looks and shops in each locale. Harajuku could easily merit an entire book on its fashion delights, but here it cozies up to Omotesando and Minami-Aoyama in one chapter, since these are all strong fashion areas that blend into one another along the axis of Omotesando Boulevard.

This has required strict distillation of each area's shops, but hopefully it will make somewhat overwhelming districts more manageable and accessible for the traveler. And just as the book provides a wide overview of the most renowned fashion spots around town, it also takes the reader deep into lesser-known corners of Tokyo and some of its more obscure boutiques and locations.

Of course, fashion is at the forefront of this take on Tokyo, but the reader will find references to bars, cafés, art, and music venues popping up here and there where

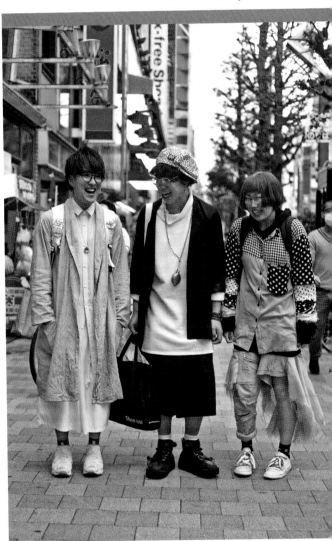

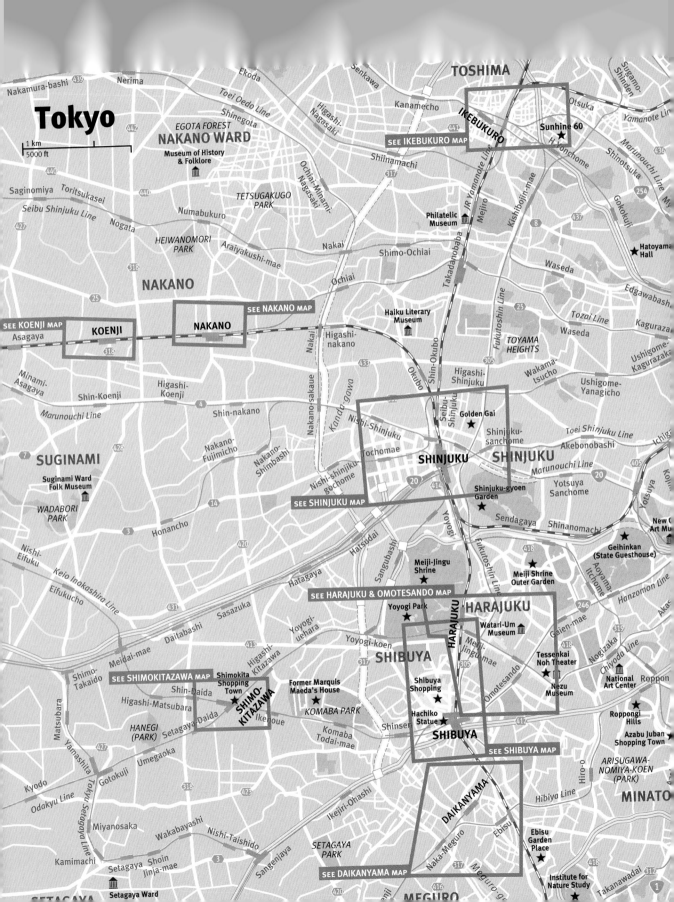

Tokyo

1 km
5000 ft

Nakamura-bashi 439
Nerima
Ekoda
Senkawa
TOSHIMA
Sugamo-Shinden

Toei Oedo Line
Shinegota
Higashi-Nagasaki
Kanamecho
IKEBUKURO
Otsuka
Yamanote Line

442
EGOTA FOREST
NAKANO WARD
Shiinamachi
SEE IKEBUKURO MAP
Sunshine 60 ★
Shinotsuka
Marunouchi Line 436

440
Museum of History & Folklore ♜
317
Meijiro
Kishiboijin-mae
Shinotsuka
254

Saginomiya
Toritsukasei
Numabukuro
Nakai
Shimo-Ochiai
Philatelic Museum ♜
JR Yamanote Line
Meijiro
8
437
Gotokuji
★ Hatoyama Hall

Seibu Shinjuku Line
Nogata
HEIWANOMORI PARK
Araiyakushi-mae
Ochiai
Waseda
Fukutoshin Line
Tozai Line
Waseda
Edgawabashi

427
TETSUGAKUGO PARK
Shimo-Ochiai
25
Kaguraza

NAKANO
25
SEE NAKANO MAP
Higashi-nakano
Shin-Okubo
TOYAMA HEIGHTS
Wakama-tsucho
Ushigome-Yanagicho
Ushigome-Kagurazaka

SEE KOENJI MAP
KOENJI
NAKANO
433
Haiku Literary Museum ♜
Okubo
Higashi-Shinjuku
305

Asagaya
318
Nakano-sakaue
Golden Gai ★
Shinjuku-sanchome
Toei Shinjuku Line
Akebonobashi
Ichig

Minami-Asagaya
Shin-Koenji
Higashi-Koenji
Shin-nakano
Nakai
Nishi-Shinjuku
Seibu Shinjuku
SHINJUKU
SHINJUKU
Marunouchi Line
405

Marunouchi Line
4
Shin-nakano
Nakano-Fujimicho
Nakano-Shimbashi
Tochomae
20
414
Yotsuya Sanchome
20
Yotsuya
Koji

7
SUGINAMI
428
Nishi-shinjuku-gochome
SEE SHINJUKU MAP
Shinjuku-gyoen Garden ★
Shinanomachi
New Art Mu

Suginami Ward Folk Museum ♜
14
Sendagaya
Geihinkan (State Guesthouse) ★

WADABORI PARK
3
Honancho
420
Hatsudai
Fukutoshin Line
418
Aoyama Itchome
Hanzomon Line

Nishi-Eifuku
Keio Inokashira Line
431
Hatagaya
Sangubashi
Meiji-Jingu Shrine ★
SEE HARAJUKU & OMOTESANDO MAP
Watari-Um Museum ♜
Gaien-mae
246
319
National Art Center

Eifukucho
Sasazuka
Yoyogi-uehara
Yoyogi Park ★
HARAJUKU
HARAJUKU
Meiji Shrine Outer Garden ★
Omotesando
Nogizaka
Roppon

Shimo-Takaido
Meidai-mae
413
Higashi-Kitazawa
Yoyogi-koen
305
SHIBUYA
Meiji-Jingumae
Tessenkai Noh Theater ★
Chiyoda Line

SEE SHIMOKITAZAWA MAP
Shimokita Shopping Town
Former Marquis Maeda's House
317
Shibuya Shopping ★
Nezu Museum ♜
National Art Center
Roppongi Hills ★

Shimo-Daida
Shin-Daida
SHIMO-KITAZAWA
KOMABA PARK
Shinsen
Hachiko Statue ★
412
Azabu Juban Shopping Town

Higashi-Matsubara
Setagaya Daida
Ikenoue
Komaba Todai-mae
SHIBUYA
ARISUGAWA-NOMIYA-KOEN (PARK)

Matsubara
HANEGI (PARK)
Tokyu Setagaya Line
423
Ikejiri-Ohashi
SEE SHIBUYA MAP
Hibiya Line
Hiro-o
MINATO

Kyodo
Gotokuji
Umegaoka
318
423
SETAGAYA PARK
DAIKANYAMA
Naka-Meguro
Ebisu Garden Place ★
418

Odakyu Line
Miyanosaka
Wakabayashi
Nishi-Taishido
Sangenjaya
Shoin Jinja-mae
3
SEE DAIKANYAMA MAP
317
Ebisu
416
Takanawadai
312

SETAGAYA
Setagaya Ward ♜
Kamimachi
Setagaya
420
MEGURO
Institute for Nature Study ♜

Map of Tokyo

A note on maps and street names

The maps at the beginning of each chapter are provided as a rough guide to help visitors in their Tokyo wanderings. They are not meant to be an exhaustive list of things to see and do in the area. Depending on the chapter, not all places mentioned in the text may be included on the map. There are certainly many interesting spots—shops, cafés, bars, museums—besides the key fashion places marked; we encourage you to wander and explore, joining the dots as you go.

Only main thoroughfares tend to have street names in Tokyo; these are usually suffixed by *dori,* meaning "road" (e.g., Meiji-dori). This makes finding places using their addresses something of a challenge—but Google Maps, a bilingual atlas, or a friendly taxi driver can help you there!

Map labels

SHIOIRI PARK

Tabata Bunshimura Memorial Museum

Rikugi-en Garden

Aoki Konyo Monument

BUNKYO

Arakawa Kuyakusho-mae

Arakawa-itchumae

Mikawashima

Jaban Line

Minowabashi

ARAKAWA

SEE EAST TOKYO MAP

SUMIDA

ASAKUSA

Senso-ji

UENO

TAITO

Ginza Line

Narihirabashi

Tokyo Sky Tree & Tokyo Solamachi

Honjoazubashi

Ueno-hirokoji

Inaricho

Tawaramachi

Ace World Bag & Luggage Museum

KINSHI PARK

Bakuro-Yokoyama

La Qua

Hongo-sanchome

Shin-okachimachi

Koishikawa Korakuen Garden

Tokyo Wonder Site Hongo

Tokyo Dome (Big Egg)

Suehirocho

AKIHABARA

Akihabara Electric Town

AKIHABARA

Kuramae

Edo-Tokyo Museum

Sobu Line

Kinshicho

Suidobashi

Ochanomizu

Nikolai Cathedral

Asakusabashi

Ryogoku

Yasukuni Shrine

Jimbocho

SEE AKIHABARA & OKACHIMACHI MAP

Higashi-nihon-bashi

Morishita

Kikukawa

Sumiyoshi

Kogeikan (Crafts Gallery)

National Museum of Modern Art

Iwamotocho

Kodenmacho

Hamacho

Imperial East Gardens

Imperial Palace

Otemachi

Ningyocho

Kiyosumi-Shirakawa

Kiyosumi Teien (Garden)

Museum of Contemporary Art Tokyo

TOKYO STATION

Base Gallery

Suitengu-mae

Parliamentary Museum

Marunouchi My Plaza

Kayabacho

KIBA PARK

CHIYODA

Tokyo Int'l Forum

National Film Center

Hatchobori

Kiba

Kokkai Gijido National Diet Bldg

Hibiya Park

Hibiya

GINZA

SEE GINZA & MARUNOUCHI MAP

Monzen-Nakacho

Etchujima

Kasumigaseki

Ginza Noh Theater

Higashi-ginza

Shintomicho

TORANOMON

Kabuki-za Theater

Tsukiji

Shiodome

Shio Sight

Tsukiji Fish Market

Kachidoki Bridge Museum

Yurakucho Line

Tokyo Tower

Vita Italia

Hama Rikyu Garden

Kachidoki

Tsukishima

Shiomi

Zojo-ji

Daimon

Shiba Rikyu Garden

KidZania

Urban Dock Lalaport Toyosu

Toyosu

Shibakoen

Takeshiba

Hinode

KOTO

Tatsumi

Tamachi

Tokyo Bay

Ariake Tennis-no-mori

Shinonome

Port of Tokyo

SHINAGAWA

Ariake Tennis-no-mori Park

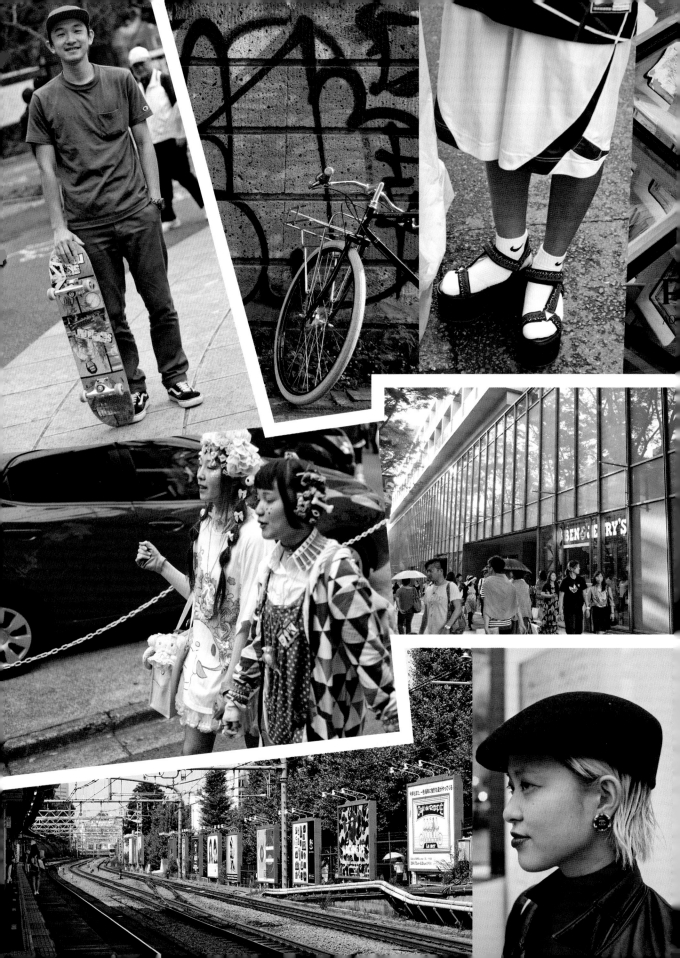

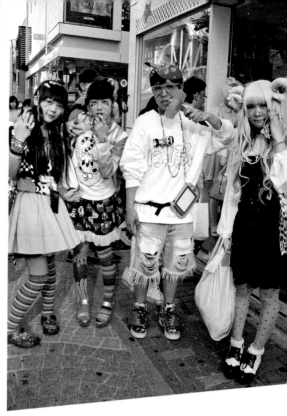

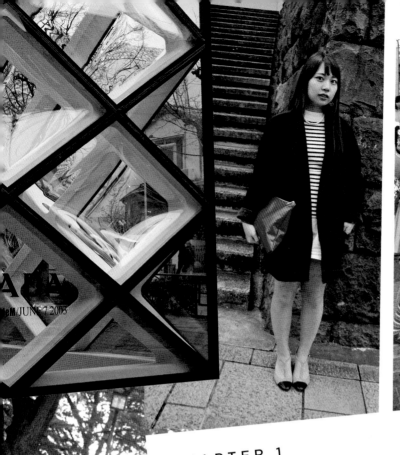

CHAPTER 1

Harajuku & Omotesando

GROUND ZERO IN TOKYO'S INCREDIBLE FASHION UNIVERSE

Tokyo's Style Mecca

FROM HIGH TO LOW FASHION AND EVERYTHING IN BETWEEN

Spreading eastward from the green of Yoyogi park and the solemn sanctity of Meiji Shrine is Tokyo's most diverse, concentrated, and perhaps famous fashion landscape. In fact, within this one sprawling location spanning the three train stations of Harajuku, Meiji-jingumae, and Omotesando are three areas that, despite blending geographically into each other, are distinct in terms of their fashions, architecture, and atmospheres: Harajuku, Omotesando, and Minami-Aoyama. Home of the residences of American Occupation forces in the postwar years, the district has since then held the exciting promise of the "foreign," attracting a rich succession of *zoku* youth tribes, and laying the foundations for its fashion prowess.

HARAJUKU MAGIC

Across the train tracks from the otherworldly Meiji Shrine, Harajuku has a more irreverent sense of the magical and wondrous about it: its reputation as a melting pot for fashion, combining trends and throwing out radical outfits, precedes it both in Japan and around the world. The encroachment of global fast fashion and broad gentrification has caused many to bemoan the loss of Harajuku's golden years. Those were the heady days of the *hokoten* "pedestrian paradise" in the 1990s, when the main thoroughfare was closed to traffic, providing a breeding and parade ground for new fashions. The next decade saw the live bands in Yoyogi Park and the cosplayers on the bridge between Harajuku station and Meiji Shrine. Although these scenes have faded away, the maze of backstreets still deliver on the Harajuku promise of spectacular style.

GRAND OMOTESANDO

Omotesando, meaning "main shrine approach," is historically the road that leads to Meiji Shrine. While the huge stone lanterns standing at its major junctions serve as reminders of its original function, it has now become home to a reverence of a very different kind, as shoppers and tourists alike gawp at the polished exteriors and tempting offerings of the many luxury shops that line the wide boulevard.

HIGH FASHION IN AOYAMA

Walking away from Harajuku station along Omotesando, you will cross first Meiji-dori and then Aoyama-dori into Minami-Aoyama. The short stretch of Omotesando between this crossing and the Nezu Museum, and the side streets shooting off it, are an enclave of stylish sophistication. Here, away from the traffic and bustle of the main Omotesando thoroughfare, you will find the cream of international Japanese fashion, with stores from heavyweights Yohji Yamamoto, Comme des Garçons, and Issey Miyake, as well as next-generation stars like Undercover, thrown into the mix of domestic and international boutiques.

A DAY OUT

Not only is the area worth visiting for an exhaustive day of shopping, but the architecture and cityscape themselves make for a stimulating stroll. You'll weave between the backstreets—crammed with a tangle of shops and telephone poles—and the grand, leafy boulevard studded with the striking flagship creations of global architectural superstars. And of course this is prime people-watching territory: teenyboppers mix with avant-garde fashion lovers and smartly attired young adults.

RIGHT Stone lanterns attest to Omotesando's original purpose as the approach to Meiji Shrine.

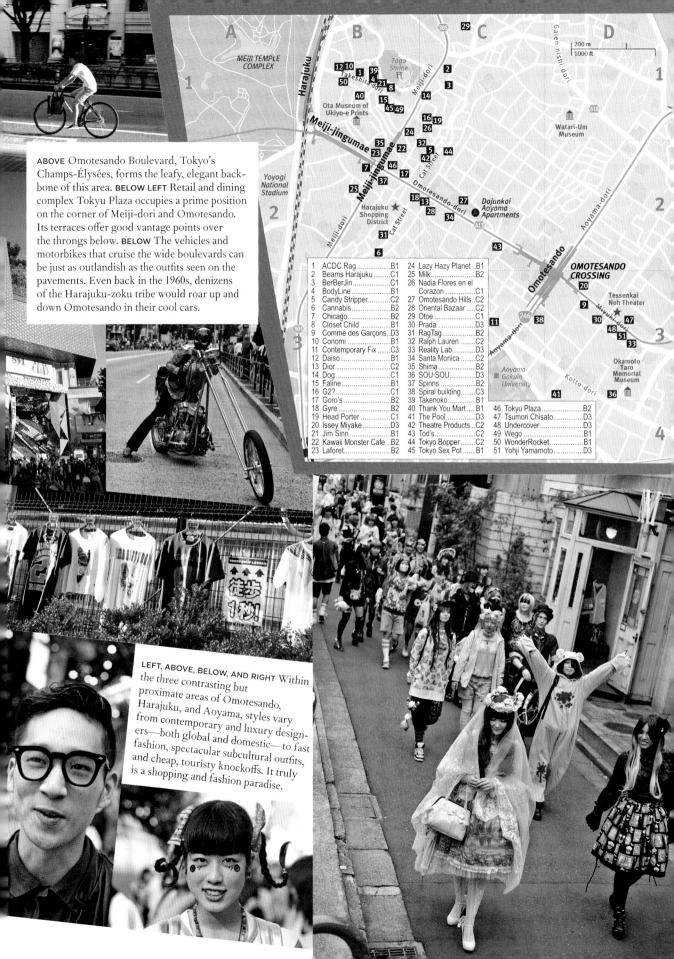

ABOVE Omotesando Boulevard, Tokyo's Champs-Élysées, forms the leafy, elegant backbone of this area. **BELOW LEFT** Retail and dining complex Tokyu Plaza occupies a prime position on the corner of Meiji-dori and Omotesando. Its terraces offer good vantage points over the throngs below. **BELOW** The vehicles and motorbikes that cruise the wide boulevards can be just as outlandish as the outfits seen on the pavements. Even back in the 1960s, denizens of the Harajuku-zoku tribe would roar up and down Omotesando in their cool cars.

LEFT, ABOVE, BELOW, AND RIGHT Within the three contrasting but proximate areas of Omotesando, Harajuku, and Aoyama, styles vary from contemporary and luxury designers—both global and domestic— to fast fashion, spectacular subcultural outfits, and cheap, touristy knockoffs. It truly is a shopping and fashion paradise.

1 ACDC RagB1	24 Lazy Hazy Planet ..B1
2 Beams HarajukuC1	25 MilkB2
3 BerBerJinC1	26 Nadia Flores en el
4 BodyLineB1	CorazonC1
5 Candy Stripper............C2	27 Omotesando Hills ..C2
6 Cannabis....................B2	28 Oriental BazaarC2
7 Chicago......................B2	29 OtoeC1
8 Closet ChildB1	30 PradaD3
9 Comme des Garçons ..D3	31 RagTagB2
10 ConomiB1	32 Ralph LaurenC2
11 Contemporary FixC3	33 Reality LabD3
12 Daiso.........................B1	34 Santa MonicaC2
13 DiorC2	35 Shima.......................B2
14 DogC1	36 SOU·SOU..................D3
15 FalineB1	37 SpinnsB2
16 G2?C1	38 Spiral building...........C3
17 Goro'sB2	39 Takenoko..................B1
18 GyreC2	40 Thank You MartB1
19 Head PorterC1	41 The Pool....................D3
20 Issey MiyakeD3	42 Theatre Products...C2
21 Jim SinnB1	43 Tod's........................C2
22 Kawaii Monster Cafe ..B2	44 Tokyo BopperC2
23 Laforet.......................B2	45 Tokyo Sex PotB1

46 Tokyu PlazaB2	
47 Tsumori Chisato..........D3	
48 UndercoverD3	
49 WegoB1	
50 WonderRocketB1	
51 Yohji YamamotoD3	

Where It All Started

Fast-fashion chains and brand flagships may line Omotesando and Meiji-dori, but venture into the backstreets in the quadrants formed by these crossing main roads and all the fashion eccentricity and charming chaos of Urahara (literally "behind Harajuku") bubbles into view. This is where to come and see Tokyo's most passionate and egregious fashionistas, young adults who live and breathe fashion (and usually work in it or are training to, whether as shop assistants, designers, or hairdressers). Catch their outfits, carefully considered to express individuality and originality while referencing the particular labels and looks du jour, but worn with an air of nonchalance, as they weave their way to the coolest shops on their fashion radar.

For young fashion lovers, Harajuku has long been more than a shopping destination; it's a place to gather, socialize, create, and strut one's stuff. This frenzied fashion activity used to take place on Omotesando itself on Sunday mornings, when the road was closed to traffic to become a "pedestrian paradise," but in 1998 the road reverted from being a weekly impromptu catwalk to a permanent traffic thoroughfare. The backstreets have remained a more diffuse repository of the idiosyncratic Harajuku fashion scene and its movers and shakers, and as yet are still holding strong against the encroaching knockoff and fast fashions.

BACKSTREET BEGINNINGS

Ironically, it was a shop called "Nowhere" that really put Urahara on the map. Opened in 1993, this was a joint venture by the then relatively unknown Nigo and Jun Takahashi. (Nigo went on to found the A Bathing Ape streetwear empire, and Jun Takahashi has become a darling of the international fashion circuit with his Undercover label.) It was initially an outlet for American vintage, and crystallized the area's association with a US streetwear/skater-inspired style called Urahara-kei. Now the area is home to a much wider array of styles, from the subcultural to the boundary-breaking looks of young fashion leaders (although they are often erroneously all still lumped together under the Urahara-kei label).

The social hierarchies that pulse through the streets and shops of Harajaku throw up not just fashions but also fashion icons. DJ and stylist Hiroshi Fujiwara preceded Nigo and Takahashi; there are also current leaders such as Nara Yuya, hairstylist from the salon Shima; Hirari Ikeda, model and

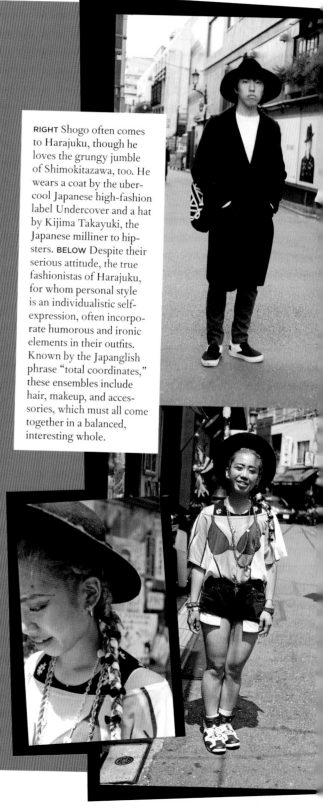

RIGHT Shogo often comes to Harajuku, though he loves the grungy jumble of Shimokitazawa, too. He wears a coat by the uber-cool Japanese high-fashion label Undercover and a hat by Kijima Takayuki, the Japanese milliner to hipsters. BELOW Despite their serious attitude, the true fashionistas of Harajuku, for whom personal style is an individualistic self-expression, often incorporate humorous and ironic elements in their outfits. Known by the Japanglish phrase "total coordinates," these ensembles include hair, makeup, and accessories, which must all come together in a balanced, interesting whole.

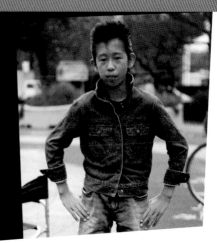

LEFT Nineteen-year-old Chiaki, a fashion student in Yokohama, loves making shopping trips to Harajuku and Shibuya, about an hour away. She pulls off her jumbled look—typical Urahara—perfectly, with elements including hip-hop, street, bodycon, frills, and ethnic print all mixed into one. **FAR LEFT** Yasu works at the high-end men's fashion select shop Nubian, which is nestled in the maze of Harajuku back streets. It stocks a wide range of international avant-garde designers, including Japanese brands Facetasm and Dress Camp.

former shop assistant at the avant-garde clothing boutique Dog; DJ and designer Mademoiselle Yulia; and kooky pop sensation Kyary Pamyu Pamyu.

BACKSTREET BOUTIQUES

Interspersed among the cheap rip-off shops and outposts of established youth fashion brands are dozens of boutiques that are key to to the Harajuku fashion scene. They all boast unique and ever-evolving stock, distinctive interiors, and uber-cool shop staff. While the many that focus on vintage will be introduced on the following pages, fashionistas in search of the hottest domestic and import labels might start by heading to the tiny but influential Faline, with its pink pop interior, just off Takeshita-dori. At the end of Takeshita-dori, cross Meiji-dori and keep heading south down Harajuku-dori and into a rich quadrant of backstreets. Here you'll find Harajuku legend Dog, with its underground location and clothes; the dramatic and playful fashions at Japanese label Theatre Products; and 6% Doki Doki, the headquarters of the kitsch accessories of the *decora* decorative style and purveyor of ever-popular Head

Porter bags, among others. A stroll along Cat Street, which connects Harajuku to Shibuya, puts you in the path of Tokyo Bopper's outré shoes, longstanding fun pop women's brand Candy Stripper, and the cutting-edge men's high-fashion store Cannabis, to name a few. The area has also become home to dozens of outdoor-gear shops catering to the growing number of women getting into camping and hiking who need cute clothes to wear for those activities.

Beams—perhaps Japan's most influential select shop—has up to ten different stores covering everything from suits to records clustered on and just off Meji-dori, including the original Beams shop, which opened in 1976. Also on Meiji-dori are Milk, whose frilly clothes were one of the early influences on girly Lolita fashion; fashion-forward select shop Lazy Hazy Planet; and last—but not least—Harajuku's famed fashion building Laforet. Within the thirteen half-floors of this youth fashion hub are select shops offering the most eccentric of high fashion: Wall, GR8, and Cannabis Ladies. Laforet also features Japanese labels Né-Net, Frapbois, and Mercibeaucoup (not to mention Gothic Lolita and punk in the basement dungeon floors).

STYLISH TRIBES

The first Harajuku style tribes, or zoku, were drawn here in the 1950s by the cool Western atmosphere bestowed on the area by foreign services and shops catering to American residents. This was where Tokyo youth, dressed in Western casual styles, came to dance, drink, and hang out. Several "tribes" developed over time: the eponymous Harajuku-zoku drove their cars up and down Omotesando in the mid-1960s, and in the 1970s the brightly attired singing and dancing *takenoko-* (bamboo-shoot) zoku provided a contrast to the *karasu-* (crow) zoku, dour followers of black avant-garde fashions. Such groups helped spread the fame of Harajuku to the nation's youth and cemented its status as a fashion center.

From Secondhand to Remade

Harajuku is known as a wellspring for new youth fashions across Japan, Asia, and beyond, so it is perhaps surprising that many of the shops contributing to this wealth of creative clothing are vintage boutiques peddling the garments of yesteryear. In Japan, "vintage" usually refers to used Western clothing that is either sufficiently old, interesting, branded, or high in quality to be more than merely "secondhand." Examples of vintage could range from old Chanel earrings to faded and worn Levis or faded cream net pannier underskirts. There are plenty of shops in Harajuku that deal exclusively in a selection of vintage clothes. One of the long runners, still going strong, is BerBerJin, which is heavy on workwear and American casual. Another, supposedly favored by kitsch pop sensation Kyary Pamyu Pamyu, is the quirkily named G2?, a treasure trove whose vintage haul spans many genres and periods.

"REMADE" WEARABLE ART

The more distinctive vintage boutiques in Harajuku add their own creativity to their selection of old clothes through the category known as "remakes." A "remade" garment is literally that: it is worked upon in whatever state it was found in (whether pristine or worn) with all manner of techniques and materials to produce a one-of-a-kind piece. The skill and imagination that goes into a remake can almost reach the level of producing a wearable artwork, and certainly gives certain shops the edge when it comes to producing cutting-edge looks. Perhaps the most famous of the vintage stores also specializing in spectacular remakes is Dog, whose underground lair has graffiti on the walls by Lady Gaga, just one of their high-profile international clients. The shop assistants at Dog are Harajuku style icons in themselves, and it is their brains and hands that forge the remakes, creating an irresistible shopping and fashion experience for the shop's many devotees. Otoe is a more chic counterpart to Dog's grunge, with a selection of vintage clothes and remakes along with some new labels. Both shops have interiors that are as fanciful as their clothes. A popular newcomer, mixing vintage with the store's own designs, is Nadia Flores en el Corazon.

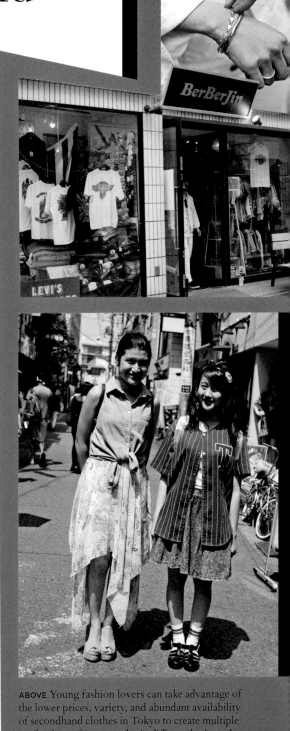

ABOVE Young fashion lovers can take advantage of the lower prices, variety, and abundant availability of secondhand clothes in Tokyo to create multiple outfits that reference and mix different looks and historical styles. The flexibility of furugi opens the door wide to sartorial experimentation.

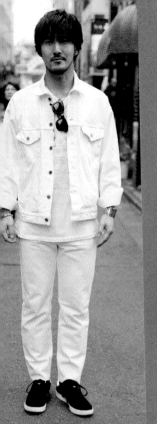

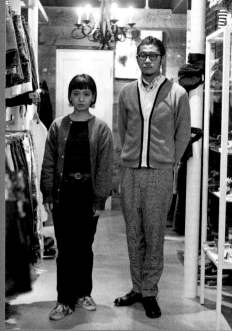

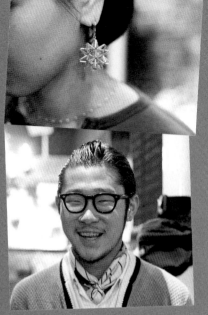

FAR LEFT AND LEFT Mr. Sakamoto is an employee of Harajuku vintage stalwart BerBerJin, beloved of the fashion crowd. Complementing his vintage '80s denim are glasses from Max Pittier (a classic brand recently revived by musician John Mayer) and silver bracelets, including one from Tiffany & Co. and one from legendary Harajuku silver shop Goro's (identifiable by the constant line of fans outside its shop on Omotesando).

LEFT, TOP, AND ABOVE These two are pictured at work in vintage shop Sankaku. Ayaka (left) is wearing all vintage, which she sources mainly from Koenji and Naka-meguro as well as emerging vintage hot spot Machida, far out in suburban western Tokyo, where she bought her earrings. Rei (right) combines his secondhand cardigan with traditional Alden brogues and a scarf from the edgy vintage-inspired designs of Silviya Neri. Harajuku's Sankaku is now closed, but it has operational sister shops in Nakameguro, Koenji, and Shimokitazawa.

FURUGI SHOPS

The poorer and more common cousin of vintage is *furugi*, literally "old clothes"—a category of used, often mass-produced, unexceptional, cheap garments. Furugi is a popular addition to any fashionista's outfit for its broken-in, nonchalant look and reasonable cost. There are many furugi stores in Harajuku; unlike their vintage counterparts, they are often large in scale, with many similar clothes arranged by color, type, etc. Among the most famous are Spinns, which has three Harajuku stores, one of which focuses on furugi (the others feature new eclectic lifestyle and fashion stock); Santa Monica; and Chicago, which stocks old kimono as well. Wego, with over 20 years' history in Harajuku, is another nationwide chain popular with youth whose furugi looks are actually mostly brand-new. For secondhand and out-of-season designer stock, head to RagTag's Cat Street location; and for used clothes at 390 yen apiece—no more than the price of a cup of coffee—try Takeshita-dori's Thank You Mart ("Thank you" sounds like "*san kyuu*"—Japanese for 3 and 9).

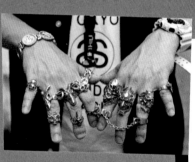

LEFT AND ABOVE Convoy, as he is known, is one of the trend-setting employees at Harajuku institution Dog. Decked out in black and white, his Stüssy T-shirt could be authentic or one of the obvious brand fakes that are a regular Dog theme. All the accessories weighing on his hands give them a literal "heavy metal" appearance, in addition to the gold bracelet bling that fits the dash of rapper in his outfit. Convoy not only helps man the shop, but also helps to "remake" some of their secondhand clothing stock into Dog originals.

TAKESHITA-DORI
Teenybopper Heaven

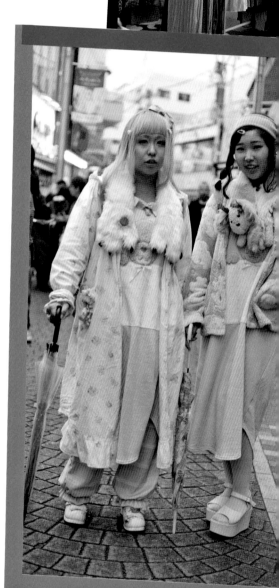

Takeshita-dori, a pedestrianized shopping street between Harajuku station and Meiji-dori, is a microcosm of Japanese tween youth culture. Stroll along—or, if visiting on the packed weekends, shuffle along—and you'll be bombarded by a riot of clothes, signs, music, tempting sweet snacks, and sales calls from the shops on either side. Gothic punk shop ACDC Rag, check; *kawaii* Shibuya *gyaru* shop Liz Lisa, check; Lolita shop Closet Child, check; hip-hop shop Broadway, check. Stores come and go with the whim of teen tastes, but a few—including the glitzy costumes of Takenoko and the raw punk style of Jimsinn below it—have stood the test of time. Besides fashion, you'll see the fresh faces of many Japanese idols grinning out from postcards and posters at shops like Harajuku Idol Shashinkan, which sell various merchandise of pop stars and actors. After buying a photograph of your idol du jour, you can take one of yourself at Harajuku Purikko, one of Takeshita-dori's "print club" photo-sticker booth arcades. The numerous crepe shops along the way provide a feast for the stomach as well as the eyes. In fact, pancakes are essential to the Takeshita-dori experience, as is a visit to the colossal Daiso hundred-yen store, which sells everything from nail polish to gardening goods, all priced at just a hundred yen (around a dollar).

TOURIST TOWN

Despite being a fabled center of teenage culture, a closer look shows that Takeshita-dori is full of cheap knockoffs and trends that have gone mainstream. BodyLine, for example, seems like a purveyor of authentic Lolita culture with knock-down prices, but not many self-respecting Japanese Lolitas would buy the generic maid-like dresses sold there. Unlike the pockets of sartorial cutting edge that still exist in Harajuku, Takeshita-dori's seemingly original and spectacular fashions are for trend-conscious tweens and teens rather than true trendsetters (although there are some destinations for the latter in the side streets, notably fashionista legend Faline and proper punksters Tokyo Sex Pot). Japanese schoolgirls enjoy shopping at WonderRocket, purveyors of the whimsically pretty "*mori* girl" style (look out for the rabbit-head mannequin at the entrance), as well as at Conomi, a store devoted to school uniforms and the all-important accessories from ribbon neckties to loafers and loose socks. Takeshita-dori can be summed up as part tourist attraction, part destination shopping experience for schoolkids. This is not to denigrate the experience, which remains a sensory and cultural barrage, but to warn the visitor that, while a cool T-shirt from Takeshita-dori can be enjoyed for what it is, it's unlikely to be a sample of truly avant-garde Harajuku cool.

TOP A shop on Takeshita-dori bursts with the bright pop clothing beloved by the colorful kids who dress in the *decora-kei* "decorated" style. **ABOVE** A couple of girls in the saccharine "fairy" look that features pastels, '80s and '90s childhood imagery, bows, glitter, and candy-floss hair colors. Popular fairy-*kei* (style) shops include Nile Perch and Spank.

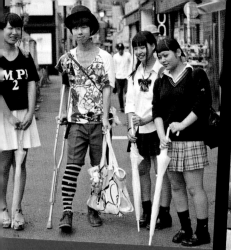

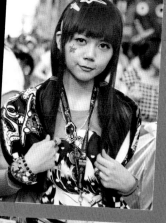

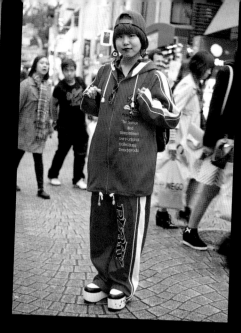

ABOVE These four met through online fashion networks. The girls love the Monki shop (from the H&M group) on Takeshita-dori, and read the fashion magazine *Nylon*. Ikumin (second from left) is a bit more whimsical, influenced by the '20s fashions of the Taisho era.

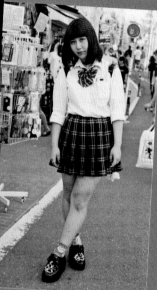

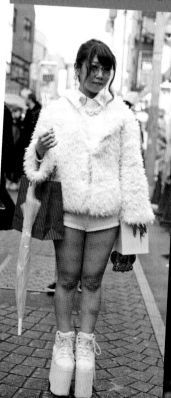

TOP Though cosplayers no longer hang out on the Jingu bridge by Harajuku station on weekends, they still frequent Takeshita-dori, where they can pick up accessories and garments from the various cheap and funky stores that line the road. **ABOVE** Japanese schoolgirls like sixteen-year-old Lala are Takeshita-dori's most iconic visitors, drawn by the fashions, crepes, idol goods, photo-sticker booths, and specialty shops like Conomi, which sells cute uniforms and accessories.

ABOVE AND RIGHT Barbie branded clothes for women are more popular in Japan than Barbie dolls for girls. There is a Barbie clothes shop in the backstreets of Harajuku not far from Takeshita-dori.

TOKYO HIP-HOP STYLE

Takeshita-dori is a hodgepodge of tween trends, subcultural looks, and street styles, so it is perhaps not surprising that several hip-hop fashion outlets can be found on and just off it. Many shops along Takeshita-dori vie for attention and custom by sending an employee out front to holler about their various wares. The hip-hop shops selling imported goods typically have particularly enthusiastic "callers," as they are known. Mostly from Nigeria, these shop assistants may follow likely clients along the road for a while in hopes of clinching a sale, though the practice is officially frowned upon. Hip-hop music and fashion, both domestic and imported, are also represented heavily in nearby Shibuya.

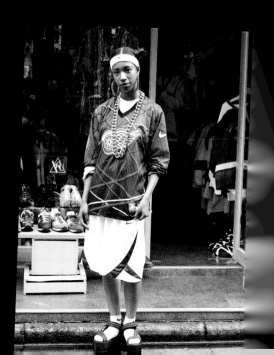

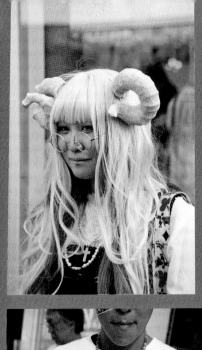

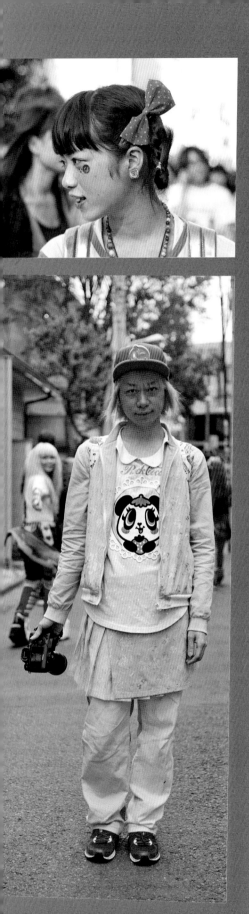

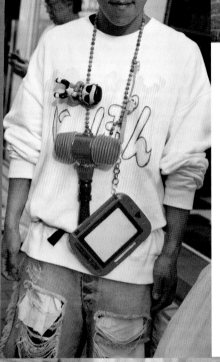

FAR LEFT Junnyan is the organizer of the Harajuku Fashion Walk, which sees an assortment of people decked out in Tokyo's most eccentric and outrageous styles parade through Harajuku. **TOP LEFT AND TOP MIDDLE** Eye-catching outfits are topped off by creative hair-dos. For the experimental dressers of Harajuku, hair accessories range from oversized bows in black braids to horns in long pink-and-purple tresses. **ABOVE, LEFT, AND BOTTOM** Decora style, with its clashing riot of color and plastic accessories, is just one of the many looks worn in the Harajuku Fashion Walk, and to some extent, Harajuku itself, especially on weekends. Lolita, visual-kei (a Japanese type of rock music), gothic/punk, decora: all these are represented in the basement floors of Harajuku's famous Laforet.

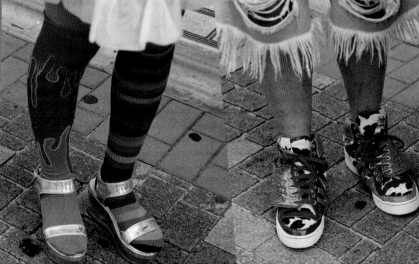

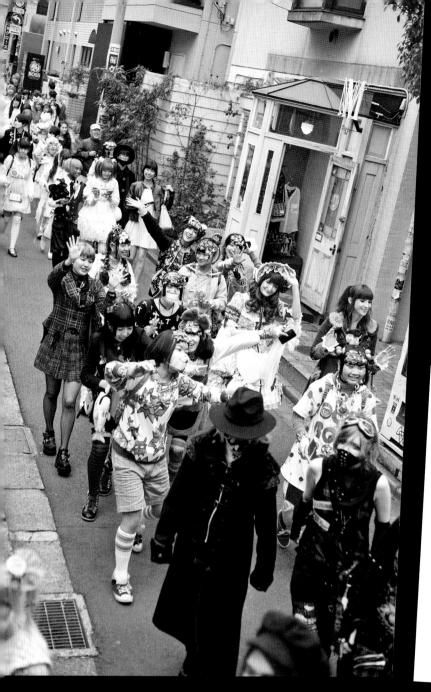

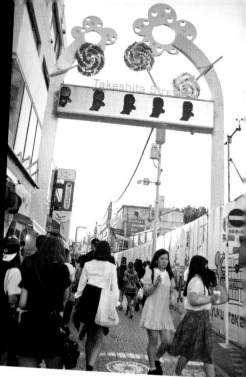

DECORA-KEI STREET EXCESS

Decora—as may be guessed from the highly colorful and accessorized appearance of the proponents of decora-kei (decora style)—is a Japanized abbreviation of "decora-tion." The style first came to fame in the 1990s with the iconic *Fruits* street-fashion magazine which documented it, and continues amongst a core of young fans today. The look is all about childlike excess: the brightest colors, the most contrasting layers of clothes and legwear, hair covered in cute plastic clips, repurposed cheap toys hanging around the neck…even surgical masks that cover the nose and mouth are a common part of the decora effort to decorate every possible part of the body.

In Japan, the over-the-top aesthetic of decora is not lim-ited to these candy-like Harajuku kids, but is also applicable to everything from calculators to mobile phones—even long-distance trucks (*decotora*) with vibrant paint jobs and arrays of flashing lights. "*Decoru*" is a slang verb derived from the term that has come to refer to the act of covering items from pens to game consoles in rhinestone bling. The most famous decora kei shop is Harajuku's 6% Doki Doki, whose creator, Sebastian Matsuda, is behind the uber-kitsch, decora-inspired Kawaii Monster Cafe just around the corner.

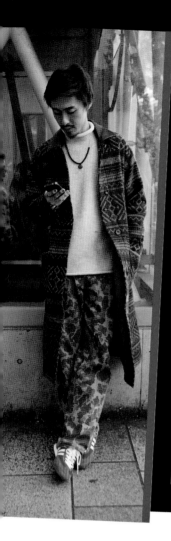

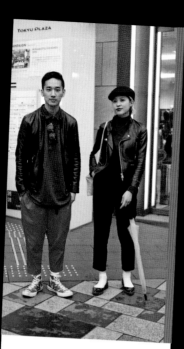

LEFT Two more hairstylists, in leather jackets. He wears minor Japanese high-fashion brands, including Tellsit (jacket), a young brand shown at Tokyo Fashion week that is stocked in the fashion-forward Harajuku select shop Cannabis; and the sculptural clothes of Dulcamara (trousers). Cheap plastic glasses hang from his shirt. Her French-inspired look is completed by Chanel earrings.

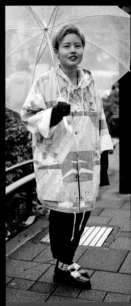

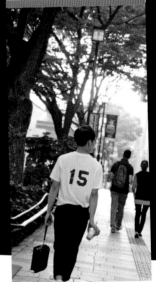

ABOVE The sleeves of this hairstylist's Vivienne Westwood jumper poke out of her secondhand raincoat, with Vivienne Westwood socks peeking above the shoes she bought from Harajuku's fashionista select shop Cannabis.

STREET FASHION AND STREET SNAPS

The Harajuku Street Runway

For some of Tokyo's most *oshare* (stylish) teenagers and young adults, walking down Omotesando can be like running the gauntlet as they are pounced upon by various eager scouts who lie in wait and chase them down the street, clipboard in hand. On any day, and particularly on weekends, the boulevard's pavements are lined with magazine staff perched on the railings with their cameraman accomplices, hoping to capture Tokyo's finest fashionistas for the "street snap" pages of magazines that feature real people wearing inspirational outfits.

PAPARAZZI FOR THE PEOPLE

Japanese fashion-magazine culture is obsessed with the "street snap." Street-fashion magazines such as *Kera*, *Choki Choki*, *Zipper*, and so on feature them heavily in every issue—not to mention the blogs devoted to snaps of people on the pavement. Such is the desire to see what real people are wearing as opposed to the fashions featured in the often-prescriptive editorial. The street-snap subject typically stands straight, staring into the camera with an expressionless face and showing off their clothes like a shop-window mannequin.

People come from far and wide to bask in Omotesando's stylish surroundings. These sculptural trousers and shoes belong to a fashion lover from Oita, Kyushu; they are from the Oita select shop Welles.

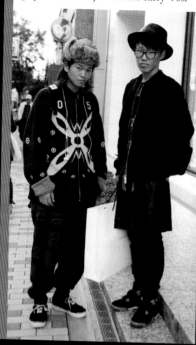

These two friends, who often go shopping together, are pictured here after buying shoes at Balenciaga. Kento (left) used to work in a used-clothes store in Shibuya; he is wearing trousers by W<, a Belgian brand popular in Harajuku in the early '90s.

FRUITS AND *TUNE* MAGAZINES

One magazine in particular set the precedent for street snaps: *Fruits*. It was started by Shoichi Aoki in 1997, when he was captivated by the blossoming fashions of what was then Harajuku's "pedestrian paradise" era. At first he photographed youngsters in their creative and colorful outfits himself, devoting each page to one full-length portrait. He later employed "hunters" who, by carefully selecting aspiring fashionistas to appear on the magazine's influential pages, became the de facto gatekeepers for achieving fame and fashion cred. Now *Tune*, exclusively for street snaps of men's fashion, has joined *Fruits*; together, these print precursors of websites like New York's Sartorialist remain a source of domestic and global fashion inspiration.

HAIRDRESSING TRENDSETTERS

The coolest of the cool fill the pages of street-snap magazines, but who are they? For the most part, they are people who are invested not just in their own clothes, but in the fashion industry somehow—they're often fashion students. But hairstylists, too, are fashion leaders in Tokyo. Plugged into the social networks of the city's young, fashionable movers and shakers, they're as ripe for trendsetter status as their counterparts working in hip clothing boutiques. Two iconic young hairdressers of the last decade are Yuya Nara, of the Shima chain of salons (his own *Yuya Nara Fashion Style Book* is out in the shops); and Kaori Shinohara, now at Land in Aoyama. Both were frequent subjects on the pages and covers of *Fruits* and *Tune*. With such social status available to Japanese hairstylists, it is a popular occupational choice. Young trainees trying to get ahead of the competition may also be among those accosting passersby on Omotesando as they scout for models to practice their scissor skills on and add to their portfolios.

Flaunting Fine Fashion and Architecture

If the backstreets of Harajuku are about chaotic creativity, Omotesando, the wide thoroughfare that slices through them, is about polished grand design. The heady youth fashion action that once took place on the main road—from the 1950s style tribes to the weekend "pedestrian paradise" that ended in 1998—has melted into the side streets, giving way to impressive shiny buildings housing international luxury fashions. The superstar designer reigns supreme here over both the fashions and the buildings. But while the brands are international, the buildings that house them are mostly Japan-designed: Dior's luminous glass and curtain edifice is by hot Japanese architect team SANAA; the renowned Toyo Ito designed the Tod's building to incorporate the angular zigzag of the zelkova trees that line the avenue into its glass tower structure; and one of the latest additions, for Hugo Boss, is a striking tree-stump-like concrete tower by Norihiko Dan. Gyre bucks the trend of airy towers with a stout brick creation by Dutch architects MVRDV, which contains Chanel and the MOMA design store, among others. The striking displays in the large windows of Louis Vuitton make up for its relatively tame building. Others reference more classical design: Ralph Lauren resembles a huge colonial mansion; and the Oriental Bazaar, an enduringly popular purveyor of souvenirs in all price ranges, looks like a garish temple, its entrance flanked by a pair of fearsome-looking Buddhist guardian statues (don't miss the adjacent Kiddy Land for more lighthearted souvenirs).

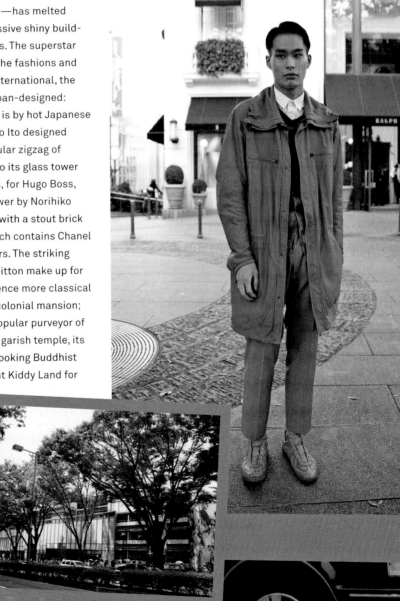

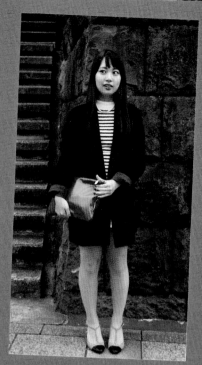

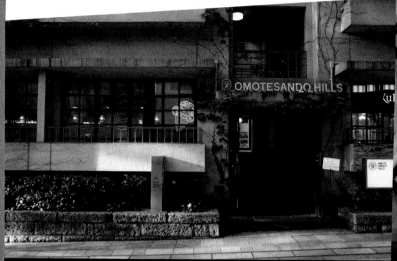

ABOVE This architecture student stands in front of a roughly hewn stone wall, unusual amongst Omotesando's otherwise gleaming glass and metal buildings. Her smart contemporary look includes Japanese brands Goocy (bag), which has a shop nearby, and Kastane (coat). **LEFT** This hairstylist is a lover of the deconstructed high fashion of Martin Margiela. His coat, shirt, trousers, and shoes are all Margiela, which has a flagship boutique in the Omotesando Gyre building. Pictured here in front of the palatial Ralph Lauren store opposite, he often goes shopping in Shinjuku, heading to fashion-forward department store Isetan. **MIDDLE LEFT** The zelkova trees lining the pavement lend to Omotesando's signature look and are reflected in the buildings: Omotesando Hills rises to about the same height as the trees, and their branch formation is echoed in the Tod's building. **FAR LEFT** Just as much a feature of Omotesando as its spectacular architecture are the astonishing queues that line its pavements. People queue for everything from idol goods at Johnny's talent agency shop to silver accessories at Goro's, and for the latest fads, whether they be Hawaiian pancakes or popcorn.

DOJUNKAI APARTMENTS & OMOTESANDO HILLS

Global superstar architect Tadao Ando was called upon to build Omotesando Hills, a shopping and residential complex that opened in 2006 on the site of the Dojunkai Aoyama Apartments. Since their creation in 1927, the apartments had come to house more small shops than residents, and their passing was bemoaned by many; Ando preserved a small block of them at the eastern end of the otherwise sleek glass-and-concrete building. The profile of the edifice is intentionally set below the height of Omotesando's zelkova trees, extending three floors underground instead: all six floors are connected by a spiral walkway that leaves an airy atrium in the middle of the triangular building. Shops include interesting Japanese brands like Facetasm and Maison Mihara Yasuhiro, as well as a subterranean branch of the eclectic Pass the Baton. There are numerous cafés and restaurants, too. Don't miss the opulent juice bar Forbidden Fruit, which contains a hidden gem: unmarked, down the staircase at the back of the shop, is the edgy fashion boutique Bedrock, which stocks an eclectic range that includes Alaia and Galliano.

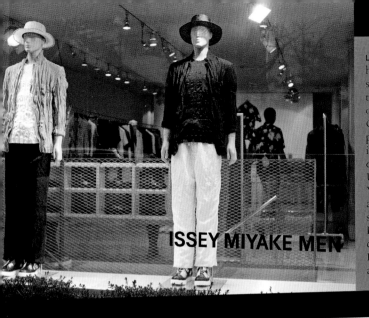

ISSEY MIYAKE MEN

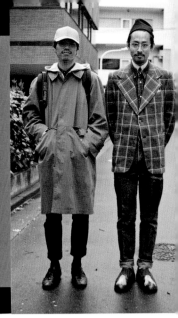

MINAMI-AOYAMA

Home to the "Big Three" Japanese Designers

Omotesando, the grand boulevard studded with international brands, narrows as it crosses Aoyama-dori into a smaller street that nevertheless packs a powerful fashion punch. In fact, it is an almost sacred ground for Japanese high fashion. Along its short length lie boutiques of the legendary three Japanese fashion designers who stormed the Paris catwalks and disrupted the international fashion scene in the 1990s: Issey Miyake, Yohji Yamamoto, and Rei Kawakubo. Minami-Aoyama, as the environs are known, is the sophisticated, more refined member of the Harajuku-Omotesando-Aoyama trio, catering to the more discerning older fashionista who revels in the relatively eccentric Japanese fashion labels, unusual boutiques, and smart cafés and restaurants that are concentrated in its quiet streets.

MIYAKE, YAMAMOTO, AND KAWAKUBO

Issey Miyake has the biggest presence on this short length of Omotesando, with nine of his lines—including Issey Miyake men's and women's, Pleats Please, and Bao Bao—currently distributed through six different shops. His experimental Reality Lab, on the ground level of the seminal From First building that bookends this narrow end of Omotesando, includes his sculptural, architectural aesthetic in everything from clothes to bags and lamps. Miyake is the most unabashed of the three about incorporating Japanese influence into his products (now mostly designed by his team of protégés) with garments that fold up like origami or encase the body like a kimono.

Yohji Yamamoto's eponymous brand flagship takes over an airy, deconstructed concrete space along the road. The raw interior mirrors his pared-down black-centric clothes that were favored by members of the area's karasu-zoku "crow-tribe," so called for their head-to-toe black high-fashion outfits.

A curved-glass-fronted shop by UK architects Future Systems houses Rei Kawakubo's Comme des Garçons in its maze-like interior, whose nooks and crannies are filled with different lines as well as various artistic installations relating to current collaborations. Unlike its much larger Ginza branch, this shop just stocks Comme des Garçons items. The eccentric, humorous, challenging, and sometimes disconcerting looks that once shocked the fashion industry are still in evidence (just a glance at the shop

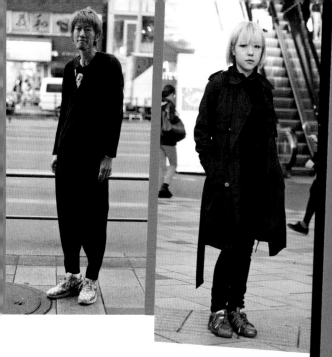

assistants and many of the adoring customers will affirm that), but the brand is also eminently accessible with the help of some masterly marketing: the CdG heart-logo T-shirts have become a top Tokyo fashion souvenir for travelers from Asia and abroad.

OTHER NOTABLE JAPANESE LABELS

In addition to the Japanese designers mentioned above, this end of Omotesando and the backstreets shooting off it are home to other notable domestic labels, too. Frapbois, the Tokyo brand with a contemporary, offbeat look, is also stationed in the From First building; Tsumori Chisato, with her whimsical prints and designs, has a shop on the street; and tucked behind on a street running parallel is Jun Takahashi's cult Undercover brand. There are many exclusive select shops in the area, notably the dark and glamorous basement-level Loveless; the quirky select shop Contemporary Fix, with its café; and The Pool, which arranges its racks of clothes around a disued swimming-pool space. Kotto-dori, a few streets south of the narrow end of Omotesando, is also dotted with various unique and independent boutiques, including the antique shops that give the street its name. Just off it, a truly Japanese look can be found at SOU•SOU, the Aoyama outpost of the Kyoto brand famous for *tabi* split-toe shoes and socks in graphic prints, kimono and other fabric garments, accessories, and knickknacks. There's even a modern tea-ceremony counter for some refreshment.

STYLISH ARCHITECTURE

In contrast to the imposing architecture along the bulk of Omotesando, these Japanese designers have gone for shops housed in understated, pre-existing buildings, prefer-ring to focus on an interior space that lets the clothes speak for themselves.

This is not to say that Minami-Aoyama is an architec-tural dead zone. It boasts what is possibly the most striking building along Omotesando's entire length—Herzog and de Meuron's Prada building, with its soaring walls of bulbous glass trapezoids. In contrast to the prevalence of glass structures, the From First building is notable for its solid brick appearance. It was built in 1975, when there was very little of interest on the street, and its street-level corner café, Figaro (still there) was reputedly an early hangout of the Japanese designers whose shops came to fill the space between it and the wide Omotesando boulevard further along. Just off the end of Omotesando is the Nezu Museum, designed in its 2009 reincarnation by acclaimed Japanese architect Kengo Kuma. It is a peaceful retreat of bamboo, light, and shade worth visiting for the building and garden alone, not to mention the exhibits. The Spiral building, one of Aoyama-dori's landmark structures, has an interior circular ramp leading from the chic café to the smart gift and lifestyle shop Spiral Market.

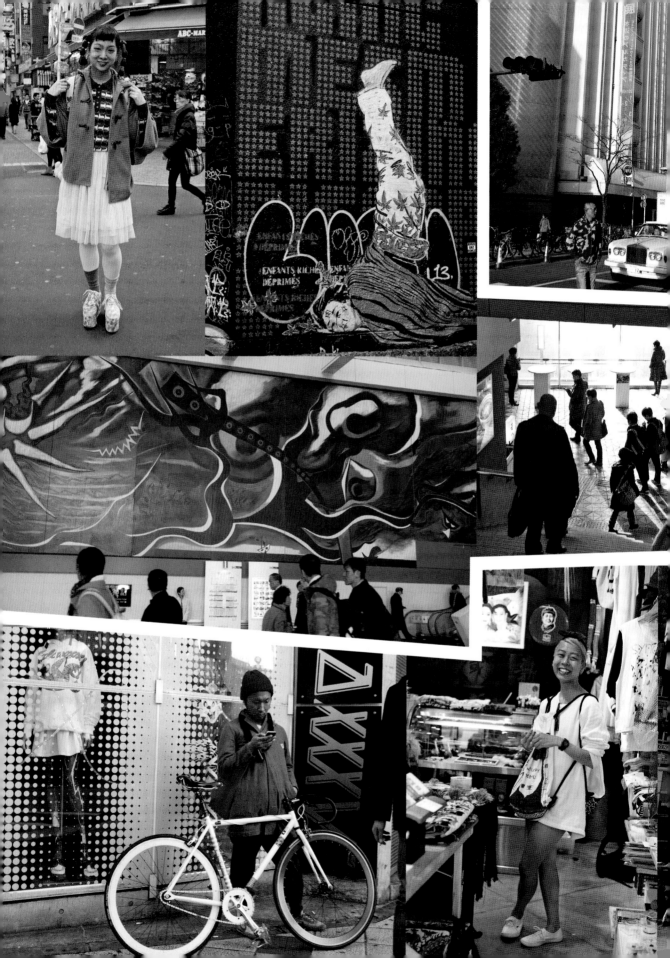

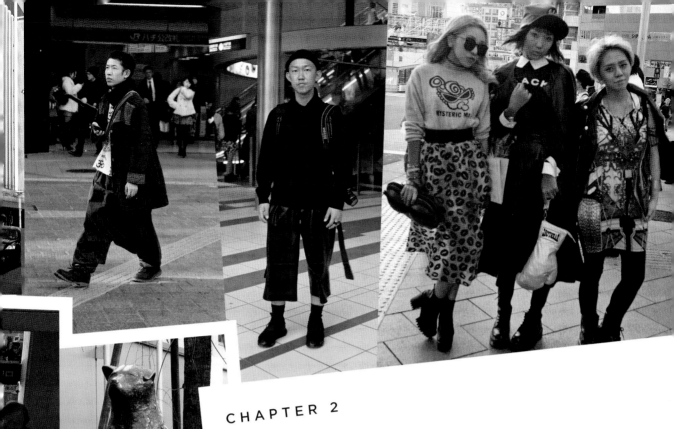

CHAPTER 2
Shibuya
THE PULSATING HEART OF TOKYO'S YOUTH FASHION CULTURE

From Gyaru to Hipster

THE MANY FACES OF TOKYO YOUTH AND POP CULTURE CONVERGE

Shibuya is the pulsating heart of Tokyo's youth culture, famous for its range of shops, nightlife, eateries, and entertainment and cultural offerings. In fact, Shibuya now comprises several areas, each with its own distinct flavor: the seedy nightlife area packed with love hotels behind Dogenzaka; the *sentaa gai* (Center Street) thoroughfare lined with cheap shops and fast-food joints; the nearby iconic fashion building 109; the big brands and department stores of Koen Dori; the hipster-fashion Jinnan area; and most recently, the area developed to the west of the station with the Hikarie office, retail, and cultural complex, a sometime venue for Tokyo Fashion Week. The world-famous "scramble crossing" in front of the station is a potent symbol of the jostling collision of these different worlds. But if Shibuya belongs to anyone, it is to the sassy *gyaru* ("gals") that set the trends for mainstream teenagers throughout the nation.

FROM KAJI TO KOGYARU

Shibuya came to the fore in the late 1980s, when for the first time it bred its own fashion style known as Shibu-kaji (short for "Shibuya casual"). This preppy look started among rebellious students of nearby high schools and universities, but soon spread, becoming a trend that put Shibuya on the street-fashion map. Before this, Shibuya had been shaped by a developer war between the Tokyu and Seibu corporations. Both aimed to create a surrounding culture in their particular patches, starting in 1934 with Tokyu's department store (now the Tokyu Toyoko store), through retail offerings as well as galleries, cinemas, theaters, and so on. The more progressive, youth-oriented Parco came out on top, growing into a national chain after opening its iconic, still-extant fashion and culture building Parco 1 on Koen-dori in 1973. Besides the Seibu department store and Tokyu's upscale Bunkamura complex, Shibuya has become a magnet for various "fashion buildings" (where each floor is full of individual fashion and accessory shops), from the original 109 and Parco to three mainstream Marui outposts.

Meanwhile, an alternative and even underground culture sprang up in the backstreets in the 1980s, and music culture followed when eclectic pop group Pizzicato Five spearheaded the Shibuya-kei music scene in the 1990s. Around the same time, "select shops," which allow buyers to pick and choose from overseas and domestic brands, clustered in the Jinnan area, attracting fashionistas and avant-garde word-of-mouth boutiques.

While all this was going on, the *kogyaru* "small gals"—the uniform-wearing high-schooler gyaru—were blooming on another Shibuya patch around 109. The latest Shibuya development that youth have brought is venture IT industries, lending it the name "bit valley" (a pun on the word *shibuya*, literally "bitter valley").

Shibuya is alternatively edgy, vibrant, dodgy, and smart, depending on where you tread. You can buy everything from Louis Vuitton (new and used) and obscure vinyl records to esoteric vintage clothes and used panties. You can eat, drink, party, and dance late into the night, or just hang out observing Tokyo's youth, who swarm like ants around Shibuya's rich offerings.

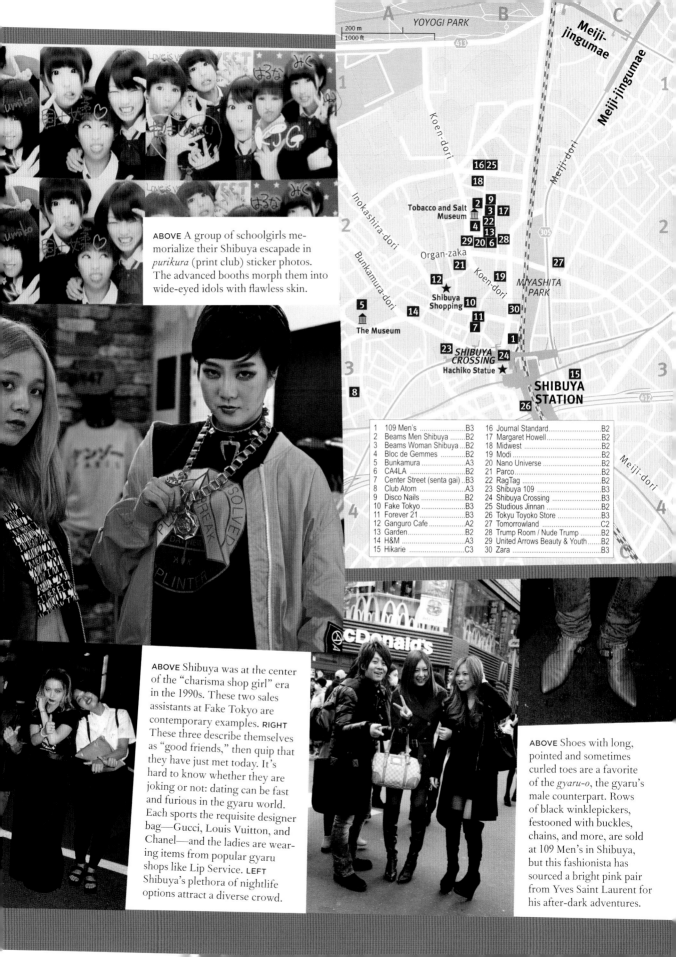

ABOVE A group of schoolgirls memorialize their Shibuya escapade in *purikura* (print club) sticker photos. The advanced booths morph them into wide-eyed idols with flawless skin.

1	109 Men's	B3	16	Journal Standard	B2
2	Beams Men Shibuya	B2	17	Margaret Howell	B2
3	Beams Woman Shibuya	B2	18	Midwest	B2
4	Bloc de Gemmes	B2	19	Modi	B2
5	Bunkamura	A3	20	Nano Universe	B2
6	CA4LA	B2	21	Parco	B2
7	Center Street (senta gai)	B3	22	RagTag	B2
8	Club Atom	A3	23	Shibuya 109	B3
9	Disco Nails	B2	24	Shibuya Crossing	B3
10	Fake Tokyo	B3	25	Studious Jinnan	B2
11	Forever 21	B3	26	Tokyu Toyoko Store	B3
12	Ganguro Cafe	A2	27	Tomorrowland	C2
13	Garden	B2	28	Trump Room / Nude Trump	B2
14	H&M	A3	29	United Arrows Beauty & Youth	B2
15	Hikarie	C3	30	Zara	B3

ABOVE Shibuya was at the center of the "charisma shop girl" era in the 1990s. These two sales assistants at Fake Tokyo are contemporary examples. **RIGHT** These three describe themselves as "good friends," then quip that they have just met today. It's hard to know whether they are joking or not: dating can be fast and furious in the gyaru world. Each sports the requisite designer bag—Gucci, Louis Vuitton, and Chanel—and the ladies are wearing items from popular gyaru shops like Lip Service. **LEFT** Shibuya's plethora of nightlife options attract a diverse crowd.

ABOVE Shoes with long, pointed and sometimes curled toes are a favorite of the *gyaru-o*, the gyaru's male counterpart. Rows of black winklepickers, festooned with buckles, chains, and more, are sold at 109 Men's in Shibuya, but this fashionista has sourced a bright pink pair from Yves Saint Laurent for his after-dark adventures.

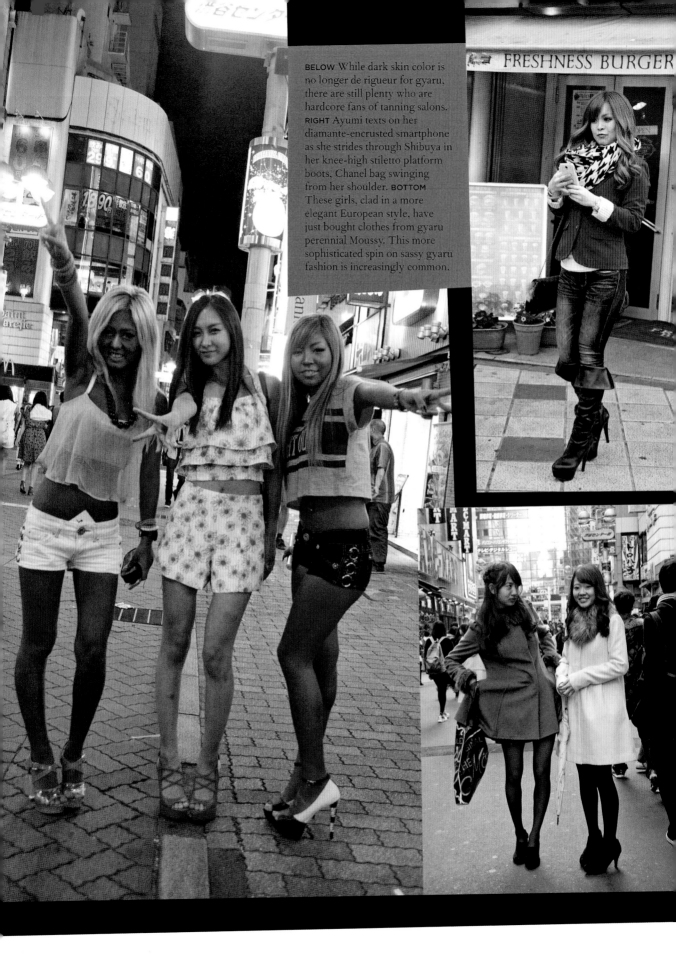

BELOW While dark skin color is no longer de rigueur for gyaru, there are still plenty who are hardcore fans of tanning salons. **RIGHT** Ayumi texts on her diamante-encrusted smartphone as she strides through Shibuya in her knee-high stiletto platform boots, Chanel bag swinging from her shoulder. **BOTTOM** These girls, clad in a more elegant European style, have just bought clothes from gyaru perennial Moussy. This more sophisticated spin on sassy gyaru fashion is increasingly common.

A Nation's Trendsetting Tribe

Gyaru (originating from the English "gal") are young, sassy, fun-loving girls for whom beauty and style are of prime importance, although their behavior and appearance have been frequently characterized as antisocial and even delinquent over their checkered history.

HISTORY OF THE GYARU PHENOMENON

There were rumblings of gyaru forebears as early as the 1970s, with young women letting their hair down to party and shop, followed by the body-con club girls of the 1980s bubble era, but the gyaru subculture burst onto the Shibuya landscape in the early 1990s, quickly reaching its kogyaru ("little gal") zenith in the middle of the decade. The kogyaru image of a flirtatious school-girl with long light-brown-dyed hair, tanned skin, Louis Vuitton accessories, and loose white socks bunched up and stuck to her calves with special glue below her short pleated skirt remains the epitome of gyaru styles, although there have been a great variety since. Such ko-gyaru shopped at 109 (see page 35), whose stores sold the bright beach-party styles beloved by deeply tanned gyaru in platform shoes and hibiscus-print clothing from cult gyaru brand Alba Rosa.

For the most ardent devotees, "gyaru" was—and still is—not just a fashion but a lifestyle. Key to the subculture were *gyarusa* ("gal circles"), which would organize events such as competitions in *para-para*, the high-octane yet strangely static dance style loved by gyaru. Often meeting in the fast-food restaurants of Shibuya's Center Street, the gyarusa enforced strict membership, initiation, and graduation rituals in what ironically resembled similar groups of their university-going contemporaries. Although gyarusa still exist, their presence, like that of the more extreme gyaru themselves, has gone somewhat underground.

It is increasingly hard to distinguish between gyaru and other fashion-loving young women as the gyaru world voraciously draws on more and more influences. The pursuit of beauty and a slim physique remains a constant, however: leg-elongating high heels or platforms are still gyaru staples, as are impeccable (sometimes extreme) hair and makeup.

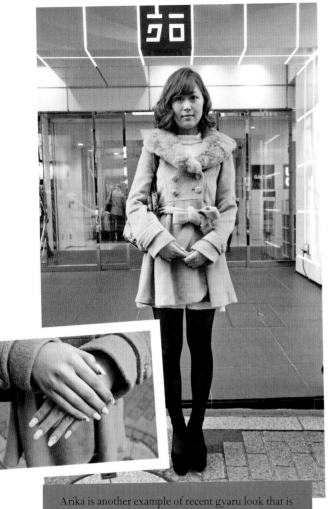

Arika is another example of recent gyaru look that is simultaneously demure and alluring. Her nails, too, despite the rhinestones and pastel patterns, are toward the understated end of the gyaru nail spectrum.

Ms. Matsunaka is rocking the revived "bubble" look as only a gyaru could: masculine pin-striped jacket, multi-pocketed clutch update on the '80s Japan so-called "second bag," sleek hair, and white platform heels capped in silver.

SHIBUYA GIRLS TODAY

Gyaru have now grown out of the platform shoes of their early years and expanded into an amorphous assortment of girls and young women with all manner of appearances. In fact, it is difficult now to distinguish who is truly a gyaru and who is merely buying from gyaru fashion shops (although gyarusa membership is a sure sign). This national league of women and their ringleaders in Shibuya absorb fashions and trends from left, right, and center, rehashing them and throwing them out again at a furious rate: a spot of Paris catwalk chic here, a dash of Harajuku fairy cute there, with some LA gangster bling and some punk spikiness thrown into the mix. These are not necessarily com-

bined within the same outfit, however. The gyaru family tree and fashion market are large enough to support a diversity of shops, each uniquely positioned along the multiple axes of cute/hard, feminine/boyish, elegant/trashy, etc. It works the other way, too: fashionista magpies, who would not mix socially with gyaru, nevertheless often pick and choose cheap garments from the plethora of gyaru shops to incorporate into their higher-end wardrobes.

At the gyaru core still remains a rampant materialism, brand fetishism, and dedication to the pursuit of one's own beauty aesthetic, with a touch of delinquency and a lively party-girl spirit. The result is a group of gyaru who inspire fashion followers, even if not living the gyaru life themselves, throughout the nation and abroad.

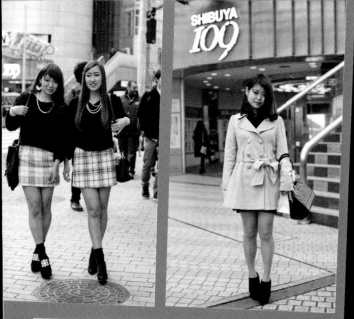

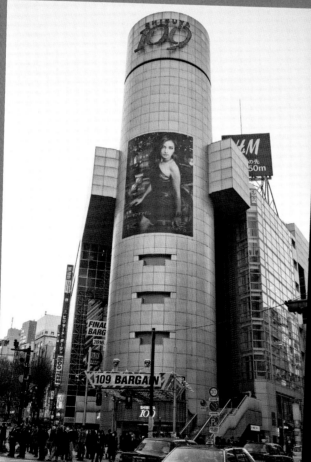

Shopping Mall 109

The shopping mall 109 (pronounced "*ichi maru kyuu*" or "*maru kyuu*" for short) is the huge silvery cylinder that looms large over Shibuya like some kind of fashion sentinel. Poised on a V-shaped plot of land facing the station, this monolithic edifice is a Shibuya icon, a beacon luring hordes of gyaru and other curious visitors through its doors.

Built by the Tokyu Corporation, which also owns the upmarket Bunkamura shopping and culture center down the road, 109 first opened its doors in April 1979. Its retail environment was slow for some years until the gyaru vanguard started to shop there. Soon its ten floors were packed with gyaru boutiques manned by vivacious, glamorous staff, and in the kogyaru heyday of the 1990s, it became the epicenter of gyaru fashion. Arguably, 109 spawned the first fast fashion in Japan—its trendsetting staff picked up the next big thing with their style antennae and transmitted the information back to the design and production teams, which eventually were able to convert ideas to garments on the shop floor within a few weeks. While 109 is still the beacon that beams the latest gyaru trends across Tokyo and the nation, its supremacy has come under challenge by encroaching international fast fashion—Zara, H&M, and Forever 21 are all within a couple of minutes' walk. Although these forces provide new fodder for the increasingly globalized gyaru fashion repertoire, they also undercut many of the already reasonable 109 prices. None, however, can replicate the devotion that many gyaru hold for 109, as evidenced by the fervor surrounding the 109 *fukubukuro* ("lucky bag") seasonal sales, with thousands of women queueing up overnight in freezing January temperatures for a stab at the best bargain hunting.

The 109 brand expanded with the launch of Men's 109-2 down the road, various 109 malls throughout the country, and an online store. Even so, the 109 main building retains a special presence, presiding over Shibuya like some sort of sartorial guard, watching over its streets and preserving its place as a global fashion destination.

ABOVE The iconic Shibuya 109 emporium is a shiny magnet for fashion-loving gyaru, who queue in droves at its doors when it opens for the bargain sales. TOP LEFT These two matchy fashion sales assistants often coordinate their outfits for days off, when they enjoy being on the other side of the counter. TOP RIGHT Shibuya 109 caters to a range of gyaru tastes, from elegant to brash.

Achieving the "Gyaru" Look

"A little bit of powder and a little bit of paint, make a woman look like what she ain't." This expression, though American, is perhaps truer in Japan than anywhere else. And Japan's gyaru are the true masters of *me-ku* (cosmetics), lugging a huge makeup pouch—sometimes two—in their bags, containing all manner of lotions, potions, and tools, perhaps a professional brush set, or even some electric curling tongs. In fact, it is a compliment to tell a gyaru that her makeup is *moreteru* (gyaru slang for "looking better than the real thing"); i.e., fake is good. Although natural beauty has made a comeback in the early 2010s, for gyaru this means applying perhaps just as much makeup, but to give a more organic than obviously exaggerated moreteru appearance. For some gyaru, going bare-skinned in public, sometimes even before a boyfriend, is unthinkable.

The gyaru beauty routine is as long as the list of necessary beauty products, and although gyaru take pride in varying their makeup according to season, outfit, occasion, and so on, there are several fundamentals.

A gyaru who does not wear some kind of *karakon* color contact lenses is a rarity; some even say, "Without my karakon in, it's not my face." So these go in first, enlarging both pupil and iris, morphing brown eyes into sparkling orbs of blue or green or hazel, with clearly defined darker outlines. Then a spot of temporary DIY plastic surgery: with the help of some expertly applied stringy glue or special sticky strips, single-fold eyelids are transformed into the more depth-giving double-fold variety. Next come false eyelashes, known as "*tsukema*," applied to both top and bottom. These delicate daily essentials come in all sorts of lengths and clumping patterns; the market is so huge that you can even buy cute tsukema cases for carrying them around. Eye enhancement doesn't end there, however: BB "blemish balm" all-in-one cream is layered on, then foundation, with perhaps a top coat of powder. Then pencils, shadows, and liquid eyeliners take to eyebrows, eyelids, and under-eyes. To achieve maximum Bambi-like wide eyes that pop out from the face, a final touch is to add some eyebags. Yes, the cutely named *namida bukuro* "tear bags" are enhanced with special shading sticks and even glitter gels to give the eyes the appearance of greater 3D volume. Cheek and lip color add the final touches, perhaps with some highlighting powder here or there, and the gyaru is ready to go.

Gyaru have also taken nail art to the extreme; some wear several-centimeter-long fake talons encrusted with all manner of jewels and 3D objects, and even nail piercings. Even mainstream Japanese women who are into manicures would very rarely have a plain color on all their nails: nail art of some kind is de rigueur in most cases, and literal "art" in others (see the sidebar on Disco Nails). Hair, likewise, is never black and straight for gyaru; in fact, straight black hair is almost an anti-fashion statement for Japanese women (and is of course worn by some anti-establishment fashionistas). Cue the need for hairdressers on every corner to keep the nation's female tresses a glossy shade of brown. Wigs are used regularly—not just by gyaru who like to change their appearance from one day to the next, but by Lolitas and cosplayers as well.

Variations on these themes are employed by many women outside of the gyaru style-tribe in Japan, from Lolitas pursuing doll-like prettiness to Harajuku magazine models; false eyelashes are a staple for many beauty-conscious women from all walks of life. But gyaru are the mavens, the innovators of makeup—sometimes going to extremes, as in the *ganguro* boom of the 1990s, which saw some gyaru achieve very, very dark (*gan-gan guro*) faces through intensive tanning and makeup. The self-styled *yamamba* ("mountain hags") took this even further by layering on white circles around their eyes and white stripes down their noses.

While past its peak, some versions of the yamamba style can still be seen today. You can even experience it at Shibuya's Ganguro Café, staffed by the style's modern-day incarnation. Tanned young women wearing multicolored tresses, provocative fashions, and extreme makeup will serve you drinks, take photos with you, and, for an extra fee, give you an authentic ganguro makeover.

Most recently, in a kind of yamamba reversal, Japanese avant-garde youth have borrowed from traditional kabuki and geisha makeup to completely whiten their faces before applying various styles of makeup, usually with bold black eyes. Adherents of this *shironouri* ("painted white") style gather at underground club events, only occasionally taking to the streets in their getup.

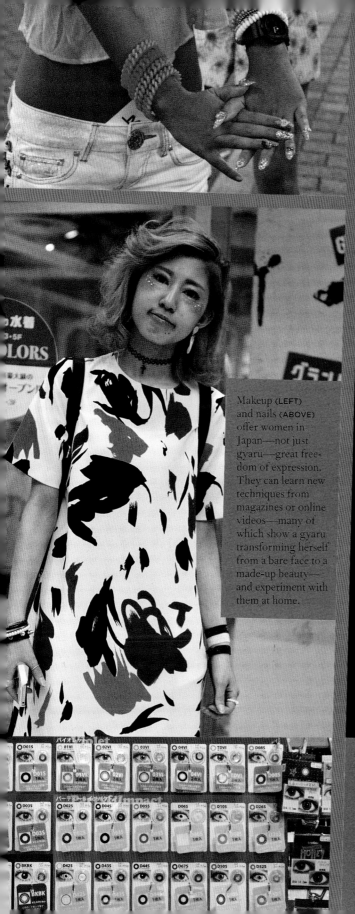

Makeup (LEFT) and nails (ABOVE) offer women in Japan—not just gyaru—great freedom of expression. They can learn new techniques from magazines or online videos—many of which show a gyaru transforming herself from a bare face to a made-up beauty— and experiment with them at home.

DISCO NAILS

For urban Japanese women, nails are as important to one's makeup and outfit as mascara and earrings. This is as true for "office ladies" who tap away at keyboards all day with fingers topped with pretty feminine nail art as it is for gyaru with over-the-top sculptural nail creations. But avant-garde fashionistas have nail needs, too, and Shibuya's Disco Nails has provided the solution. Opened by whimsical nail artist and hard-headed businesswoman Kaneko Nagisa in its current Jinnan location in 2012, Disco completes hand-painted gel-nail marvels for around ten fashion-forward women in its kitschy, edgy surroundings every day. Photo albums testify to the imagination and skill of Nagisa and her small crew, with images of everything from flora and fauna to abstract patterns and Japanese erotic art delicately drawn on thousands of nails over the years. They also incorporate plenty of shiny treasures into nails, such as pearlescent shells and miniature stones. Most customers come in with only a vague concept of the nails they'd like, allowing Nagisa to extemporize, but others come in with very specific themes, like Francis Bacon paintings, or a Japanese chess set. A Disco how-to nail book has been released in Japan; Disco's fame has also spread abroad—they see lots of foreign customers and have been known to team up with London's sought-after nail artist Sophy Robson for nail master classes.

LEFT A wall of "karacon" colored contact lenses at an accessory shop in Shibuya. Buyers range from gyaru seeking high-contrast, large-pupiled doe eyes and cosplayers needing to mimic the iris color of the character they are "playing" to participants in darker subcultures, perhaps going for a cat- or snake-eye stare.

JINNAN DISTRICT
Fashionista Shibuya

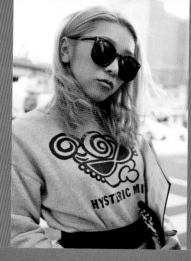

Wedged behind fashion building Modi (from the Marui group), between Koen-dori (Park Street) and Faiyaa-dori (Fire Street, so called because of the fire station at one end), is a small area of select shops, independent boutiques, cafés, and salons that cater to the fashion-forward crowd. This triangle of narrow, hilly streets, topped by Yoyogi Park, is the district known as Jinnan, home to the flagship branches of some of Japan's most popular select shops, notably Tomorrowland, Beams, United Arrows Beauty & Youth, and Nano Universe. These *serekuto shoppu* function as curators of (usually) European and American brands, presenting them to the Japanese public alongside their own labels. Other notable emporia include Midwest's adjacent his and her shops; Studious, which showcases Japanese brands and knickknacks; the many small select shops like menswear stalwart Garden; and vintage boutiques like the eccentric Nude Trump. After a relaxed tea and shop at Margaret Howell, you can get exquisitely and crazily detailed art nails done at Disco around the corner, have your hair cut by a charisma stylist at Bloc de Gemmes, top it off at Japan's largest branch of CA4LA (pronounced "kashira," meaning "head")—the hat wonderland a few paces away—then pop into RagTag's secondhand designer heaven for a lucky bargain. Jinnan is almost like a breakaway splinter of fashionista Harajuku with an added sheen of sophistication, piercing into the brasher parts of Shibuya, then tapering off and fading away as it gets closer to the hectic Shibuya terminal station.

ABOVE Hysteric Mini, the kids' line from Japanese brand Hysteric Glamour, draws its inspiration from all corners of pop culture: rock, pop art, comics, even porn. This is a particularly apt sweatshirt for its wearer, a singer called Mini. **BELOW LEFT** Hairstylists Mizuki and Natsuko are snapped here outside Midwest, one of the edgier select shops in Jinnan. Their feminine soft-curl hairstyles in greyish-blonde shades are popular with young fashionistas. **BELOW RIGHT** Nakazawa and Fukuda, turning the corner by the Jinnan branch of hat emporium CA4LA, typify the stylish spin on smart that Jinnan and its many select shops represent. The *sutajyan* (stadium jacket), an item from '80s bubble Japan, is back on trend.

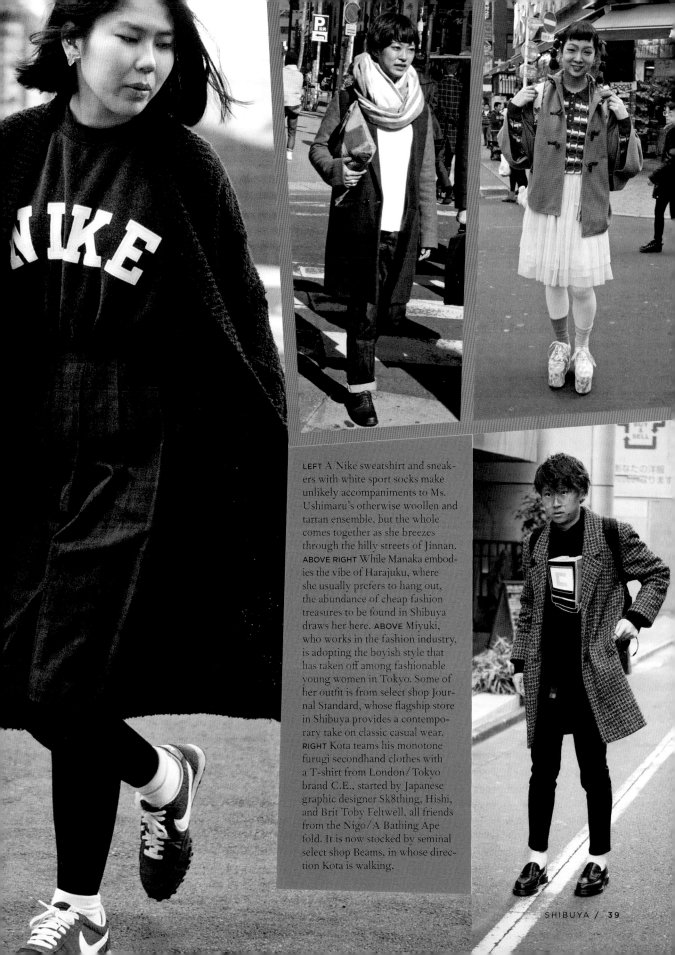

LEFT A Nike sweatshirt and sneakers with white sport socks make unlikely accompaniments to Ms. Ushimaru's otherwise woollen and tartan ensemble, but the whole comes together as she breezes through the hilly streets of Jinnan. **ABOVE RIGHT** While Manaka embodies the vibe of Harajuku, where she usually prefers to hang out, the abundance of cheap fashion treasures to be found in Shibuya draws her here. **ABOVE** Miyuki, who works in the fashion industry, is adopting the boyish style that has taken off among fashionable young women in Tokyo. Some of her outfit is from select shop Journal Standard, whose flagship store in Shibuya provides a contemporary take on classic casual wear. **RIGHT** Kota teams his monotone furugi secondhand clothes with a T-shirt from London/Tokyo brand C.E., started by Japanese graphic designer Sk8thing, Hishi, and Brit Toby Feltwell, all friends from the Nigo/A Bathing Ape fold. It is now stocked by seminal select shop Beams, in whose direction Kota is walking.

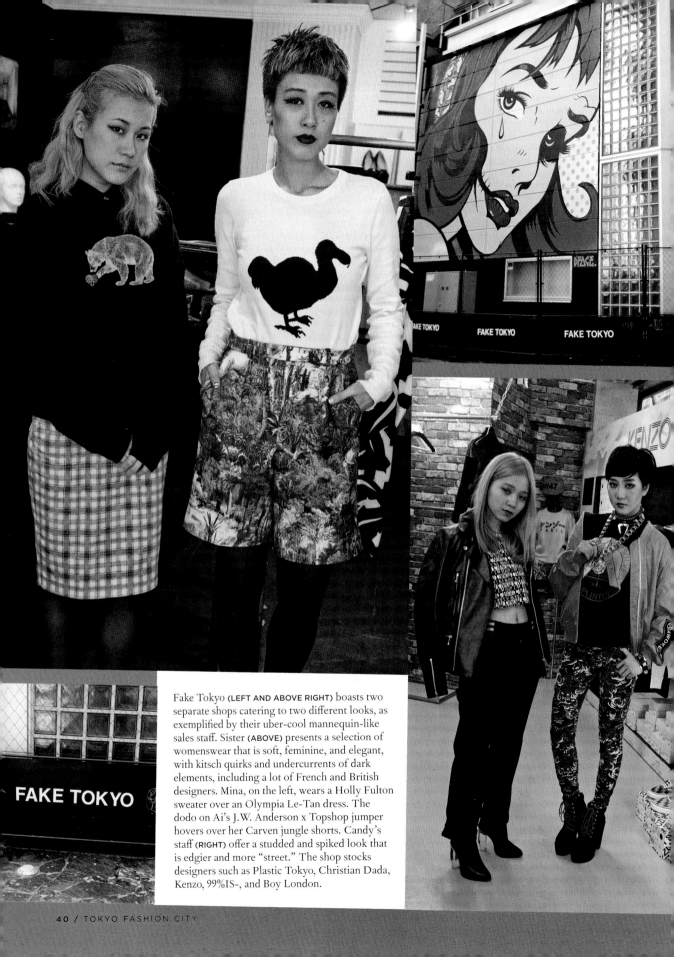

Fake Tokyo (LEFT AND ABOVE RIGHT) boasts two separate shops catering to two different looks, as exemplified by their uber-cool mannequin-like sales staff. Sister (ABOVE) presents a selection of womenswear that is soft, feminine, and elegant, with kitsch quirks and undercurrents of dark elements, including a lot of French and British designers. Mina, on the left, wears a Holly Fulton sweater over an Olympia Le-Tan dress. The dodo on Ai's J.W. Anderson x Topshop jumper hovers over her Carven jungle shorts. Candy's staff (RIGHT) offer a studded and spiked look that is edgier and more "street." The shop stocks designers such as Plastic Tokyo, Christian Dada, Kenzo, 99%IS-, and Boy London.

FAKE TOKYO

FAKE TOKYO BUILDING
Candy & Sister

The Fake Tokyo building is an edgy high-fashion bubble in the scruffier part of Shibuya, tucked away just off the Center Street thoroughfare. It houses two very different but complementary shops: Candy on the first floor, and Sister on the second and third. Candy started life in Tokyo's LGBT hot spot, Shinjuku 2-chome, and has maintained its ethic of being new and different in the new Shibuya location. The aesthetic in musical terms would be something like punk meets electroclash: homegrown brands like Christian Dada hang alongside foreign ones like Korea's 99%IS-. Sister, as the name suggests, is a women's-wear boutique: the chic interior features European labels like Carven, selected by "boss" Yumi on trips to Paris, as well as young Japanese designers like Toga—particularly those trained at Antwerp's famous Royal Academy of Fine Arts, such as Akira Naka and Taro Horiuchi. The clothes are feminine and sophisticated but playful, and there is also a fun rack of secondhand garments. Amid the clothes and accessories are shelves of books both old and new, whose wide-ranging scope give an idea of the cultured, idiosyncratic women the shop is catering to.

Customers move between the two worlds contained in Fake Tokyo as they navigate the Sister and Candy floors—the former with bookshelves and languishing mannequins (TOP AND TOP RIGHT); the latter with harsh strip lighting and an industrial interior (MIDDLE AND ABOVE).

The 24/7 Party

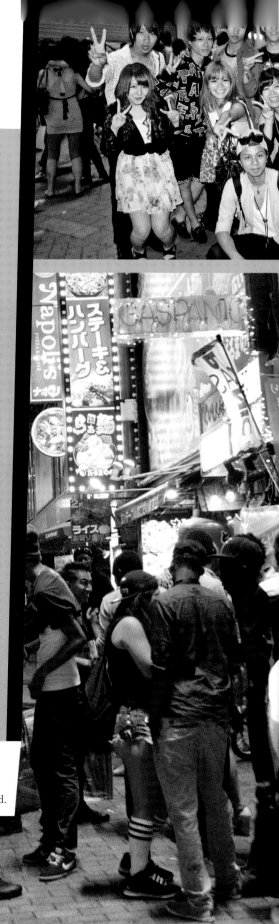

Shibuya, the largest youth culture conglomeration in Tokyo, is a twenty-four-hour party neighborhood. When the shops close, the restaurant and bar scene picks up, handing the baton to the many nightclubs in the area as the evening wears on. Especially on weekends, you'll see revelers waiting on the platforms at Shibuya station for the first early-morning trains home.

Shibuya has long been a nightlife area, but as its fashions and tastes have diversified, so have its clubs. As gyaru central, it has clubs offering the high-octane Eurobeat and trance music that gyaru love to dance to, like Club Atom. But Ageha, a superclub located in Shin-Kiba, in southeast Tokyo, is where they go for a real night of partying. Though it's far from Shibuya, a shuttle bus takes clubbers there from near the station. Other gyaru like to congregate for lengthy karaoke sessions in rooms rented by the hour, or even just hang out in noisy huddles on Center Street in warmer months.

In recent years, Shibuya has been host to an all-night bacchanalia that takes place in bars, clubs, and not least on the streets every Halloween. Riot police are drafted in to herd the thousands of revellers, dressed as everything from mass mobs of Ronald McDonald to walking mini-versions of famous Shibuya landmarks like the 109 building, as well as all the usual gory and occult costumes.

Shibuya is not just a place for the young to party: *nonbei yokocho* (boozer's alley), a row of tiny, rickety bars stacked upon one another by the side of the train tracks, is as alluring to salarymen as it is to young Japanese adults and foreign visitors. Indeed, Shibuya itself is a haven for tipsy partygoers of all kinds, ranging from the energized dancers in its many clubs to the staggering drunks who litter the streets in the early hours.

Crowds gather in Shibuya's Center Street, where less salubrious nighttime entertainment spots, including the cheap and sleazy Gas Panic, heave with foreigners and Japanese alike every weekend.

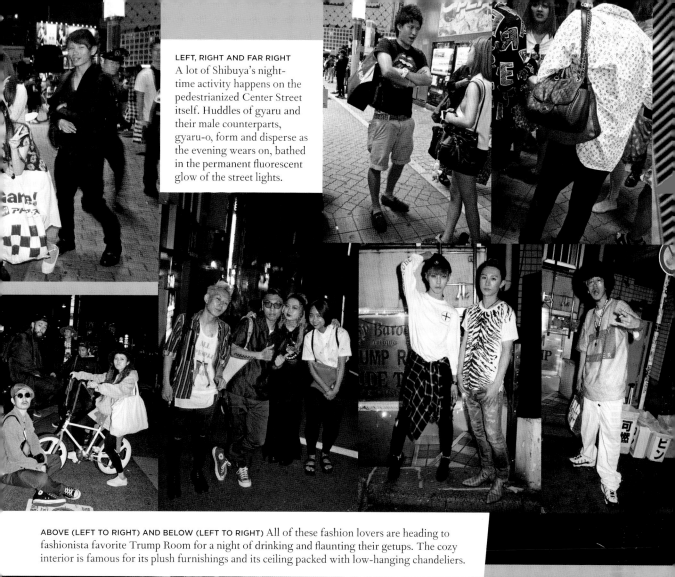

LEFT, RIGHT AND FAR RIGHT A lot of Shibuya's night-time activity happens on the pedestrianized Center Street itself. Huddles of gyaru and their male counterparts, gyaru-o, form and disperse as the evening wears on, bathed in the permanent fluorescent glow of the street lights.

ABOVE (LEFT TO RIGHT) AND BELOW (LEFT TO RIGHT) All of these fashion lovers are heading to fashionista favorite Trump Room for a night of drinking and flaunting their getups. The cozy interior is famous for its plush furnishings and its ceiling packed with low-hanging chandeliers.

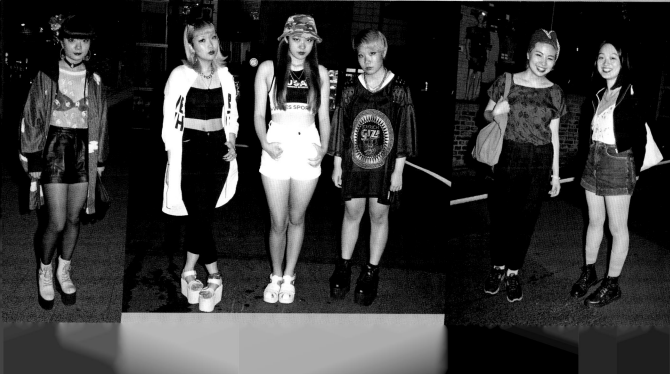

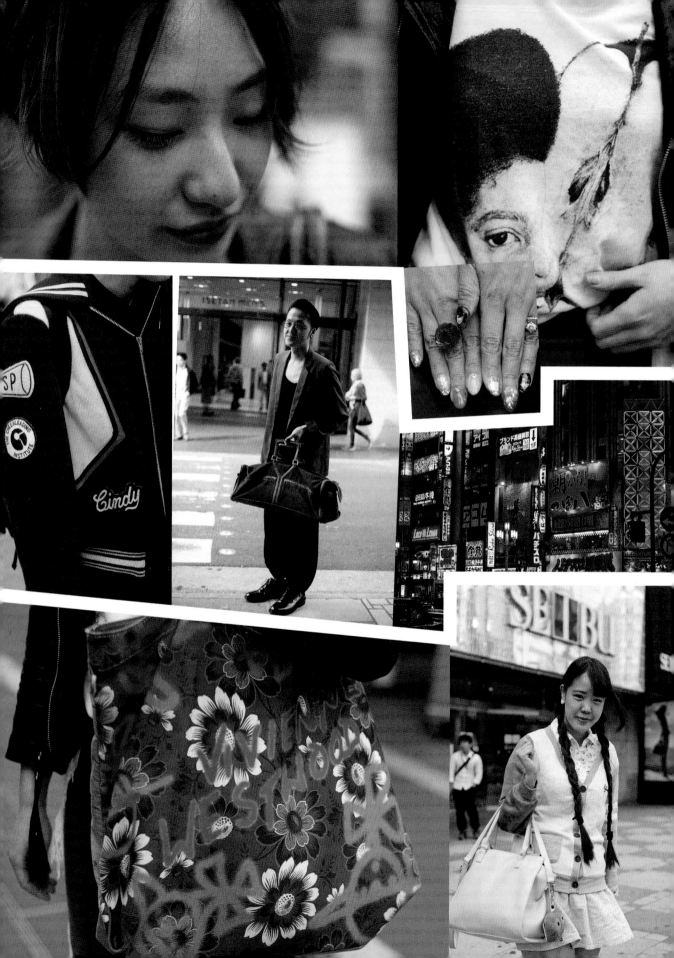

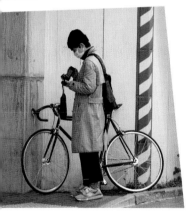

CHAPTER 3

Shinjuku &
Ikebukuro

DIVERSE FASHION CENTERS AT TOKYO'S BUSIEST RAIL HUBS

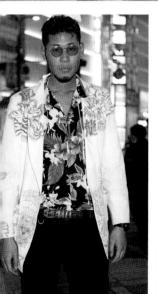

Bustling Urban Giants Shinjuku and Ikebukuro

MINI-CITIES WITH UNDERWORLD AND UNDERGROUND SCENES

Even though Tokyo is a vast megalopolis, it is nevertheless remarkable that, separated by just four train stops in its northwestern quadrant, there are two areas so enormous that they function as cities within the city. Like rival siblings, the two have many surface similarities but very different natures. Shinjuku, the more responsible older brother (although not without his hedonistic side) is the behemoth that eclipses any other major station areas in Tokyo; indeed, it boasts the busiest train station in the world. Ikebukuro is the odd, ungainly little brother who no one expects very much from—although, having the second-busiest station in Japan and the world, it also wields significant clout. Both are divided clearly into east and west sides around their sprawling station complexes, with each side having a distinctive character. Both, particularly Shinjuku with its governmental and corporate elements, function as microcosms of Japan as a whole. In terms of retail, they each offer branches of pretty much any chain store imaginable, as well as numerous department stores; they both have significant subcultural underbellies as well as high-culture complexes; and they both are home to big business.

MAINSTREAM & HIGH FASHION

Fashion-wise, Shinjuku is certainly the more diverse and stylish. Ikebukuro, being the train portal to Tokyo's neighboring prefecture of Saitama (nicknamed "Dasaitama"—*dasai* means "uncool" in Japanese), is full of casually attired suburban day-trippers. Both, however, have seminal department stores—Isetan in Shinjuku and Seibu in Ikebukuro—with enough cutting-edge labels (Isetan in particular) to draw fashionistas to these areas that are otherwise full of generic chain-shop fashions. The world-famous fashion design school, Bunka Fashion Institute, is also situated in west Shinjuku, producing innumerable budding stylists and designers in outlandish attire. Due to its sheer size, diversity, and its incubation of future style makers, Shinjuku is up there with Harajuku and Shibuya as a well-spring for Japanese fashion.

SUBCULTURAL STYLES

Both Shinjuku and Ikebukuro have a fair subcultural style presence: two spacious floors of the fashion chain store Marui in Shinjuku are given over to gothic, Lolita, and other alternative looks, while Ikebukuro's Otome Road is a paradise for female *otaku*. Shinjuku is full of independent live-music clubs, many of the pokey punk sort, and Ikebukuro is well known for its "visual-style" rock gigs; these add another facet to their respective sartorial landscapes. Shinjuku is also home to the nightlife and sex-industry quarter Kabukicho, which at night comes alive with its own distinctive looks: hostesses and hosts, both in the business of providing titillating talk, drinks, and fun for their clients, can be seen out and about with snazzy outfits, over-the-top grooming, and coiffed hair. For an alternative nightlife scene, Shinjuku's gothic Christon Cafe hosts the Tokyo Decadance club night, perhaps the most magnificent regular showcase of subcultural style in Tokyo, and is home to the Decadance Bar. For a more gloomy—though no less breathtaking—experience, check out Tokyo Dark Castle at Shinjuku's Marz club.

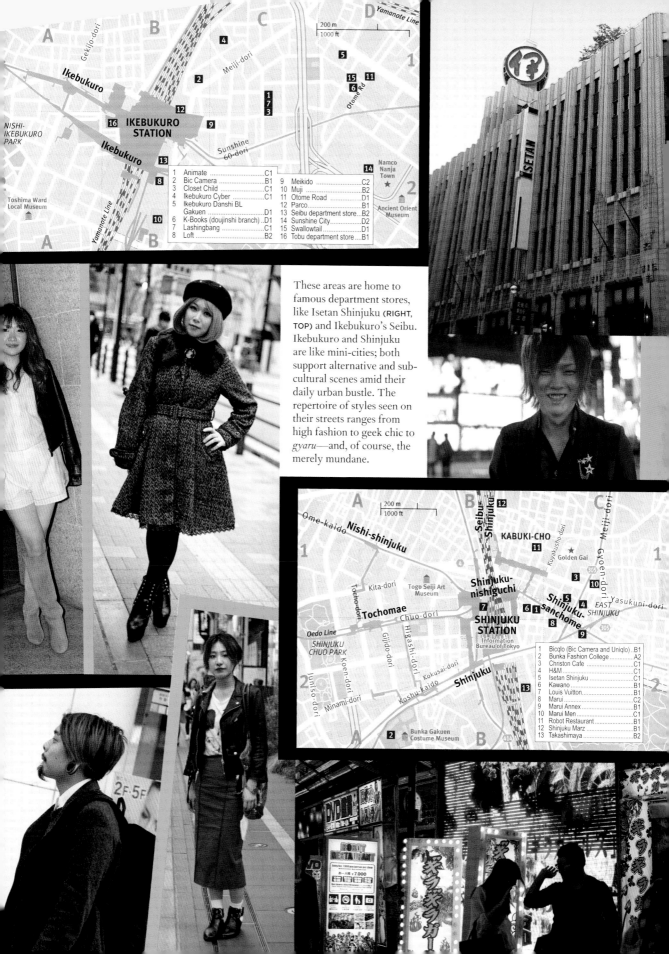

Ikebukuro map legend:

1 AnimateC1	9 MeikidoC2
2 Bic CameraB1	10 MujiB2
3 Closet ChildC1	11 Otome RoadD1
4 Ikebukuro CyberC1	12 ParcoB1
5 Ikebukuro Danshi BL	13 Seibu department storeB2
GakuenD1	14 Sunshine CityD2
6 K-Books (doujinshi branch) ..D1	15 SwallowtailD1
7 LashingbangC1	16 Tobu department storeB1
8 LoftB2	

Map labels: Yamanote Line, Gekijo-dori, Meiji-dori, Ikebukuro, NISHI-IKEBUKURO PARK, IKEBUKURO STATION, Toshima Ward Local Museum, Yamanote Line, Ikebukuro, Sunshine 60-dori, Otome Rd, Namco Nanja Town, Ancient Orient Museum, 200 m / 1000 ft, A B C D

These areas are home to famous department stores, like Isetan Shinjuku (RIGHT, TOP) and Ikebukuro's Seibu. Ikebukuro and Shinjuku are like mini-cities; both support alternative and sub-cultural scenes amid their daily urban bustle. The repertoire of styles seen on their streets ranges from high fashion to geek chic to *gyaru*—and, of course, the merely mundane.

Shinjuku map legend:

1 Bicqlo (Bic Camera and Uniqlo) ..B1	
2 Bunka Fashion CollegeA2	
3 Christon CafeC1	
4 H&MC1	
5 Isetan ShinjukuC1	
6 KawanoB1	
7 Louis VuittonB1	
8 MaruiC2	
9 Marui AnnexB1	
10 Marui MenC1	
11 Robot RestaurantB1	
12 Shinjuku MarzB1	
13 TakashimayaB2	

Map labels: Ome-kaido, Nishi-shinjuku, Seibu Shinjuku, KABUKI-CHO, Meiji-dori, Golden Gai, Kuyakusho-dori, Gyoen-dori, Yasukuni-dori, Kita-dori, Togo Seiji Art Museum, Shinjuku-nishiguchi, Shinjuku-sanchome, EAST SHINJUKU, Toshodo, Tochomae, Chuo-dori, SHINJUKU STATION, Oedo Line, Higashi-dori, Gijido-dori, Information Bureau of Tokyo, SHINJUKU CHUO PARK, Koen-dori, Kokusai-dori, Shinjuku, Juniso-dori, Minami-dori, Koshu-kaido, Bunka Gakuen Costume Museum, 200 m / 1000 ft, A B C

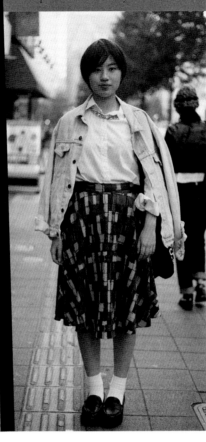

BELOW This Bunka student has cobbled her look together from mainstream and fast-fashion brands like Zara and Sly, a modish gyaru fashion brand whose concept is the "New Sexy."

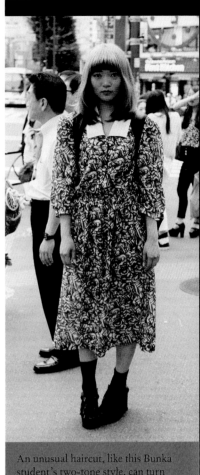

An unusual haircut, like this Bunka student's two-tone style, can turn what might otherwise be a secondhand granny dress into a directional look.

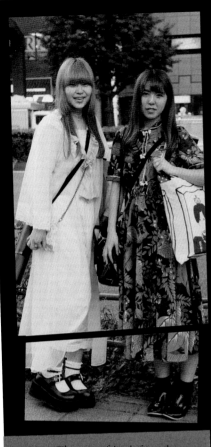

ABOVE These two friends from the fashion college are into vintage clothes; they buy them from Harajuku and Shimokitazawa.

BUNKA FASHION COLLEGE
Japan's Style Incubator

Shinjuku's Bunka Fashion College, a world-renowned fashion institution, is the most famous fashion school in Japan. It offers two-year programs, as is typical of Japan's many *senmon gakkou* (technical schools), the most popular being the stylist and design programs. The Japanese fashion industry is packed with alumni from these courses, as well as from the prestigious attached Bunka Graduate University.

CULTIVATING CREATIVITY

The school, which started in 1923 as a sewing and dressmaking school, has not lost its focus on technique during its transformation into the powerhouse it is today. In fact, Bunka is known for its reliance on rote learning, with students having to copy procedures over and over, but it still manages to turn out pioneering individuals. The design course in particular is notorious for the workload—a test of perseverance and endurance, which are prerequisites for stellar success in the fashion industry.

A glance around the campus will show, however, that neither individuality or creativity are lacking among students. Unique looks are encouraged and carefully cultivated. Students are literally wearing their styling and design skills on their sleeves, creating a spectacular daily fashion parade as they trudge between Shinjuku station and the school.

Thanks to its good reputation throughout Asia, Bunka Fashion College attracts many students from Korea, China, and further afield. The Global Fashion Concentration course, which is conducted in English, is a strong draw for foreign students. This student, from Korea, is wearing a top she bought from the Tokyo branch of US conceptual fashion store Opening Ceremony as a dress.

There are many different programs at Bunka Fashion College. Hina is currently enrolled in the "Fashion Goods Basic Course," which focuses on the creation and sales of accessories. She wears a mix of used and new, pricey and cheap: her tassel earrings are from Japanese label Mother, which has a shop in hip Nakameguro; her shoes are from Japanese high-fashion brand Undercover; and her purple jumpsuit is from the Harajuku branch of the secondhand clothes shop Chicago.

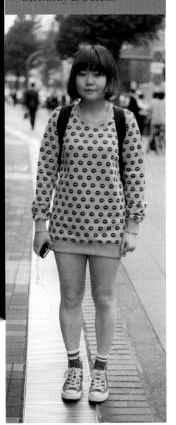

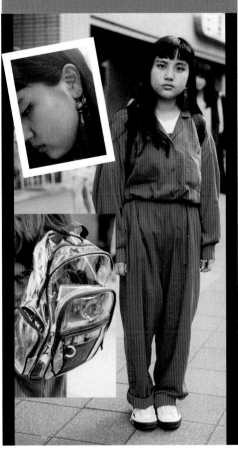

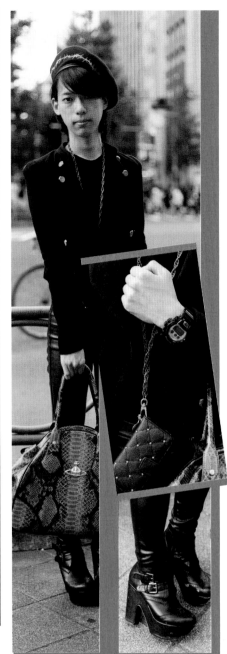

ILLUSTRIOUS ALUMNI

Kenzo Takada and Yohji Yamamoto are perhaps the granddaddies of Bunka's famous alumni: they showed in the Paris collections in the 1970s and 1980s respectively, and were instrumental in putting Japanese fashion on the world map. Since then, the roll call of internationally acclaimed designers has kept growing: Junya Watanabe of Comme des Garçons; Tsumori Chisato; Jun Takahashi, creator of Undercover, and his erstwhile collaborator and Bathing-Ape legend Nigo; and Yohji Yamamoto's daughter Limi, to name a few. Graduates have of course infiltrated the domestic fashion scene too, including the designers of strong local brands Dresscamp, Guts Dynamite Cabaret, and Matohu.

The school attracts many non-Japanese students, mainly from China and Korea, but also from further abroad. American stylist and fashion blogger Misha Janette,

Mitsuaki has touches of the visual-*kei* gothic Japanese rock fan about him: the heeled boots, Vivienne Westwood bag, and all-black outfit. A student at Bunka Fashion College, he loves the edgy fashionista online select shop Pameo Pose, the creation of Japanese fashion icon and DJ Peli.

who graduated from the stylist course, now brings Japanese fashion to the world via her illuminating site, Tokyo Fashion Diaries.

An Iconic Department Store

Many of Japan's department stores started out as textile retailers in the age when fashion meant kimono and cloth: Isetan, founded in 1886 in Tokyo's Kanda district, was no exception. Its iconic tartan logo harks back to its textile beginnings, but it has grown to have five buildings in Shinjuku alone, not to mention stores around Japan and in Asia. Of all these, the Isetan Shinjuku main building is the most illustrious: in fact, it is has the highest sales of any department store in the world (though its profits are less outstanding).

Standing on the northwest corner of Shinjuku's busy Sanchome crossing, the grand 1933 building would look perfectly at home on some of London's smarter shopping streets. In its current location it is somewhat more incongruous: its iron filigree surrounds, chiseled stone walls, and Gothic lanterns face the sleek glass fronts of fast-fashion H&M, luxury fashion house Louis Vuitton, and the flagship store of Japan's Marui fashion retail complexes. Behind Isetan Shinjuku's neo-Gothic/art deco outer walls, however, is a chic contemporary interior befitting Japan's most progressive department store.

THE WORLD'S FASHION MUSEUM

Isetan Shinjuku is not merely a purveyor of high-end fashions, but has long been a supporter of young Japanese designers with a keen eye on unusual foreign trends. Well established as the go-to fashion-forward Tokyo department store, its status was solidified with a major refit in 2013, when it boldly proclaimed it was relaunching itself as the

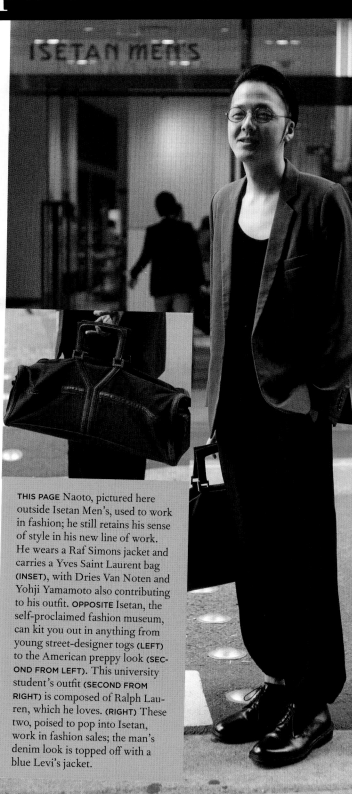

THIS PAGE Naoto, pictured here outside Isetan Men's, used to work in fashion; he still retains his sense of style in his new line of work. He wears a Raf Simons jacket and carries a Yves Saint Laurent bag (INSET), with Dries Van Noten and Yohji Yamamoto also contributing to his outfit. OPPOSITE Isetan, the self-proclaimed fashion museum, can kit you out in anything from young street-designer togs (LEFT) to the American preppy look (SECOND FROM LEFT). This university student's outfit (SECOND FROM RIGHT) is composed of Ralph Lauren, which he loves. (RIGHT) These two, poised to pop into Isetan, work in fashion sales; the man's denim look is topped off with a blue Levi's jacket.

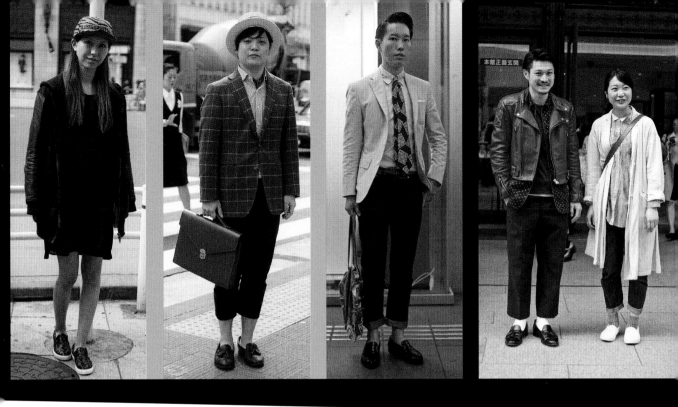

"world's finest fashion museum." The radical redevelopment cut down shelf space to make way for improved floor vistas and multi-purpose "park" areas around central escalators that squeeze in juice bars, cafés and pop-up shops. The "Tokyo Closet" department on the second floor showcases established Tokyo designers like Theater Products, Mint Designs and Cabane de Zucca. "International Creators" on the third floor features avant-garde brands such as Japan's Comme des Garçons and Undercover and the UK's House of Holland. The ReStyle sections, both for women on the third floor and kids on the sixth, offer an ever-changing selection of current international trends. Isetan collaborates frequently with fashion labels around the world; the store's 2013 renewal saw the iconic tartan print that graces their shopping bags updated to a lively pink, green, and yellow check, along with an explosion of tartan collaboration products with everyone from Scotland's Mackintosh to Japan's own textile-centric Minä Perhonen label and conceptual local brand Anrealage.

Men's fashion is big business in Japan, and Isetan has devoted an entire building to menswear. Connected to the main store, the Isetan Men's annex is a self-contained temple to men's fashion, with eight floors dedicated to suits, accessories, shoes and designer labels.

DELICIOUS TREATS

If all that shopping—or "museum" browsing—is making you peckish, rest assured that Isetan is just as well known for its gastronomic delights as its style ones. You could stop into any one of the cafés and bars scattered around the floors, including a petite branch of Rose Bakery (the café to Comme des Garçons shops) and the cosmopolitan Bistro Café Ladies & Gentlemen. For a snack or meal, if the restaurants on the top floor are too full, you could descend to the depths of the store. The *depachika* food floor (abbreviated from *depato no chika*, "department-store basement," where such food floors are located) is in itself a museum of food. The displays of gourmet bites of every description, from sushi to *wagyu* beef bento and artisan breads, are a sensory overload. Choose a treat to munch in the rooftop garden—if you can decide from among the overwhelming options.

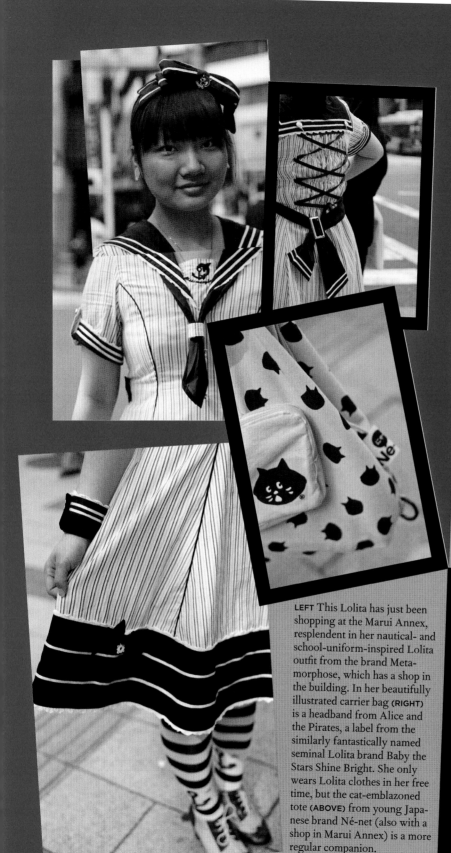

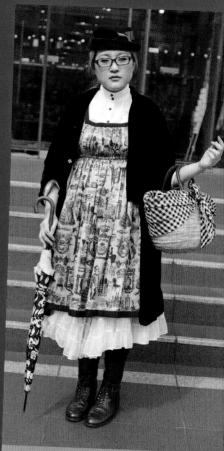

There are many nuanced Lolita variations; this one is a "Classic Lolita" look. The dress is from the Excentrique boutique in Marui Annex, which describes its European-antique-inspired clothes as "classical and lyrical."

LEFT This Lolita has just been shopping at the Marui Annex, resplendent in her nautical- and school-uniform-inspired Lolita outfit from the brand Metamorphose, which has a shop in the building. In her beautifully illustrated carrier bag **(RIGHT)** is a headband from Alice and the Pirates, a label from the similarly fantastically named seminal Lolita brand Baby the Stars Shine Bright. She only wears Lolita clothes in her free time, but the cat-emblazoned tote **(ABOVE)** from young Japanese brand Né-net (also with a shop in Marui Annex) is a more regular companion.

http://www.babyssb.co.jp/

Gothic & Lolita Fashion

Shinjuku is home to the highest concentration of Gothic and Lolita fashion shops in the world, on the sixth and seventh floors of the Marui Annex building. Before the establishment of that building's forerunner, Marui One, independent Lolita shops were to be found in the eclectic youth center of Harajuku (there are still several in the basement of Laforet) and in chic Daikanyama, where the legendary Baby the Stars Shine Bright store was the object of many a Lolita pilgrimage, as depicted in *Kamikaze Girls*, the feature film that brought Lolita to the mainstream and abroad. But what is Lolita fashion?

LOLITA

Think Little Bo-Peep meets Victorian lady and throws in some Rococo extravagance. The basics of a Lolita outfit are a knee-length "jumper" skirt, puffed out from underneath by a structured petticoat, perhaps attached to a pastel pinafore and worn over a prim white frilly blouse with a ribbon bow at the neck and tights or long socks with T-bar Mary Jane shoes, all topped off with a bonnet-like lacy headdress. While the aesthetic is definitely childlike, and a Lolita is guided by the principle of cute at every step, do not confuse this with the childish sexual precociousness of their namesake from Nabokov's novel. Nor should a Lolita be conflated with the admittedly similarly attired "maid." Rather, a Lolita is inspired by the French Rococo era of decorative opulence, indulgence in pleasure, and delicate manners: she avoids exposing flesh, dressing cutely yet primly, and behaves with the poise of a princess.

Within the Lolita style repertoire are various subclassifications: the above is the most typical form, known as "Sweet Lolita," but there are also Classic, Punk, and Victorian varieties, among others.

GOTHIC LOLITA

Some Lolitas prefer to hark to the world of Edgar Allen Poe than that of a Rococo princess: these Gothic Lolitas have co-opted the cute girly frills and debased them with Gothic and Victorian colors and imagery: black replaces pastel colors; and crosses, bats, skulls, and so on grace their garments and accessories. The term and style is said to have been started by legendary visual-kei guitarist-turned-fashion-creator Mana. His cross-dressing onstage persona often wore this fashion, which he coined "Elegant Gothic Lolita," along with its male counterpart, "Elegant Gothic Aristocrat."

HOBBIES

Despite their different cultural inspirations, Gothic and Sweet Lolitas remain part of the same alternative style tribe. It is acceptable to flit between Lolita subcategories and just to wear the outfits on weekends or for special events, although for some Lolitas whose homes and underwear are influenced by the style, it is more of a lifestyle choice. Lolita hobbies include visual-kei rock and concerts, reading *doujinshi* (fan-made comics) and manga, "taking tea," shopping, or just dressing up to feel special and pretty: a princess for the day. The experience doesn't come cheap, however: serious Lolitas are fussy about their brands and expect to pay the best part of $200 for a dress. And for the most part, they are not dressing to attract the opposite sex: these are kooky Japanese girls doing it for themselves.

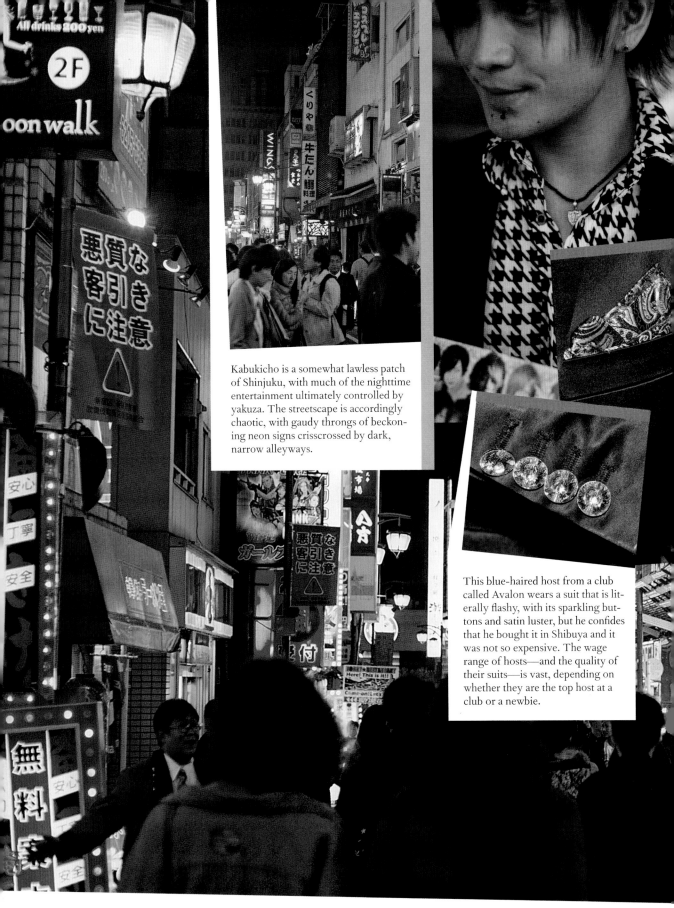

Kabukicho is a somewhat lawless patch of Shinjuku, with much of the nighttime entertainment ultimately controlled by yakuza. The streetscape is accordingly chaotic, with gaudy throngs of beckoning neon signs crisscrossed by dark, narrow alleyways.

This blue-haired host from a club called Avalon wears a suit that is literally flashy, with its sparkling buttons and satin luster, but he confides that he bought it in Shibuya and it was not so expensive. The wage range of hosts—and the quality of their suits—is vast, depending on whether they are the top host at a club or a newbie.

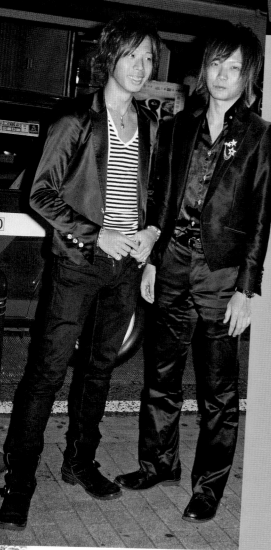

Despite their job requirement to flirt with women, hosts don't look macho. Rather, they have some feminine touches, including long, styled hair, plucked eyebrows, jewelry from piercings to brooches, lots of sparkle and shine, and even some makeup.

Suave Hosts & Flirty Hostesses

L ate-night Shinjuku offers its own distinctive fashion spectacle in the nightlife district known as Kabukicho. A sprawling area that is dowdy by day (it contains the gloomy local governmental ward office) but flashy by night, Kabukicho is home to bars, clubs, karaoke, love hotels, and various sex-trade establishments.

Despite its atmosphere and reputation, Kabukicho has become somewhat of a tourist attraction—a recent hot spot is the Robot Restaurant, with its bizarre show featuring scantily clad dancers, tanks, and giant buxom robots. Efforts are always being made to clean up the area, but seedy shop signs, shady touts loitering by uninviting alleyways, and a whiff of the yakuza underworld still confront the nighttime visitor.

HOST AND HOSTESS CLUBS

The hundreds of host and hostess clubs in the area trade in conversation, attention, flirtation, and the promise of future liaisons. The most common incarnation of hostess clubs are called *kyabakura* (literally "cabaret club," a moniker that distinguishes them from higher-class hostess clubs and from plainer *sunakku* "snack bars"), and the women working there are known as *kyabajyo* (cabaret girls). Kyabajyo offer their ego-boosting services—pouring drinks, lighting cigarettes, conversation laced with innuendo—to male clients, often businessmen on company expenses. Host clubs, where male "hosts" serve female clients, are typically frequented by kyabajyo themselves, or other young "ladies of the night" who get hooked on the attention and tantalizing promise of romantic love offered by their lothario hosts.

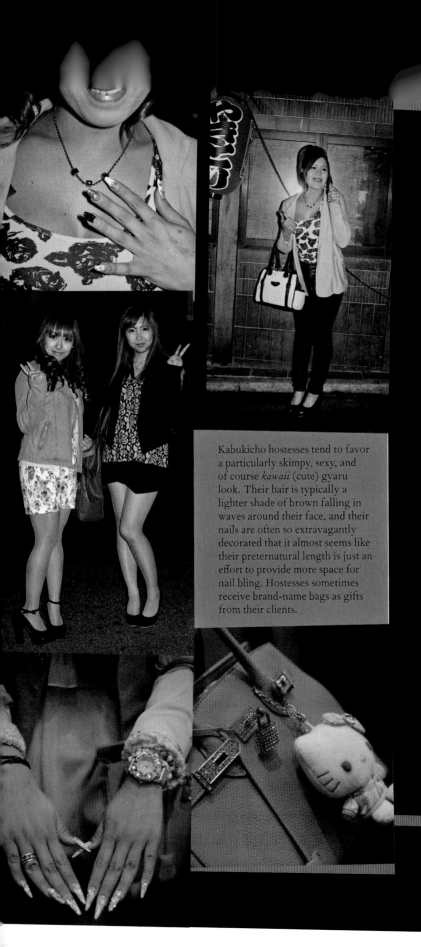

HOST AND
HOSTESS GLAM

Both hosts and kyabajyo have their own styles, chronicled in magazines like *Men's Knuckle*, *Koakuma Ageha* and *Egg*. In general, both host and kyabajyo styles are particularly formal, glam spins on the world of gyaru style. Kyabajyo typically wear frilly, provocative dresses—think slutty prom—and fantastic high-heeled platform creations on their feet. Hosts tend to favor sleek, lustrous dark suits with sharp collars and long, pointed brogues or boots with toes that curl up off the ground. Accessories and grooming are vital for both: chunky silver accessories and long, feathered manga-esque hair for men, dyed bouffant hair falling in ringlets about elaborately made-up faces for women, and plenty of diamanté all round. Brands are also de rigueur, being a part of the host/hostess economy (kyabajyo often supplement their incomes by pawning brand goods given to them by loyal customers). Favorite brands include Chrome Hearts and Dolce & Gabbana for men and Chanel for women, with Bulgari, Gucci, and Louis Vuitton beloved by both. With top earners making over 10,000 USD a month, luxury spending is both a treat and marker of success. Catch these night style tribes as they strut their stuff in Kabukicho, either flitting to and from work or soliciting customers on the streets.

Kabukicho hostesses tend to favor a particularly skimpy, sexy, and of course *kawaii* (cute) gyaru look. Their hair is typically a lighter shade of brown falling in waves around their face, and their nails are often so extravagantly decorated that it almost seems like their preternatural length is just an effort to provide more space for nail bling. Hostesses sometimes receive brand-name bags as gifts from their clients.

RIGHT Billboards wrap around a Kabukicho corner advertising various host clubs in the area. The illuminated boards feature photos of their androgynous-looking employees, often indicating who is the top-earning "no. 1" host.

BELOW LEFT There are shops that specialize in suits for hosts—the shinier and sharper-cut the better, much like their hair—but these men also love brand items like Dolce & Gabbana and Bulgari. Kawano is a flashy select shop in Shinjuku that many hosts go to for brand-fashion fixes.

BELOW MIDDLE This host from the Top Dandy 1st club in Kabukicho has silver jewellery from Chrome Hearts and a clutch "second bag" (a boxy handheld bag associated with old men and yakuza members) from Roen, both host favorites. **BELOW RIGHT** Many host-club customers are hostesses or women otherwise employed in *mizushobai* (literally "water trade") after-dark entertainment. Unlike the hosts, who proudly and boldly patrol the night streets scouting for new clients and are eager to be photographed, hostesses rush through the same streets with earphones in, barely glancing up from their phones, to avoid unwanted attention. This lady in the night (not necessarily "of" it!) is a devotee of gyaru ground zero, the 109 fashion building in Shibuya.

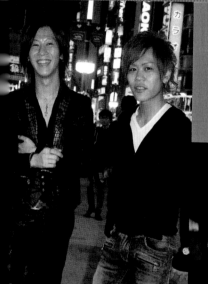

Tokyo's Humdrum Rail Hub Hides a Weird & Wonderful Side

"*Fushigi na, fushigi na Ikebukuro*" (strange, strange Ikebukuro) go the opening words to a ditty that blares out from electronics retailer Bic Camera's Ikebukuro branch. Indeed, Ikebukuro—located out on a limb in the northwest corner of the JR Yamanote Line circling inner Tokyo—is something of an oddball area. Despite the size of this sprawling conglomeration around the second-busiest station in Japan—the world, even—it is not really on the tourist trail, and is only just shaking off its image as Tokyo's uncouth and dangerous corner. To put it kindly, Ikebukuro is one of the most unpretentious areas of Tokyo.

INFLUENTIAL RETAIL HISTORY

Ikebukuro's fashion credentials are, accordingly, mostly unremarkable or even dasai (uncool), with few independent fashion shops, although it has a wide selection of chain stores. It is, however, home to the original Seibu department store, opened in 1940, which was once a groundbreaking purveyor of the latest fashions, and still holds its own in terms of fashion despite its less than stylish location. In addition to Seibu, you'll find Muji, with its no-nonsense, high-quality lifestyle goods in clean, simple designs; the ever-intriguing home and lifestyle shop Loft; and the trend-setting fashion-building chain Parco.

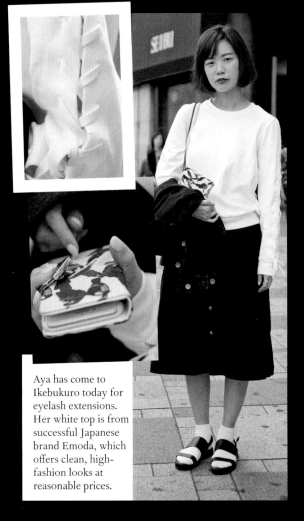

Aya has come to Ikebukuro today for eyelash extensions. Her white top is from successful Japanese brand Emoda, which offers clean, high-fashion looks at reasonable prices.

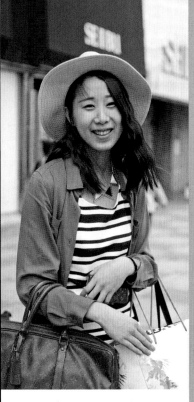

Natsuki often comes to Ikebukuro to shop—among its more quotidian fashion offerings, there are many used luxury brand shops that sell bags like the Louis Vuitton one she is holding.

"Ikebukuro brings to mind the image of cosplayers," says this hairstylist, who stands in front of the Seibu department store where he sometimes shops.

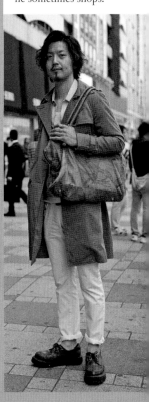

Back to back with the Seibu ("west part") department store is the Tobu ("east part") department store. The two stores were developed by train operators whose lines still run out of the vast station. Confusingly, Seibu is actually on the east side of the station, and Tobu is on the west, a fact also referred to in the "strange, strange Ikebukuro" song.

A SHIFTY SIDE

As a terminal station with lines running into neighboring Saitama prefecture, Ikebukuro is a Tokyo repository for the *yankii* (delinquent working-class youth) culture of regional suburban Japan. This yankii presence in Ikebukuro literally colored its atmosphere with the presence of American-influenced *karaa gyangu* "color gangs." These rival youth gangs, who distinguished themselves from each other by decking themselves out in different "team" colors, contributed to the perceived menace of Ikebukuro streets in the 1990s. They were also featured in the Ikebukuro West Gate Park (*Ikebukurou Uesto Ge-to Paku*) novels by Shoichi Ishidaira, which later became a popular TV drama and manga series—perhaps the area's most famous foray into the popular imagination.

Ikebukuro's most famous landmark is the family-friendly Sunshine 60 skyscraper, which was the tallest building in Asia when it went up in 1978. It now houses an aquarium, conference facilities, a hotel, and plenty of eating and shopping, with particularly rich choices for tweens and gyaru. Some feel a chill on entering its halls, however, as it was built on the old execution ground of Sugamo Prison—yet another facet of the "strange, strange Ikebukuro" story. Wandering the streets, you can easily chance upon slightly unhinged characters and at the same time get a feeling for the down-to-earth Japanese city life that exists outside more fashionable areas.

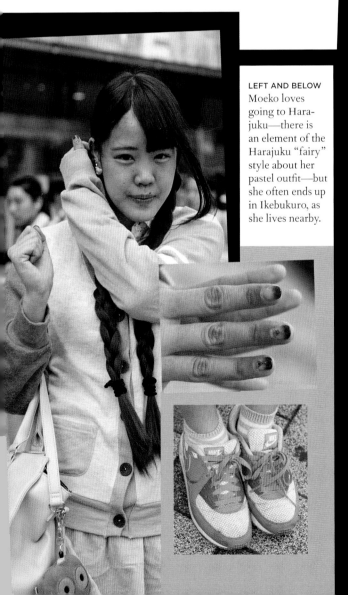

LEFT AND BELOW Moeko loves going to Harajuku—there is an element of the Harajuku "fairy" style about her pastel outfit—but she often ends up in Ikebukuro, as she lives nearby.

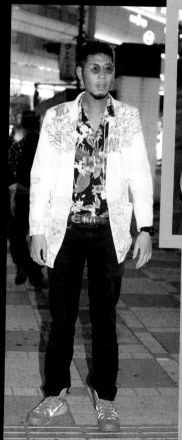

Ikebukuro brings to mind an uncategorizable offbeat style, seen in this middle-aged man with permed dyed hair tied up in a ponytail (RIGHT), and this guy (ABOVE), who has a touch of the gangster about him. He decorated the white jacket he is wearing himself.

OTOME ROAD
Where Girls Geek Out

In the shadow of the towering Sunshine City complex is a road that has become to female *otaku* geeks what Akihabara has to male ones. Called Otome (Maiden) Road, it features along its stretch a cluster of both independent and major otaku establishments, like anime specialist shop Animate and new and used manga store K-Books, which all cater to the whims of Japan's female otaku. The most typical products are *doujinshi*, self-published comics created by manga fans for other fans, particularly the *yayoi* genre of fan fiction, in which the story line centers on often explicit romances between two male characters, usually parodying existing manga stories. Fans of this genre revel in their deviant hobby, and have ironically appropriated the offensive term *fujoshi* (rotten girl) as a moniker. Often having a totally regular appearance, this type of female otaku is particularly hard to spot.

Otome-kei ("maiden" genre) anime and related merchandise is the other mainstay of Otome Road, but among the big anime and book stores there are also numerous visual-kei record shops and good secondhand shops like Lashingbang and Closet Child (which sells Gothic/Lolita/punk brands, as well as dolls), as well as a few bizarre cafés. In addition to a regular maid café, there is a *shitsuji* (butler) café called Swallowtail, and the "Ikebukuro Danshi BL Gakuen" (Ikebukuro Boys'-Love Academy) café. Swallowtail models itself on a fantasy aristocratic estate that is the pretend home of their female customers for the afternoon. You will be waited on hand and foot by a man in tails— your butler. At the Ikebukuro Boys'-Love Academy café, you enter the venue as a "first-year student" surrounded by beautiful older boy students (the staff) who flirt with each other, playing out your boys'-love fantasies over a cup of coffee.

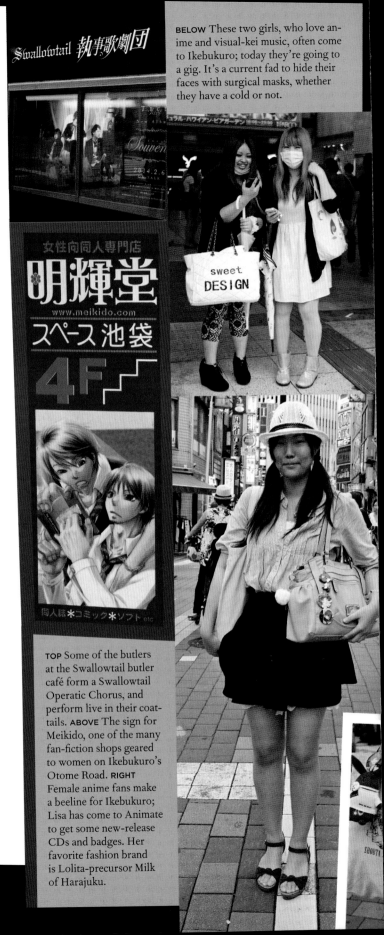

Swallowtail 執事歌劇団

女性向同人専門店
明輝堂
www.meikido.com
スペース池袋
4F
同人誌＊コミック＊ソフト etc

BELOW These two girls, who love anime and visual-kei music, often come to Ikebukuro; today they're going to a gig. It's a current fad to hide their faces with surgical masks, whether they have a cold or not.

sweet DESIGN

TOP Some of the butlers at the Swallowtail butler café form a Swallowtail Operatic Chorus, and perform live in their coattails. **ABOVE** The sign for Meikido, one of the many fan-fiction shops geared to women on Ikebukuro's Otome Road. **RIGHT** Female anime fans make a beeline for Ikebukuro; Lisa has come to Animate to get some new-release CDs and badges. Her favorite fashion brand is Lolita-precursor Milk of Harajuku.

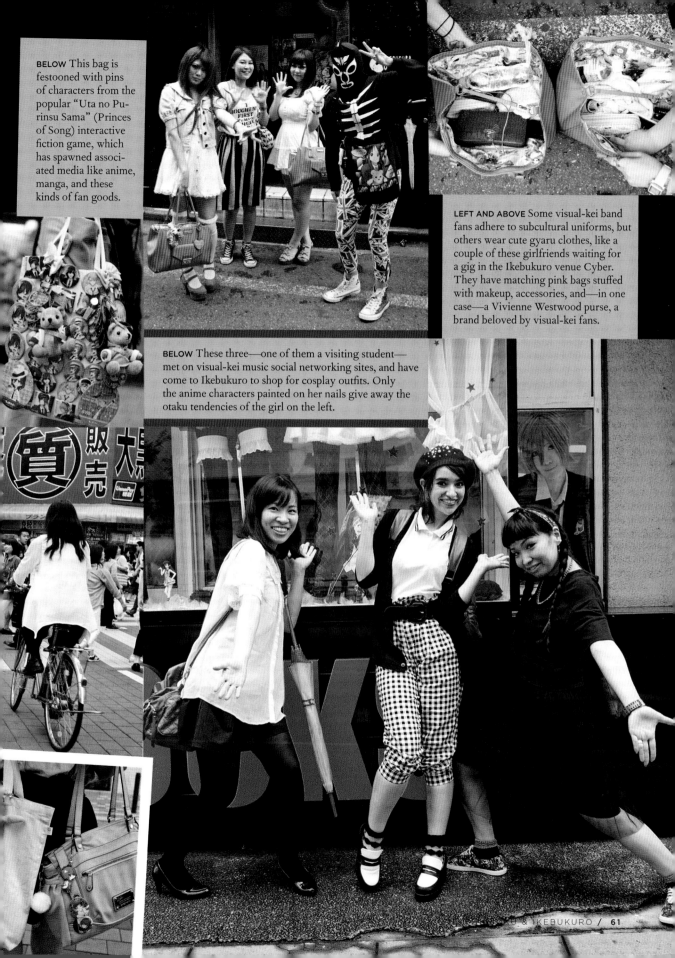

BELOW This bag is festooned with pins of characters from the popular "Uta no Purinsu Sama" (Princes of Song) interactive fiction game, which has spawned associated media like anime, manga, and these kinds of fan goods.

LEFT AND ABOVE Some visual-kei band fans adhere to subcultural uniforms, but others wear cute gyaru clothes, like a couple of these girlfriends waiting for a gig in the Ikebukuro venue Cyber. They have matching pink bags stuffed with makeup, accessories, and—in one case—a Vivienne Westwood purse, a brand beloved by visual-kei fans.

BELOW These three—one of them a visiting student—met on visual-kei music social networking sites, and have come to Ikebukuro to shop for cosplay outfits. Only the anime characters painted on her nails give away the otaku tendencies of the girl on the left.

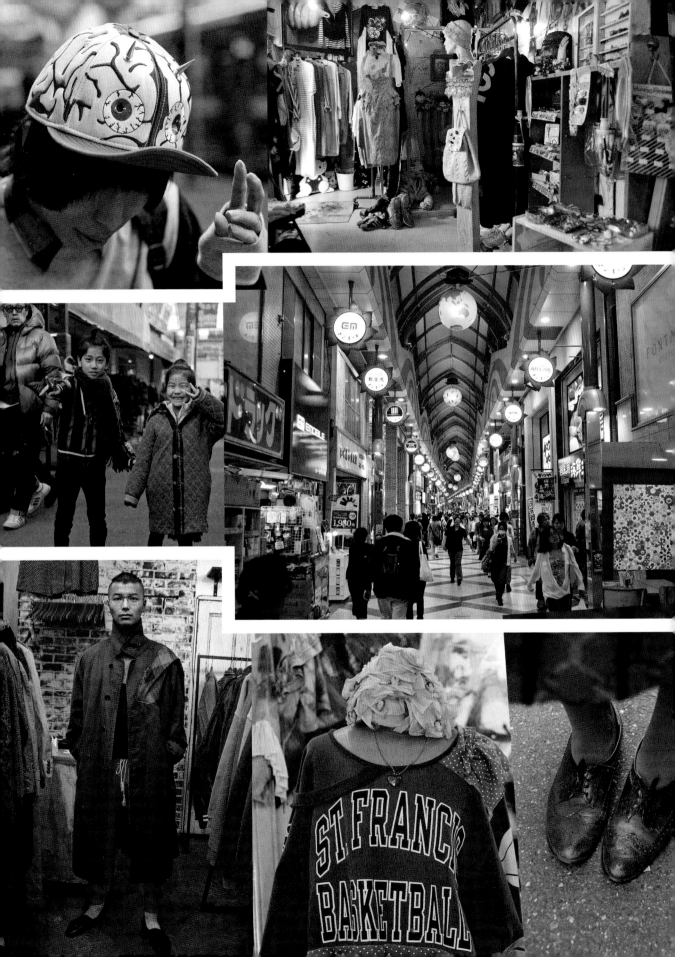

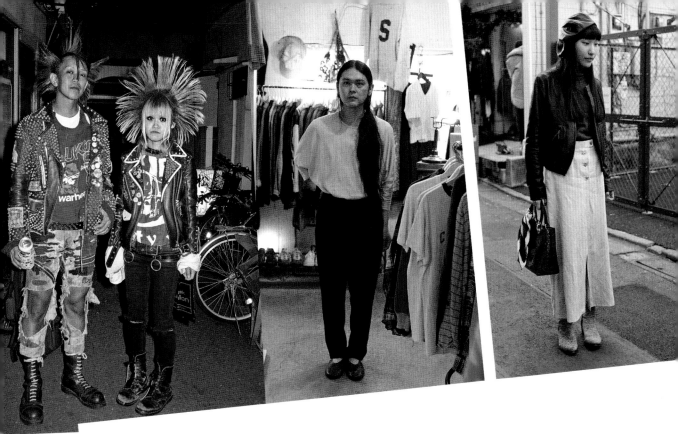

CHAPTER 4
Koenji, Nakano & Shimokita

ALTERNATIVE CULTURE AND AVANT-GARDE STYLE

Chuo Line Culture

TOKYO'S BOHEMIAN WESTERN SUBURBS

Koenji and Nakano are both located on the western stretch of Japan Rail's Chuo (central) Line, which cuts through the center of Tokyo; Nakano is just one stop west of Shinjuku on the rapid train, and Koenji the next station along. This train information is relevant, since the Chuo Line has its own cultural flavor (known as *Chuo-sen bunka*, or Chuo Line culture) and even its own stereotypical resident (*Chuo-sen jin*, a Chuo Line person). Books are affectionately written about these topics, paying homage to the countercultural quality of the neighborhoods along the line. The stops between Higashi-Nakano and Kichijoji in particular are what this Chuo Line culture refers to, being hot spots for alternative live music—notably punk and jazz—avant-garde theater, cheap but delicious *B-kyu gurume* ("class B gourmet") food, characterful book and antique shops, and generally an alternative, bohemian, slightly rough-at-the edges yet cultured approach to life.

In the postwar era, when many people were displaced from their central Tokyo homes, the cheap rents west of Shinjuku—along with the famous universities located on the stretch of line between Shinjuku and Tokyo—meant that literary figures with not much money settled into the area; Osamu Dazai is a notable example. Drinking and conversing at coffee shops and late-night watering holes, they set the scene for the development of the Chuo Line culture.

NAKANO

Nakano, the most densely populated residential area of Tokyo, is a bustling place with thriving covered shopping arcades, the most famous being the Sun Mall north of the station. At its end is Nakano Broadway, a dated shopping mall that has become one of the gems in the Chuo Line's alternative culture parade. In terms of fashion, Nakano is not a particularly stylish location, although it is the home of Japan's ubiquitous Marui fashion buildings and has its own Marui outpost. But

it does have two particularly distinctive styles, both of which come from the Broadway building itself: the fashions for Japan's growing elderly population, in shops that have changed little since the Broadway's heyday in the 1970s; and the cosplay, military surplus, and other outfits bought by the *otaku* who have come to colonize the mall. There is also a new movement underway in the Broadway, as the young and arty visit in greater numbers thanks to Japanese artist Takashi Murakami's various galleries and shops there.

KOENJI

Koenji is Tokyo's vintage fashion mecca. While there are many fine vintage shops in Harajuku and Shibuya, they are distributed among fast-fashion shops and luxury brand retailers, neither of which have a real presence in Koenji. In some areas, everywhere you look there are unpolished, organic-looking vintage shops with racks and piles of garments and accessories spilling into the streets. Koenji also has a preponderance of live music venues; it was the home of Tokyo punk, but caters now to many genres. Cafés, bars, and eateries in which you can imagine heated, alcohol-fueled debates on literature, theater, and music by passionate, informed Chuo-sen jin, are also a feature of this up-all-hours district. More so than Nakano, this is a popular area for countercultural young Japanese to rent homes—perhaps just a single tatami-floored room in which they exist surrounded by secondhand clothes, records, and old books. The jewel in Koenji's fashion crown is the Kitakore Building, in which a mix of eccentric vintage shops and new designers have set up a ramshackle collection of avant-garde style offerings. Koenji also hosts the huge and popular Awa-odori dance festival, where the distinctive traditional costumes worn by the dancers—half-moon straw hats, wooden sandals, and kimono—can be enjoyed every August.

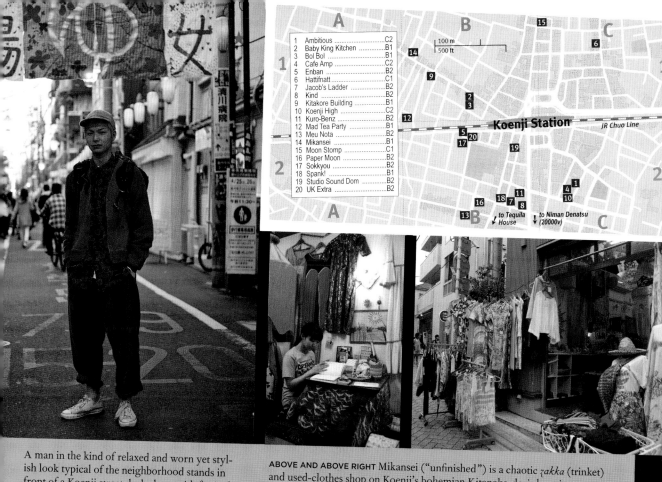

1	Ambitious	C2
2	Baby King Kitchen	B1
3	Bol Bol	B1
4	Cafe Amp	C2
5	Enban	B2
6	Hattifnatt	C1
7	Jacob's Ladder	B2
8	Kind	B2
9	Kitakore Building	B1
10	Koenji High	C2
11	Kuro-Benz	B2
12	Mad Tea Party	B1
13	Meu Nota	B2
14	Mikansei	B1
15	Moon Stomp	C1
16	Paper Moon	B2
17	Sokkyou	B2
18	Spank!	B1
19	Studio Sound Dom	B2
20	UK Extra	B2

Koenji Station — JR Chuo Line

to Tequila House to Niman Denatsu (20000v)

A man in the kind of relaxed and worn yet stylish look typical of the neighborhood stands in front of a Koenji street decked out with festival lanterns and huge *noren* curtains daubed with the words for "women's hot tub." Even when not hosting *matsuri* (festivals), these areas all have a student-ish feel and creative buzz that lends them a permanent festival-like atmosphere.

ABOVE AND ABOVE RIGHT Mikansei ("unfinished") is a chaotic *ʒakka* (trinket) and used-clothes shop on Koenji's bohemian Kitanaka-dori shopping street. Inside they have a heated table where customers can warm up.

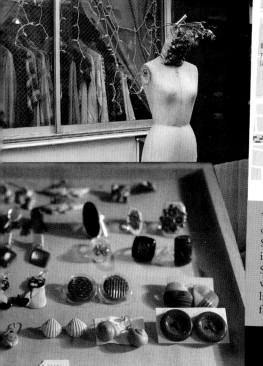

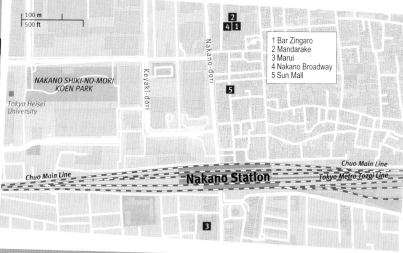

1	Bar Zingaro
2	Mandarake
3	Marui
4	Nakano Broadway
5	Sun Mall

NAKANO SHIKI-NO-MORI KOEN PARK

Tokyo Heisei University

Keyaki-dori

Nakano-dori

Chuo Main Line — Nakano Station — Chuo Main Line / Tokyo Metro Tozai Line

The intriguing shop front (LEFT, ABOVE) of discerning Koenji vintage shop Sokkyou, and a tray of accessories from inside (left). **LEFT AND RIGHT** Koenji, Shimokitazawa, and Nakano's Broadway shopping mall are full of curiosities like these vintage accessories and toys from bygone eras.

VINTAGE KOENJI
Planet Furugi

Secondhand clothing, or *furugi*, is big business in Japan, so much so that the *New York Times* once referred to Tokyo as "planet vintage." This is despite—or perhaps because of—the lack of thrift shops in Japan. As in many other countries, secondhand clothing has been reframed in Japan; it is not someone's charitable castoffs, but another fashionable choice in the cacophony of clothing styles that are at the disposal of its youth. Within the furugi category, "vintage" implies a stylistic nod to an authentic historical look, and to something that is one of a kind, rather than something cheap and old to wear.

The secondhand clothes market is highly competitive in Japan, and there are various retail strategies: bulk-buying chain stores that offer racks of non-branded togs arranged by type and color, such as Chicago; stores like Kind selling used designer clothes arranged by label; and independent shops that have carefully curated selections of vintage items. There are even street-style shops like Wego that sell what seems like vintage Americana wear but is actually all new; such is the popularity of the lived-in, retro look.

But used clothes don't necessarily come cheap. Expect a heavy markup for those goodwill throwaways that have been carefully selected by Japanese buyers—many of whom scour American and other overseas flea markets and transport their finds back to Tokyo—and displayed in niche vintage boutiques.

ECLECTIC AND QUIRKY

Estimates of the number of secondhand shops in Koenji range from 70 to 130, but even the lower range is an awful lot for a couple of square kilometers in a Tokyo suburb. Most are independent shops run by passionate and knowledgeable staff, specializing in certain eras and tastes (although Americana reigns supreme), often sourcing coveted rare items with hefty price tags. A few of the more distinguished and quirky stores include Spank! (think Rainbow Brite and My Little Pony, pastel-colored ice creams and leg warmers over Reebok booties); Mad Tea Party, where vintage gowns, capes, and Masonic items embellish the walls around a central Alice-in-Wonderland tea-party setting; grungy Kuro-Benz, a perennial fashionista favorite with a definite punk edge and eclectic stock; Sokkyou's range of fashion-forward vintage (if that's not a contradiction in terms); the "pure American style" available at Hoy-Hoy Station; UK Extra with its school jackets and bovver boots, and "European Old Clothes Speciality Store" Jacob's Ladder. Many of these places also make their own original brands or sell certain underground brands alongside their majority used stock.

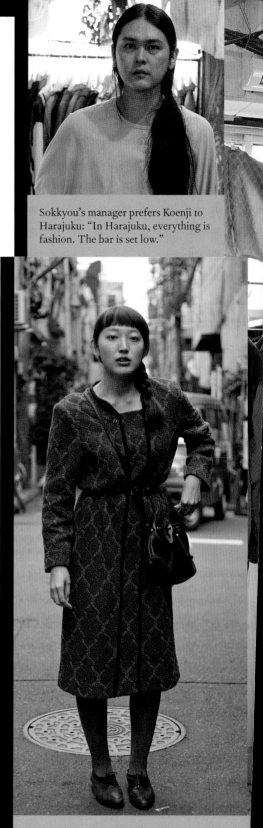

Sokkyou's manager prefers Koenji to Harajuku: "In Harajuku, everything is fashion. The bar is set low."

Sakiko hasn't ventured too far for many of her secondhand clothes: the Dior bag was her grandmother's, and her belt and shoes were handed down by her mother. The dress was bought in a vintage store; her favorite is Koenji's Sokkyou.

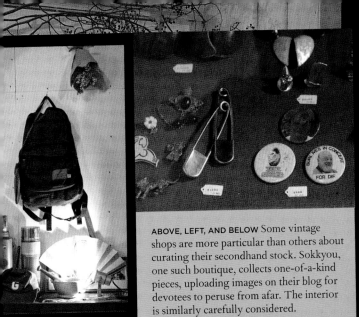

ABOVE, LEFT, AND BELOW Some vintage shops are more particular than others about curating their secondhand stock. Sokkyou, one such boutique, collects one-of-a-kind pieces, uploading images on their blog for devotees to peruse from afar. The interior is similarly carefully considered.

DENIM AFICIONADOS

In a sense, jeans were the precursor to Japan's vintage obsession, being the first fashion items that were neither new nor Japanese to be sought after and bought en masse. A penchant for these workwear items grew in Japan's postwar occupation era, when off-duty US servicemen would wear them around town. First sold used on the black market, jeans were soon imported and manufactured domestically.

Most of the vintage shops in Koenji will have some kind of jeans, but shops like Paper Moon and Ambitious have dozens of pairs of old 501s alone, priced according to rarity and condition.

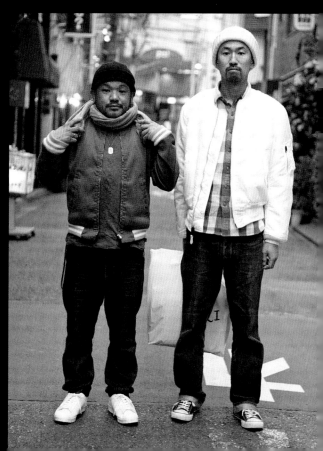

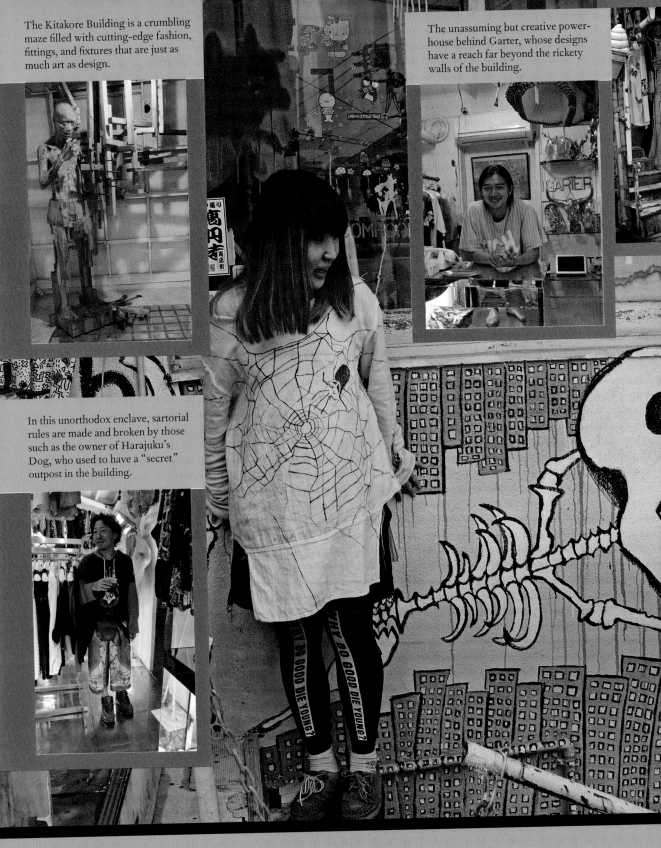

The Kitakore Building is a crumbling maze filled with cutting-edge fashion, fittings, and fixtures that are just as much art as design.

The unassuming but creative power-house behind Garter, whose designs have a reach far beyond the rickety walls of the building.

In this unorthodox enclave, sartorial rules are made and broken by those such as the owner of Harajuku's Dog, who used to have a "secret" outpost in the building.

Tokyo's Avant-garde Fashion Outpost

Walk down one of Koenji's many local shopping streets, past the restaurants, cake shops, and hairdressers, and you'll come across a squat two-story building that, when shuttered, looks like it is waiting to be demolished. When those shutters are up however, the off-the-wall fashion world of the Kitakore Biru (building) juts out onto the street, stopping passersby dead in their tracks to gaze intrigued at the ramshackle facade and curiosities on view. For this is in fact one of Tokyo's most avant-garde fashion outposts, part experimental fashion lab, part community hangout, with not a little of the vibe of a bunch of bohemian squatters. With a changing list of four or five shops that come and go as walls go up and down and new spaces are created, Kitakore has become not only a Tokyo fashion institution over its short five-year history, but has garnered the admiration of international style mavens. Lady Gaga's stylist drops by when in Tokyo—the Lady herself has been snapped in the media wearing Kitakore pieces—and Pharrell Williams has made a visit in person.

The shops below, current at the time of writing, may come and go, but as long as the building remains standing, visitors to Kitakore will surely be rewarded with a selection of some of the most out-there fashion in Tokyo.

THE KITAKORE STORY

In 2008, aspiring shop owner Goto-san opened Hayatochiri in the corner unit of the Kitakore Building. A huge pair of cartoon eyes on a green vinyl awning stare at visitors as they enter this Aladdin's cave with its manga-plastered walls, to be greeted by a veritable geeks' room of nostalgic kitsch, '80s- and '90s-centric vintage clothes, and outlandish handcrafted "remakes" such as a jacket studded with nearly 200 sharpened-down colored pencils, and trousers with bleeding noses pasted, collage-like, all over them.

Hayatochiri is an outpost of the Koenji vintage shop network and activist unit Shiroto no Ran (Amateur's Revolt), where Goto-san had previously been working. The unit's anarchic leanings and belief that great things can be achieved with little money has informed the whole punk ethos of Kitakore. The number of tenants grew by chance and invitation over the following couple of years to include designer shops, all drawn by the cheap rents and the potential for unbridled experimentation that they allowed.

Garter is the lab and gallery-like shop for designer Koushiro Ebata's highly regarded creations, to which he devotes his days in the attic space of the building. Garter stocks his technically accomplished original attire remakes, as well as selections of vintage and new clothes and accessories; these have included the Giza brand of jewelry by fashionista, DJ, and singer Mademoiselle Yulia, one of the most high-profile stars to have risen out of the Harajuku fashion scene in recent years.

Up a metal staircase disconcertingly split into two misaligned halves is Ilil, British owner Rachel's treasure trove where humorous remakes join pop kitsch: think athletic shoes glued atop traditional Japanese geta wooden platform sandals. Secret Dog, the low-profile spinoff of Harajuku fashion institution Dog, joined the throng from 2010 to 2014 in a pokey cupboard-like space whose handmade floor featured a black mazelike pattern in 3D under a see-through plastic sheet. With a separate street entrance, at the top of some rickety stairs, cutesy vintage shop Southpaw represents the next incarnation of its predecessor, the wonderfully named Nincompoop Capacity (which is now in Harajuku). The latest addition to the creators' community represents yet another direction for the groundbreaking establishment: the cheeky, politically motivated artist group Chim-Pom has taken over a gallery loft space.

Counterculture Haven

K oenji is a hotbed of countercultural activity, from music to eateries, bars, and fashion in styles ranging from punk to ethnic and vintage. It is somewhat ironic that hippie-esque vintage exists side by side with the punk aesthetics that rose as a reaction to it, but in postmodern Koenji they make good bedfellows. Every genre of music has corresponding shops and watering holes in the equivalent style, most of which are friendly on the wallet.

MUSIC AND FASHION

Considering Koenji's disdain for mainstream consumerism, and its embrace of all sorts of styles, it is no coincidence that the area was the Tokyo birthplace of punk, with its subversive music and fashion ethic. Along with its descendants noise and hardcore, punk is still a huge presence in Koenji's music scene, in particular at the new incarnation of seminal "live house" 20,000 Volt, now called 20,000 Den Atsu. Many live houses (as live-music venues are called in Japan), like Studio Sound Dom, are more like practice spaces or places to jam with an audience. They can even double up as obscure record shops, in the case of indie venue Enban.

Experimentation and nostalgia, the two polar ends of Koenji's creative cultural spectrum, are combined neatly in a yearly festival at what is perhaps the neighborhood's most "respectable" live house, Koenji High.

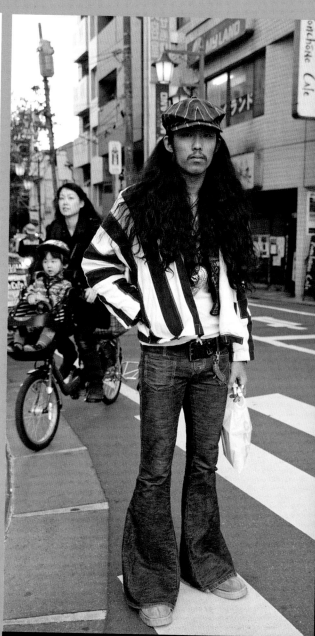

Bell bottoms are this dude's passion: he often goes to a specialist bell-bottom shop in Shibuya, and is currently planning to launch his own bell-bottom brand. A lover of rock and hippie cultures, he comes to Koenji to bask in the vibe and shop for secondhand clothes. Koenji has a strong hippie and ethnic flavor to its townscape and fashions, reflected in this fellow's accessories.

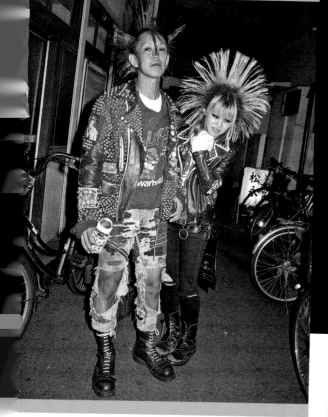

This proper punk pair have just been record shopping in Koenji; they come to the area, as well as Shimokitazawa, to go to gigs. They are wearing stuff from Killers in Shimokitazawa—but, in keeping with the proper punk ethic, they don't do much clothes shopping.

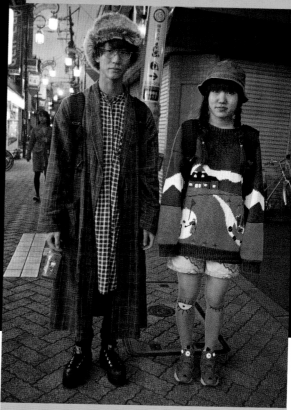

Rintaro and Kirin actually buy their used clothing online, but love to wander the streets of Koenji and Shimokitazawa, describing their atmosphere as "fun"—just like their outfits. Today they picked up some quirky toys at avant-garde Hayatochiri in the Kitakore Building.

Called the Tokyo Blip Festival, the event sees Japanese and overseas musicians gathering to celebrate chiptune music, which is inspired by the beeped melodies of vintage electronic games. Some artists play their entire sets on modified Game Boys.

ECLECTIC CAFÉ CULTURE

Koenji's café culture is not one of passionate baristas offering gourmet brews (although Café Amp, attached to the Koenji High live house, offers a great cup). Many of the area's coffee shops are small and cute in a dated way, harking back to the 1950s when Koenji was a hot spot for the fusty, dark, smoky coffeehouses known as *kissaten*, in which many a budding literary figure would ruminate over a cup of coffee and a smoke. Now these kissaten have been joined by some quirky cafés that are the interior design equivalent of a cobbled-together vintage clothing ensemble. There is Hattifnatt, which—once

you have squeezed through the diminutive street-level entrance—conjures up the childhood wonderland of a tree house, with colorful faux-naive arboreal murals and handcrafted soft furnishings. Further indulge your childhood nostalgia at Baby King Kitchen, which offers adult-sized versions of traditional children's "lunch plates" of hamburger, *omuraisu* (omelette with tomato rice), spaghetti, fried shrimp, and potato salad. For a junkyard vibe, there is Haikyo (literally "abandoned place"), with its carefully created wreckage comprising odd chairs, roughly nailed-together wall panels, and more.

Ethnic food has a strong presence in Koenji, complementing the ethnic styles available at many of its vintage shops. You could devour some Mexican food at the kitsch Tequila House, Iranian at authentic Bol Bol, vegan at Meu Nota, or grab some grub while listening to eclectic ethnic live music at Moon Stomp.

Tokyo's Time Warp Shopping Mall

Nakano Broadway opened in 1966, at which time it was a glitzy multi-function shopping mall and residence building that helped put Nakano on the map. Fashion shops once dominated the five-floor mall, but wind the clock forward half a century and a very different retail landscape awaits the shopper. Many longstanding or original vendors remain, noticeable for their almost indignantly old-fashioned style, like the clothes shops peddling fashions that in many cases have changed little since the '60s and '70s. Fashion remains a strong element of Broadway, from the secondhand luxury accessory shops to a handful of interesting contemporary fashion shops and the cheap and cheerful "Petit Paris" section in the basement. But now a whole host of other weird and wonderful independent shops are thrown into the mix. There are those that specialize in board games, old coins, Japanese wrestling masks, and replica guns. You can shop for or sell Rolexes at a number of luxury used watch shops, have some Taiwanese vegetarian temple food, eat tempura on tatami mats, or enjoy a famous eight-tiered soft ice-cream cone after doing your grocery shopping in the basement. Get your hair cut, clothes altered, or fortune read. As you navigate around the maze-like structure, the juxtapositions of old and new, mundane and obscure can be surreal, but by now the most overwhelming flavor of the arcade is subcultural.

THE OTAKU INVASION

Geeky hobbyist and collector retailer Mandarake (see sidebar) was the impetus for turning this once-chic mall into a subcultural collectors' wonderland. It now has twenty-five outlets distributed through four of the five floors. Nakano Broadway has been transformed into a haven for otaku, in particular those who, true to the broader sense of the word, are obsessive collectors of anything. While Akihabara is undoubtedly Tokyo's premier otaku spot, the two locations attract slightly different otaku breeds. Akihabara was founded on otaku gaming culture and has a strong streak of *moe* (a complex term implying passionate idolatry), but Broadway caters to those otaku who are searching for, say, the 1983 first-edition version of a particular erotic manga. Or dolls, trains, telephone cards, military goods, old erasers—Broadway otaku aren't necessarily fans of manga and anime, although many are. They can be found wandering the corridors loaded down with Mandarake bags, taking a break at Broadway's own maid café, or de-stressing at the retro games arcade on the fourth floor.

ART JOINS THE MIX

Just as Nakano Broadway underwent an image change, beginning in the 1980s, from slightly outmoded fashion emporium to geek central, a new wind is blowing again in the retro corridors. Iconic Japanese artist and savvy businessman Takashi Murakami has been colonizing the space slowly but surely since 2008 (see page 74), and now runs a couple of galleries, a ceramics shop, and a café/bar in various nooks throughout the mall. This pop-art influx has not only cemented the complex's status as a "Cool Japan" outpost, attracting more and more foreign visitors, but has also brought a new young, trendy, art-school-type clientele to the still somewhat shabby arcade.

ABOVE Customers head back in time through a tunnel of fake *torii* arches upon entering a Mandarake vintage collectors' shop. **BELOW** Various types of uniform—even military gas masks—and cosplay outfits are available throughout the mall.

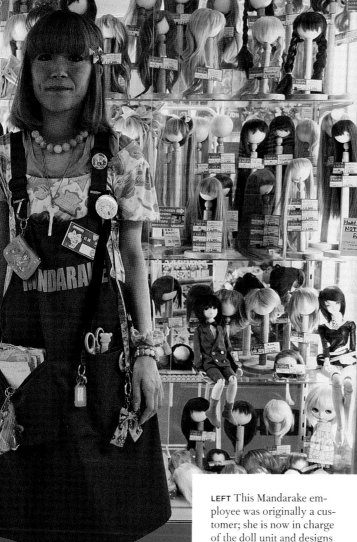

MANDARAKE

MANDARAKE

Mandarake first came into existence in 1980 as a secondhand shop—then the first of its kind—for Japanese manga comic books. It has since grown to be Japan's leading purveyor of various mostly used goods, both strange and quotidian, from the annals of Japan's otaku culture history. There are now twenty-five Mandarake shops or *kan* (annexes) in Nakano Broadway alone, each with its own collectors' niche: cosplay, vintage manga, *doujinshi* fan comics, anime cells, and so on. From its base in Nakano Broadway, the chain has spread throughout Tokyo and across the country.

It is overwhelming to think that everything in the various annexes, from an old plastic bejewelled toy wand to a wide-eyed, buxom character figurine, means something to someone, and therefore has some kind of monetary value. It is in the setting and regulation of this value that Mandarake's core business lies.

Most of the customers, by virtue of their fanatical collecting tendencies (whether of manga- and anime-related goods or not), are otaku. The number of Mandarake niche shops grows as these dedicated otaku customers turn their attention to another yet-uncollected cultural knickknack, creating new markets for more old goods as they go. The vast majority of the stock is provided by the collector customers themselves, who line up to have their otaku bric-a-brac valued at Mandarake's buy-back center, usually only to head into one of the annexes to invest in a new addition to their collection.

Trading in nostalgia and obscurity, Mandarake is a testament to the fervor of Japanese fanatics, the dedication of Japanese collectors, and the diversity and richness of Japan's material culture. For Mandarake, the otaku customer is truly king. "We respond to our customers' needs," says Mr. Yamamoto, press officer for the Broadway shops. "Even if that means wiping down all the pages of a secondhand manga with benzene for them."

LEFT This Mandarake employee was originally a customer; she is now in charge of the doll unit and designs dolls herself. Mandarake has no regulations for hairstyle, hair color, or clothing, making it easier for her to wear her favorite Harajuku fairy style to work. **TOP RIGHT** Nakano Broadway is a temporary home to thousands of collectible toys that peer out from glass showcases, ranging from vintage model trains to erotic anime figurines.

TAKASHI MURAKAMI

Pop artist Takashi Murakami is one of Japan's biggest exports, so it is surprising that his most prominent spaces readily accessible to the public are in the very unglamorous setting of Nakano Broadway. Murakami's outposts in Broadway include a planning office of Kaikai Kiki, his art production company; the Hidari Zingaro gallery; Gallery Pixiv, which displays top-level manga and anime-influenced amateur art in collaboration with amateur art website Pixiv; a ceramics shop called "Oz Zingaro" (Murakami is a keen ceramics collector); and most recently, a café-cum-bar, Bar Zingaro. Opening a café had been a dream for Murakami since his art school days; he finally realized it in this hideaway Nakano spot. He asked Oslo-based café and bar Fuglen, which has a shop in Tokyo's Yoyogi-Koen area, to oversee the drinks know-how and advise on the interior for Bar Zingaro. You can sip some top-notch coffee (the iced coffee comes in a little brown bottle) in stylish Scandinavian surroundings, which of course feature some Murakami artwork.

So why did Murakami choose Broadway? The reason is partly logistical—Nakano lies between his headquarters in Azabu, in central Tokyo, and his art factory in Miyoshi, west of Tokyo—but also cultural. Much of Murakami's work draws on Japan's otaku culture, from his colorful "superflat" *kawaii* (cute) smiley flowers and manga-like characters to his huge erotic anime-esque statues, so it is fitting that he should be represented in one of the city's best-known otaku hangouts. Also, he is a master of collaboration, with a chameleon-like ability to work in fields as diverse as luxury fashion (notably his work with Louis Vuitton) and cosmetics (with Shu Uemura). This, along with with his keen business sense, makes him an unsurprising and surely successful addition to the unique, eclectic mall.

Otaku Obsessions

Otaku are, to put it quite simply, Japan's army of geeks. The term brings to mind nerdy kids who inhabit the virtual fantasy realms of manga and anime and are obsessed with certain types of video games—role-playing and dating-simulation in particular. But the "otaku" label encompasses everyone from young friends who share a passion for anime and cosplay (dressing up as a character) to the lone antisocial hobbyist and collector of obscure plastic freebies.

Being an otaku is strongly tied up with material culture and consumption. Money and time are readily invested in acquiring and knowing everything about particular objects of desire, whether they be plastic figurines, real live female idols, or vintage train models. This, for many, means skimping on efforts toward personal appearance; for the most part, an otaku's look is purely pragmatic—comfortable sneakers, combat pants, backpack—and they would be the first to admit that what they wear is *dasai* (uncool). On the other hand, since otaku are not a style tribe, but rather a weighty

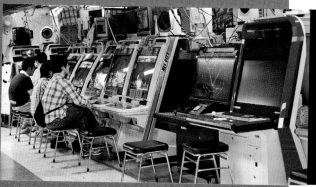

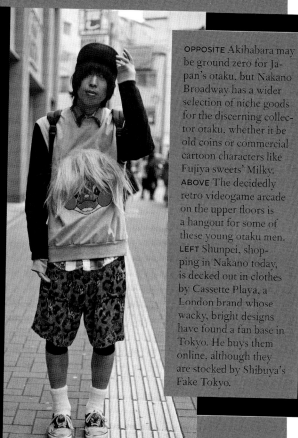

subculture, they have no stylistic frame or sartorial rules. Anything goes: if you want to dress in designer togs, feel free. Female otaku in particular have a wider style repertoire at their disposal, with some co-opting fairy-kei or Gothic and Lolita looks, for example.

COSPLAY, T-SHIRTS, AND HAIR

There are elements of personal dress that otaku do pay attention to, however. One category is cosplay, as discussed in chapter 7—but this is very much a costume and not worn in daily life. An item of regular dress that is often carefully considered is the T-shirt. This basic garment allows the otaku to express certain affiliations and identities to other otaku, perhaps in the form of an anime character or a tongue-in-cheek, often risque, image or sentence. These are often either offensive or challenging to mainstream Japanese, or totally unintelligible to non-otaku. One popular shirt has a parody image of Ronald McDonald holding a rice ball, saying "If you're Japanese, eat rice." Either way, the T-shirt has the advantage of being able to be covered with a simple shirt and revealed when needed. Finally, hairstyle can signify serious otaku commitment: many have hair that is long and/or dyed, which is an impossibility for anyone working a regular job.

FROM OTAKU TO OSHARE?

Densha Otoko (Train Man), a hugely popular novel, movie, manga, and TV series from the early 2000s in Japan, was based on the true story of an otaku pursuing love, egged on by his fellow otaku in cyberspace. In recent years, its influence has spurred efforts to try to elevate the sartorial skill of otaku, largely in the pursuit of nice girlfriends. This is called *datsu-otaku* (leaving otaku) fashion; the success of *Densha Otoko* spurred guides to datsu-otaku fashion and shops promoting the look, including an Akihabara branch of Jeans Mate where maids (of maid café fame) helped the sartorially challenged to pick out a cool pair of jeans. The venue's life was brief, however: it may take a lot more to get from otaku to *oshare* (stylish).

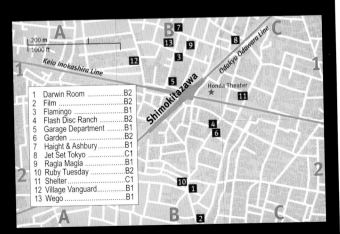

These two work in the restaurant industry in Shibuya but live near Shimokitazawa, where the man bought his shirt. Like Koenji, Shimokita is a residential area with lots of fantastic restaurants, bars, and cafés—and is a used-fashion paradise.

SHIMOKITAZAWA
Boho Vibes

Koenji may be the vintage star of Tokyo, but Shimokitazawa is its slightly more shambolic sidekick. Shimokita, as it is known, is located in the western suburbs of Tokyo a few miles south of Koenji and Nakano. It is a countercultural youth hub with a bohemian vibe that flows through its small theaters, live music venues, cafés, bars, eateries (especially curry joints)—and, of course, secondhand shops. Having escaped both wartime bombing, and, until recently, the wrecking ball of large-scale urban development, the neighborhood has a chaotic, crammed charm to it. Like Harajuku, the area has been tinged with the foreign since postwar days, when there was a black market in front of the station. Although it is located in Tokyo's western residential suburbs, it sits at the intersection of two train lines—Odakyu and Keio—and is just a short ride from both Shinjuku and Shibuya.

REDEVELOPMENT WOES

If the whole of Shimokitazawa feels like it has a backstreet vibe to it, that's because it is literally a mass of backstreets from the minute you step out of the station. Shops are crammed together on either side of the narrow streets, bearing down on pedestrians as they navigate its warren-like layout. This is not too different from the farming village of a hundred years ago, as the town has hitherto been spared large-scale urban planning and allowed to develop its current charming higgledy-piggledy nature organically. This is all to change, however. The overground Odakyu tracks have already, in a feat of modern engineering wizardry, been magicked underground, eliminating some of Shimokita's notorious level-crossing-induced congestion. But there are greater plans afoot: proposals for a wide road to be plowed through the neighborhood and for the construction of high-rise buildings face much opposition.

Keio Inokashira Line

Shimokitazawa

Odakyu Odawara Line

Honda Theater

200 m
1000 ft

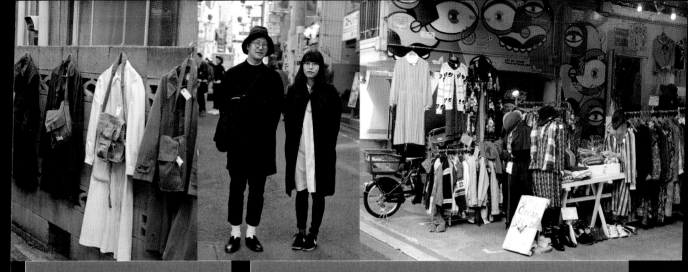

BELOW The hipster wearing the colorful vintage jacket has just bought some secondhand denim dungarees. He and his friend are studying at one of Tokyo's many hairstyling vocational colleges. They like Harajuku—this is their first trip to Shimokitazawa.

ABOVE LEFT In Shimokita, used clothes overflow from the shops into the streets. ABOVE MIDDLE This couple has been for a long stroll through some of Tokyo's more trendy suburbs, finally ending up in Shimokitazawa. A large Comme des Garçons bag adds to their their simple yet somewhat eccentric pair look. ABOVE RIGHT Shimokita Garage Department is probably "absolutely unique"—as one of its component booths selling jewellery and watches is called. Among the other twenty-two stalls are secondhand clothing shops called Jerk and Smog.

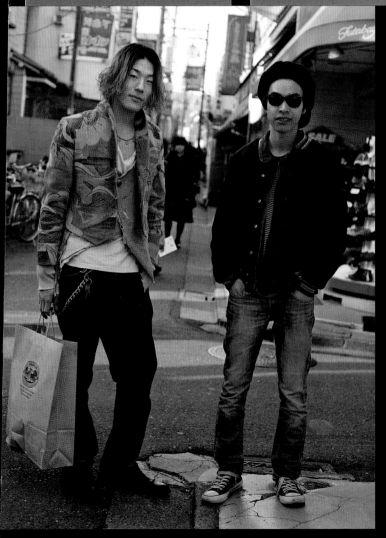

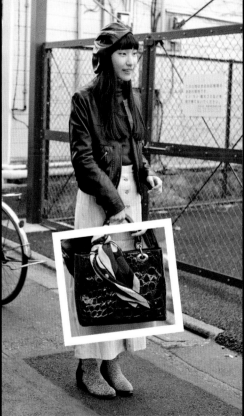

Eri prefers Shimokita to Koenji. "It's easy to feel at home here," says the university student. She studies French, and loves to incorporate French elements into her outfits, such as the vintage Givenchy scarf that is wrapped around her bag handle (INSET).

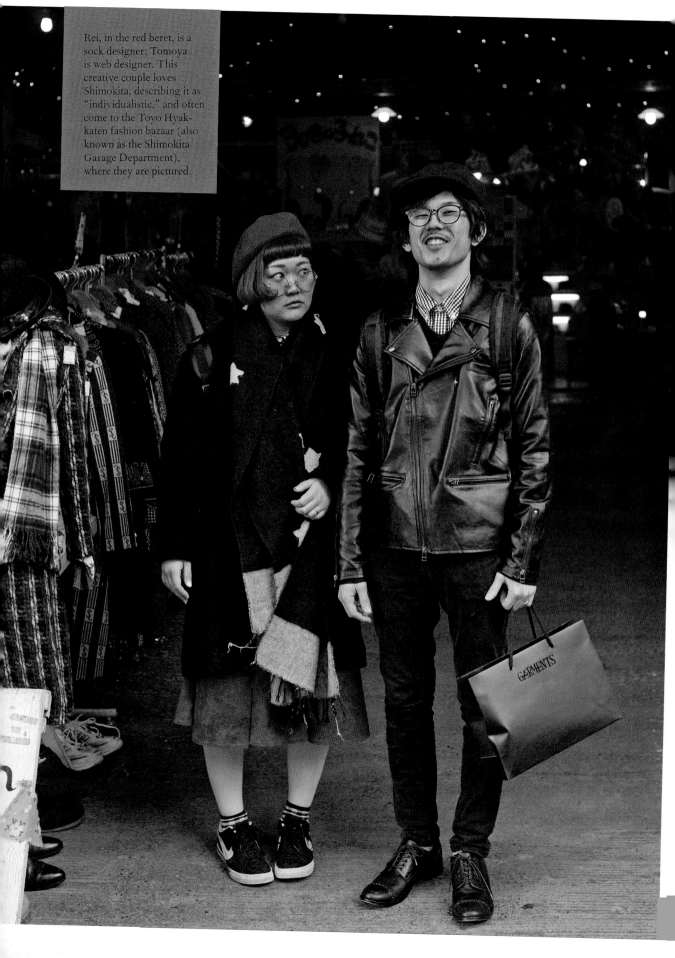

Rei, in the red beret, is a
sock designer; Tomoya
is web designer. This
creative couple loves
Shimokita, describing it as
"individualistic," and often
come to the Toyo Hyak-
katen fashion bazaar (also
known as the Shimokita
Garage Department),
where they are pictured.

SECONDHAND FASHION GALORE

Shimokita is famous for fashion of a kooky second-hand and vintage character, with a large dollop of Americana and ethnic rags. Perhaps the most absorbing of the town's fashion offerings is Shimokita Garage Department, an indoor-market-like cacophony of used clothes and accessories. Some of the better-known shops include long runners Haight & Ashbury and Flamingo, Brit-influenced Ruby Tuesday, the two Ragla Magla shops selling everything for around ten dollars, and newer but more understated ones like Film that are popular with those in the know.

Tucked in among the vintage shops is an intriguing shop featuring "used" items of a different variety: Darwin Room, a "liberal arts lab," is a nature bookshop that also sells taxidermy and pinned insects. It is one of the more unusual places to get coffee and cake amongst the neighborhood's many cafés.

COUNTERCULTURE HISTORY

A bohemian hideout for decades, Shimokitazawa is particularly renowned for its indie theater tradition: the town holds numerous drama festivals and is home to several theaters, most famously those under the Honda Gekijo umbrella. Like Koenji, it is also a haven for lovers of alternative and obscure music, with "live houses" such as Shelter and Garden and a bevy of esoteric record shops like Flash Disc Ranch and Jet Set Tokyo. Village Vanguard, the self-proclaimed "exciting book store" (a description which hardly does justice to this Aladdin's cave of bizarre knickknacks, novelties, and books), which is a national chain beloved by Japanese students, seems to be most home at its Shimokitazawa location, with the Village Vanguard Diner nestling in nearby.

One of Shimokita's most public performers is the "professional" manga reader Rikimaru Toho, who can typically be found on the Shimokitazawa streets on a Saturday night. With his long locks and outfit that comes across as both vintage and ethnic, he seems to embody the spirit of Shimokita as he leaps around, animatedly growling and shouting lines from his oversized manga copies. Hopefully he will not become a casualty of the area's redevelopment and disappear underground like the Odakyu line already has.

ABOVE LEFT Hipster military chic: khaki and army green are mixed up with white sneakers and thick-rimmed glasses. ABOVE RIGHT These stylish kids have been brought Shimokita fashion hunting by their parents, who own a boutique in Kobe. Their hair is just as cool as their clothes: older brother sports a samurai-like topknot; little sister a dishevelled high bun.

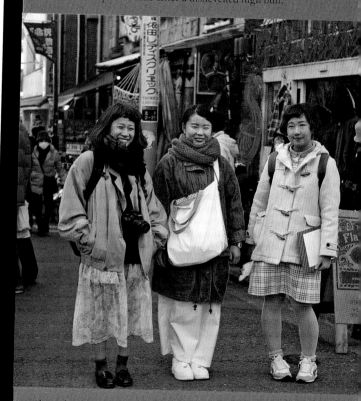

These three, united by their interest in fashion, have come to Shimokitazawa to take photos for a cross-university "fashion snap" club outing. They love Shimokita, as well as the cheaper used-clothing haven of Machida far out in western Tokyo.

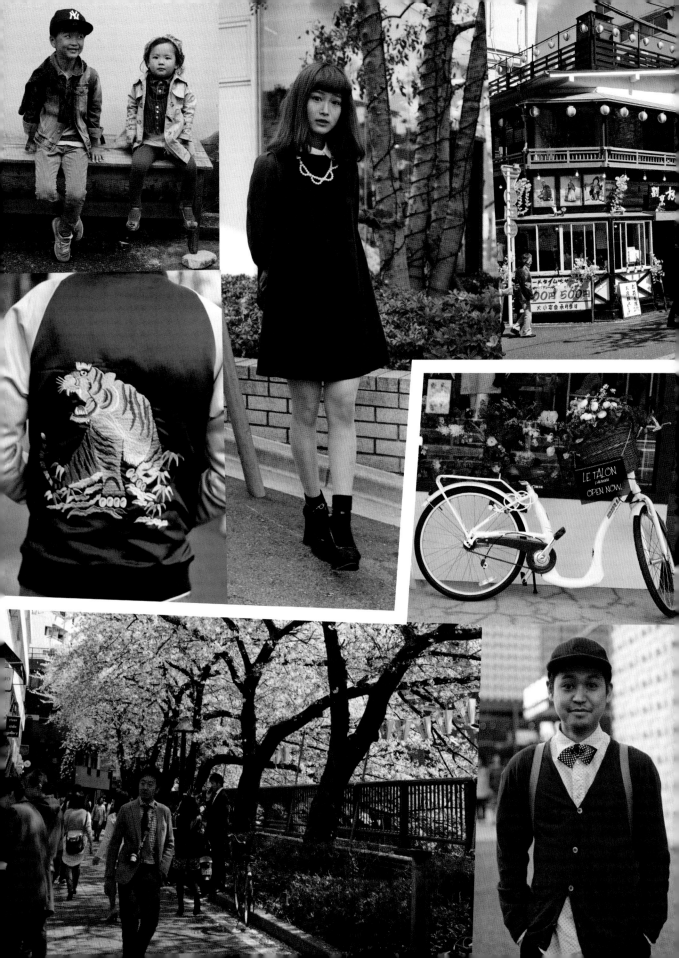

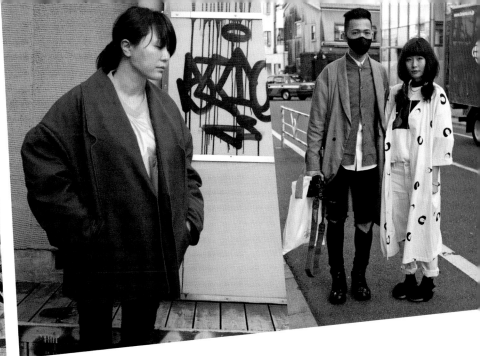

Daikanyama & Nakameguro

TOKYO'S CHIC HIPSTER NEIGHBORHOODS

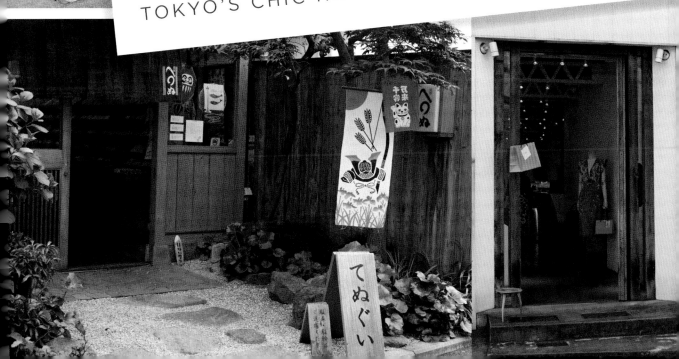

Upscale, Creative, and Hip

Head southwest from Shibuya station and escape from the high-rise urban sprawl into the chic neighborhood of Daikanyama, and hip Nakameguro just a stone's throw beyond it. Among Tokyo's most desirable residential areas, both offer visitors and locals plenty of high-quality choices of restaurants, cafés, bars, and shops. These neighborhoods rose to prominence in the 1990s, with Daikanyama first putting its name on the map as a refreshingly quiet but interesting Shibuya outpost for sophisticated fashionistas in the know. As it gentrified, its creative talent leaked into cheaper Nakameguro just a little further out.

Fuente, which invited a wider age range of weekend visitors with more varied tastes than the fashionistas who used to rule the roost. More recent developments include Daikanyama T-Site (2011), Tenoha (2104), and Log Road Daikanyama (2015). T-Site combines several specialist shops, a smart lounge and restaurant, and a vast and inviting book and audiovisual media emporium from Tsutaya, all in an architecturally award-winning cluster of three connected buildings. Tenoha and Log Road are both commercial lifestyle complexes offering a mix of eateries and design and fashion shops (Fred Segal in Log Road); Tenoha also boasts a shared office space.

DAIKANYAMA

Then-sleepy Daikanyama got its first major trendiness boost when the first part of the Hillside Terrace project was completed in 1969. This striking concrete multi-purpose complex, which houses art galleries, shops, homes, and eateries, eventually came to change the area around it as idiosyncratic shop owners and creative types drawn to its modern atmosphere began living and working in and around it. Still, even as independent boutiques started springing up, until the 1990s Daikanyama remained a little-trafficked area apart from fashionistas bored with the increasingly large retailers in nearby Shibuya and looking for something a little more unusual and distinctive. In 2000, the Daikanyama Address open-air shopping complex was built up around the Tokyu Toyoko line station. This was soon followed by the retail complex La

NAKAMEGURO

Nakameguro, on Tokyo's metro system as well as an express stop on the Toyoko line, has always been more lively than Daikanyama, but it was not popular until the grimy Meguro River was cleaned up in the late 1980s. It is now home to one of Tokyo's most popular cherry-blossom spots; the river becomes enveloped in a haze of fluttering pink, and people wander up and down and in and out of the cool boutiques and eateries that have come to line it. Both areas have succumbed to the influence of property developers, and feature pricey tower apartment buildings and retail complexes, but both still support their own independent fashion and lifestyle cultures: Daikanyama with its air of sophistication and its sleek shops, and Nakameguro with its grungy bohemian side managing to still push through its increasingly polished trendiness.

LEFT AND RIGHT The many creatives working in the compact area typically ride around on stylish bicycles as they race between clients and meetings.

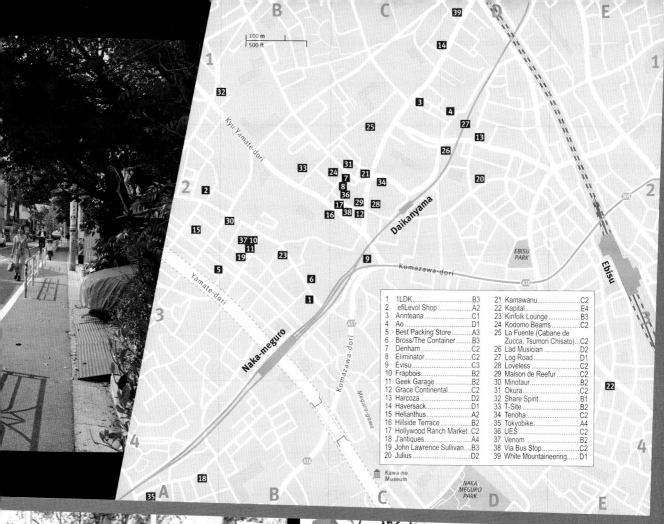

1	1LDK	B3	21	Kamawanu	C2
2	.efiLevol Shop	A2	22	Kapital	E4
3	Annteana	C1	23	Kinfolk Lounge	B3
4	Ao	D1	24	Kodomo Beams	C2
5	Best Packing Store	A3	25	La Fuente (Cabane de	
6	Bross/The Container	B3		Zucca, Tsumori Chisato)	C2
7	Denham	C2	26	Lad Musician	D2
8	Eliminator	C2	27	Log Road	D1
9	Evisu	C3	28	Loveless	C2
10	Frapbois	B2	29	Maison de Reefur	C2
11	Geek Garage	B2	30	Minotaur	B2
12	Grace Continental	C2	31	Okura	C2
13	Harcoza	D2	32	Share Spirit	B1
14	Haversack	D1	33	T-Site	B2
15	Helianthus	A2	34	Tenoha	C2
16	Hillside Terrace	B2	35	Tokyobike	A4
17	Hollywood Ranch Market	C2	36	UES	C2
18	J'antiques	A4	37	Venom	B2
19	John Lawrence Sullivan	B3	38	Via Bus Stop	C2
20	Julius	D2	39	White Mountaineering	D1

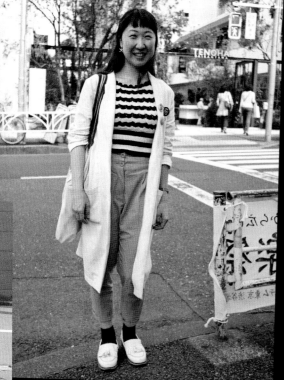

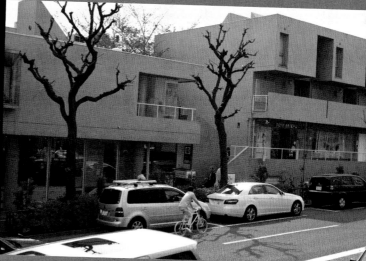

LEFT This stage actress is pictured outside Tenoha, one of the more recent developments in Daikanyama; it includes a lifestyle shop, restaurant, café, and co-working space. **ABOVE** The mixed-use Hillside Terrace, one of the older complexes in Daikanyama, helped propel the area to its chic residential and shopping status today. **TOP LEFT** With a wealth of boutiques and eateries tucked away along them, the leafy side streets of Nakameguro and Daikanyama make for pleasant strolls.

Small Scale and Hip

n Daikanyama and Nakameguro, small scale and hip are key concepts. As large national and international fashion businesses and department stores are absent in these areas, one can explore the independent boutiques that are tucked away down little lanes, hidden in apartment buildings, or standing proudly at street level with their often unique architecture and interiors. In Daikanyama, which has many celebrity and wealthy residents, exclusivity is the overall watchword for these fashion outposts, while in neighboring Nakameguro the boutiques have a casual, individualistic feel that goes with the rough-around-the-edges vibe of the district.

DAIKANYAMA DESIGNER BOUTIQUES

While Daikanyama has a long history with the "select shop" (see pages 88–89), many designers and brands have also chosen to locate one of their branches, if not their only retail base, in this area. Japanese labels like the inventive Cabane de Zucca and whimsical Tsumori Chisato have shops next to each other; the edgy men's shop Lad Musician has its minimal flagship space in a Daikanyama basement. One of the most old-school Daikanyama labels is Grace Continental, whose imposing glass store on the main Daikanyama drag is equally formidable inside, with its sweeping staircase, lush

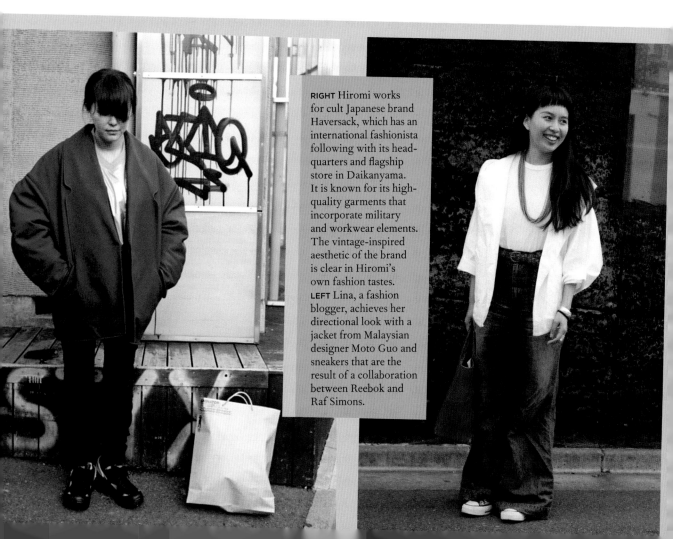

RIGHT Hiromi works for cult Japanese brand Haversack, which has an international fashionista following with its headquarters and flagship store in Daikanyama. It is known for its high-quality garments that incorporate military and workwear elements. The vintage-inspired aesthetic of the brand is clear in Hiromi's own fashion tastes.
LEFT Lina, a fashion blogger, achieves her directional look with a jacket from Malaysian designer Moto Guo and sneakers that are the result of a collaboration between Reebok and Raf Simons.

upholstery and opulent chandeliers, mirrors, and other decorative trinkets. Since starting out in 1979 on a corner of what was then quiet, residential Daikanyama, the label has grown to sell its feminine and elegant clothes throughout Japan and in Taiwan.

While domestic brands feature strong on its streets, Daikanyama is also home to a cluster of three boutiques by A.P.C., the urban basic French label that's a perennial staple for Japanese hipsters: the wood, concrete, glass, and steel spaces, like the brand, feature clean but interesting combinations of materials. Other Daikanyama fashion boutique one-offs include internationally popular black-heavy Japanese men's brand Julius; ethnic- and vintage-inspired Share Spirit; cult vintage- and workwear-inspired Haversack and sub-brand HS Attire shops; Ao with its natural fabrics; and fashion-pack favorite White Mountaineering with its high-tech textiles. For a traditional fashion touch, there is the delightful wooden Kamawanu shop, with its rows of printed *tenugui* Japanese cloths. These have myriad uses, from dishcloths to scarves and bandanas.

NAKAMEGURO HIPSTER SHOPS

Nakameguro's small-boutique delights include J'antiques, a vintage furniture and clothing store that draws all sorts of Japanese creative types looking for inspiration; and Best Packing Store, which is dedicated to traveling in style. Fashion-wise, it is home to edgy menswear label John Lawrence Sullivan, whose Japanese designer Arashi Yanagawa was previously a boxer; streetwear brand .efiLevol's simply named "Shop" with its cute patio; a playful and spacious store from fun urban brand Frapbois; technical menswear at Minotaur's minimalist space; and Venom, the flagship store of punk-rock-tinged Japanese brand Diet Butcher Slim Skin.

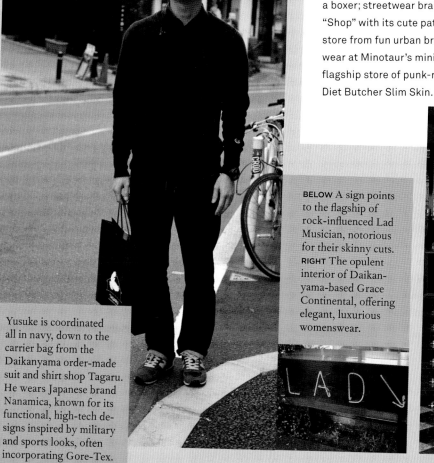

Yusuke is coordinated all in navy, down to the carrier bag from the Daikanyama order-made suit and shirt shop Tagaru. He wears Japanese brand Nanamica, known for its functional, high-tech designs inspired by military and sports looks, often incorporating Gore-Tex.

BELOW A sign points to the flagship of rock-influenced Lad Musician, notorious for their skinny cuts. **RIGHT** The opulent interior of Daikanyama-based Grace Continental, offering elegant, luxurious womenswear.

Fashion Pro Style

Daikanyama and Nakameguro are teeming with creatives and executives employed in fashion or related fields. Many of them work and live in the area, which is rich in fashion offices and ateliers as well as retail. Others travel from further afield for meetings and socializing in the neighborhoods' pleasant and inspiring environment. Catch them having a power breakfast at T-Site's Ivy Place or holding a pow-wow over lunch or coffee at Nakameguro's The Works.

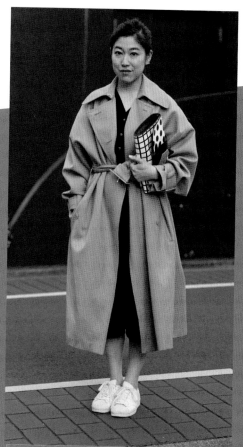

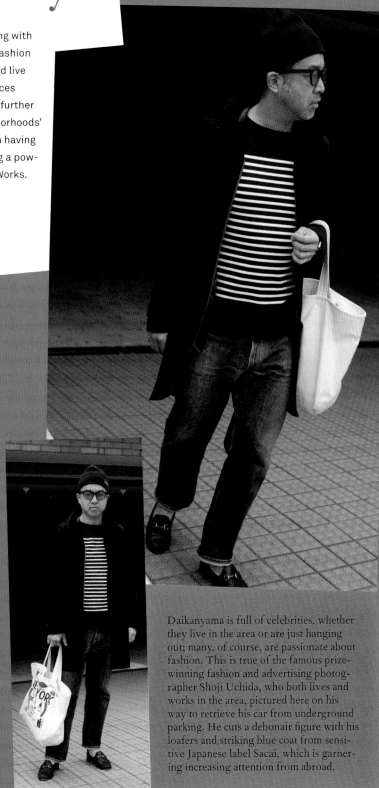

Shimatani-san, a fashion director, is pictured here on her way to a meeting in Daikanyama, a part of Tokyo she loves and feels at home in. Her coat and trousers are from the effortlessly chic and cool high-fashion designs of 3.1 Phillip Lim. She also wears Japanese labels: her top is by Toga; her earrings are by Shihara; and her bag is by Michino, the Paris-based luxury label of Tokyo-born Yasu Michino.

Daikanyama is full of celebrities, whether they live in the area or are just hanging out; many, of course, are passionate about fashion. This is true of the famous prize-winning fashion and advertising photographer Shoji Uchida, who both lives and works in the area, pictured here on his way to retrieve his car from underground parking. He cuts a debonair figure with his loafers and striking blue coat from sensitive Japanese label Sacai, which is garnering increasing attention from abroad.

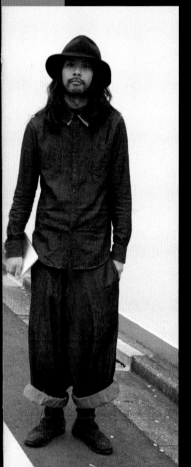

This makeup artist's double denim look is capped with a hat from Japanese hat "select shop" CA4LA (a play on words/numbers pronounced "kashira," meaning "head").

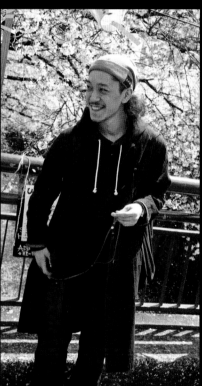

Kieta, who has lived in the Nakameguro neighborhood for two years, often buys his clothes in the boutiques that dot the riverbanks and backstreets. His coat, a sort of denim lab coat, is from a vintage shop; his hat is from French design basic brand A.P.C., which has a strong following in Japan and a shop in nearby Daikanyama. While he lives and shops in the area, Kieta works on the other side of town, in a restaurant in Marunouchi.

DENIM HEAVEN

Okayama prefecture, in the west of Japan—specifically around the town of Kojima—is Japan's denim manufacturing home and the birthplace of many Japanese jeans brands. Despite a recent renaissance, however, its glory days are over; instead, Daikanyama and Nakameguro have become the go-to places for denim connoisseurs. This is partly the legacy of early Americana-import stores like Hollywood Ranch Market (see page 88), which established denim's foothold in the area. Niche denim brands are also well suited to the eclectic range of small independent boutiques in Daikanyama and Nakameguro and the nuanced fashion sensibilities of people who shop there. Hollywood Ranch Market, in fact, has its own line of original vintage-style denim called Blue Blue, stocked at a dedicated shop in Nakameguro and at Okura (also run by Hollywood Ranch Market) in Daikanyama. Perhaps the most famous Japanese denim brand with a flagship store in Daikanyama is Evisu, originally from Osaka, but now beloved worldwide by denim nuts and hip-hop fans, among others. Kapital, one of the more inspired and creative denim brands to come out of Okayama, opened its first Tokyo shop in Ebisu, near Daikanyama, in 2003; the following year it added the Kapital Legs Craftsman store just down the road. Daikanyama was the first overseas location for cult Dutch jeans Denham, and is home to the workspace-like UES shop with its repair station and vintage stitching machine.

Curated Fashion Shopping

Select shops—*serekuto shoppu* in Japanese—which produce carefully curated collections of domestic and international brands chosen by powerful buyers, are now a staple of the global fashion industry. They have a particularly significant role in the history of Japanese fashion, and in the current fashion landscape of Tokyo.

In the 1980s, Tokyo youth were taken with a fashion trend that prescribed head-to-toe dressing in a particular domestic brand, known as "designer's character" (or DC) brands. Some of the most famous of these are still renowned today, such as Comme des Garçons, Y's from Yohji Yamamoto, and Issey Miyake. While some of the clothing designs themselves were highly original, the way in which entire looks were copied unquestioningly led to a certain style ennui among fashion leaders. Enter the select shop, which aimed to encourage stylish youth to pick and choose from brands to put together a unique outfit, and to move away from domestic to imported American and European designs.

AMERICANA

At first these were small shops whose edited selection of brands reflected the idiosyncratic tastes of their owners. While the neighborhoods of Aoyama and Shibuya were bastions of the 1980s DC boom, Daikanyama was far enough removed fashionwise yet close enough geographically to be a perfect spot for select shops. In fact, there were select shops in Daikanayama long before the reaction against DC brands sent that particular type of retailer into the Japanese mainstream. Hollywood Ranch Market, a pioneer in bringing American casual clothes to Japan, opened its first store in Daikanyama in 1979. With its mix of secondhand, imported, and original clothes displayed in the shop alongside exotic Americana home knickknacks and fashion accessories, Hollywood Ranch Market further secured its place in select-shop history by opening a succession of equally intriguing stores in Daikanyama, and later, Nakameguro. One of the most atmospheric of these is Okura, which opened in Daikanyama in 1993 as a "little bit of countryside in the city." Indeed, housed in a traditional Japanese storehouse (*kura* in Japanese), the shop is a homage to the good old days of Japan with a contemporary fashion twist. Expect traditional indigo-dyed T-shirts alongside kimono accessories and kitsch pin badges.

LEFT One of these dapper gents headed to a wedding party is wearing a suit from the trendy, sophisticated select shop and label United Arrows (left); the other sports an order-made one from J. Press (right) that's a hand-me-down from his father. **RIGHT** Sayuri allowed her photo to be taken after much protestation. "But I'm not *oshare* [stylish]!" she said. — Nor, apparently, is she interested in fashion or wearing any brands. Nevertheless, she lends a fashion splash to the streets of Daikanyama as she returns to work at an antiques shop in the area after her lunch break. **FAR RIGHT** Miyu is snapped here rushing from a hair appointment. Although she lives in Tokyo, this is the first time she has been to Daikanyama, in particular to visit one of its many well-known hair salons. One of the most intriguing hairdressers in the area is Bross, in Nakameguro, which doubles as avant-garde shipping-container gallery "The Container."

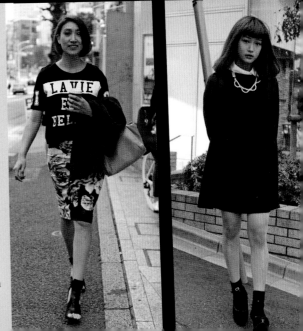

SELECT SHOPS TAKE OFF

Select shops mostly started in this Americana vein, but now they come in all sizes and styles, ranging from the market-leading Beams, United Arrows, Tomorrowland, and so on—which peddle domestic and international brands as well as their own labels across the country through their main stores and a whole host of smaller satellite shops specializing in suits, kids' clothes, etc.—to independent, minimalist avant-garde spaces. While Harajuku and Shibuya have the lion's share of select shops in Tokyo, Daikanyama and Nakameguro still boast an interesting mix that caters to their less mainstream demographic.

In Daikanyama there is an emphasis on grown-up yet high-fashion editions in shops like Lift Ecru and its counterpart Lift Étage, Harcoza, Loveless, and Eliminator. As befits an area where many celebrities live, there is also a popular European-inspired home and fashion select shop and café called Maison de Reefur, which is run by model Rinka.

Nakameguro's select shops come and go—not surprising in an area where young buyers open small independent enterprises. Recently, however, the 1LDK brand (referring to the one-bedroom, living/dining, and kitchen apartment layout) has been making waves with its collection of select shops offering menswear, womens' wear, housewares, and meals in various home-like spaces scattered around Nakameguro and beyond.

Rika and Yuki are heading to fashion-forward select shop Via Bus Stop, after a stop at Maison de Reefur. Yuki, on the left, wears Miu Miu shoes and carries a Gucci bag; Rika likes Journal Standard, another Japanese select shop with more classic, casual looks.

VIA BUS STOP

Via Bus Stop is a Japanese fashion retailer that, despite its somewhat pedestrian name (known to Japanese fans as *via basu*), collects and collaborates with cutting-edge brands from around the world. It has retail locations all over Japan and—as of 2013—in Shanghai, but most intriguing of all is the standalone Via Bus Stop Museum in Daikanyama. The shop, which opened in 2011, aims to be a kind of retail fashion museum, with a collection of fashion and lifestyle curiosities available for purchase. The expertly chosen selection of labels is a mix of classic, conceptual, and avant-garde, ranging from Valentino to Chalayan and McQueen. Via Bus Stop Museum displays its wares within a strikingly designed interior, and features exclusive collaborations with the likes of Bernhard Willhelm, a Tokyo fashionista favorite. Its concept is "Art x Relax x Gift," so along with some killer heels, you can pick up a soothing aroma candle in the venue's three stories of fashion and lifestyle treasures.

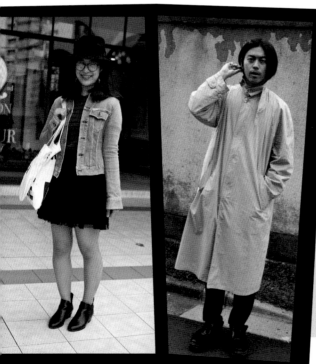

FAR LEFT Mai, a huge fan of Rinka—one of the most popular fashion models in Japan—came to Daikanyama today to visit her idol's boutique and café for the second time. She picked up a candle and some jewelry from the select shop, and proudly displays her finds in her Maison de Reefur eco-bag. LEFT Hayato headed out to Daikanyama for an exhibition; he's dressed up for the occasion in a vintage Armani coat and Prada shoes. He bought the coat at Re.Quality, a high-end select shop in Harajuku that offers both new and used clothes and accessories. A student at the prestigious Bunka Fashion College in Shinjuku, this creative says he has loved making things since he was little.

Bicycle Fashion

Strolling the streets of Daikanyama and Meguro, you might notice that the neighborhood's many fashion-conscious cyclists are getting around on rather distinctive sleek, simply designed candy-colored rides with "Tokyobike" printed in white on the frame. Not for speed freaks, these light bikes were designed for cruising the city at an enjoyably slow pace, emphasising comfort over tech specs (although of course they knock the socks off the average shopping bike). The Tokyobike company, founded in 2002, has its flagship store in Yanaka (see chapter 8) in a charming old wooden building where you can rent one of the stylish bikes to explore the area. Tokyobikes are now available at an equally cool Nakameguro store, as well as at branches in Koenji and overseas.

LEFT AND ABOVE Bicycle regulations have tightened in Japan, but riding is still fairly relaxed. People weave between sidewalk and road, and wear stylish headgear instead of helmets.

Tokyo is one of the world's top cycling cities, not because it has an extensive cycle-lane network (it doesn't) but simply because nearly everyone has a bike. There are several cyclist types in Tokyo: the vast majority ride cheap *mama chari* ("mama chariot") shopping bikes with upright handlebars and a basket in front to ride around the neighborhood, skillfully weaving between the pedestrians with whom they are unofficially allowed to share the sidewalk. Real "mamas," however, usually ride specially designed battery-assist bicycles with a child seat on the back and often one on the front, too: these are indispensable to urban parents needing to ferry their young offspring around. The cyclists on the road in Tokyo are often bicycle messengers, who are no exception to the global anti-establishment messenger-bike culture: in fact, Tokyo is a leader in "fixie" fixed-gear bikes. Finally, there are those who use bicycles as their main form of transport and flit between road and pavement; these include stylish youth with equally stylish rides.

Japan has a thriving culture of bicycle fanatics who assemble highly customized and often colorful bikes (ABOVE), but there are also legions of sit-up-and-beg bikes (ABOVE LEFT) with practical baskets that prioritize comfort and practicality over looks and speed. This one is stationed outside Daikanyama's 1-800 Toll Free vintage shop, from the Hollywood Ranch Market stable of shops.

BICYCLE SHOPPING

While hipster cyclists are by no means exclusive to Daikanyama and Nakameguro, they are found in great numbers in the area, which has quieter roads and a selection of cycle shops. In Daikanyama, bike enthusiasts can find Narifuri "fashion and bicycle" shop and T-Site's Motovelo, which has a wide range of electric and battery-powered rides and accessories. In Nakameguro you can find classic bikes at Nukaya; and the name of "Geek Garage" says it all (although most of these bicycle "geeks" are of course exceedingly hip). When you're done bike shopping or cruising, stop by Nakameguro's cocktail lounge for bicycle lovers, Kinfolk, where bicycles and parts adorn the walls.

Share-cycle service Cogicogi, which operates around Shibuya, has docking stations in Daikanyama and Nakameguro, as well as one-day passes, making it a fun and easy way to get around the area. For those who prefer their mobile transport to come on four wheels rather than two, California Street in Daikanyama, founded in 1988, sells all manner of skateboards, skater gear, and accessories.

LEFT Bicycles are not the only means of covering short distances in the area: a man clutching his neon penny skateboard pauses outside Daikanyama select shop Eliminator, with its selection of futuristic street looks from the likes of Raf Simons and Y-3. FAR LEFT This guy stops for the duration of a red light to be photographed, and then is on his speedy way again. The bicycle, with its old-style headlight, complements its rider's vintage look.

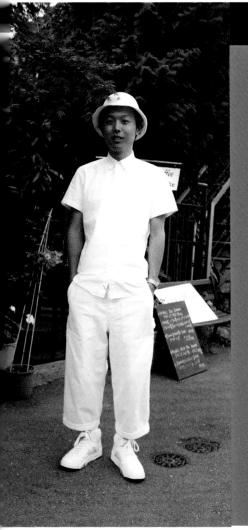

ABOVE LEFT The cozy Kinfolk Lounge in Nakameguro's back streets is run by bicycle enthusiasts. **ABOVE RIGHT** Nakameguro hipster select shop 1LDK has its own café, bar, and restaurant, Taste AND Sense, next door. With a regularly changing menu, it is a favorite spot for lunching creatives. **LEFT** This hairdresser works opposite Mocha Coffee in the backstreets of Daikanyama, but has not yet been in. Yet another coffee specialist in the area, the café uses only beans imported from Yemen for its brews. **RIGHT** Daikanyama's T-Site has a number of café and restaurant options, including a Starbucks where one can sit among the bookshelves of Tsutaya Books, and Anjin, a sumptuous lounge, café and bar. These make T-Site a great place for everything from studying to dates. This couple, in their matching sneakers, is pictured in front of Tsutaya Books.

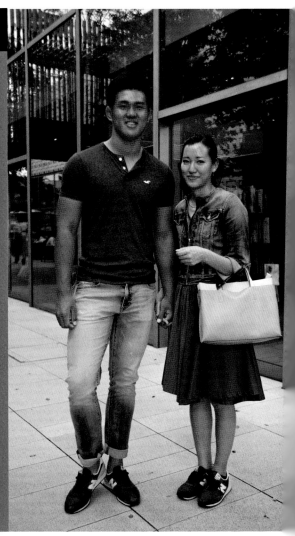

CAFÉ SOCIETY

Hip Hangouts and Watering Holes

This stylish pocket of Tokyo shows itself off not just through its fashion offerings but also through its concentration of tastefully trendy eateries, cafés, and bars. The neighborhood's culinary delights—from bistro Beard to submarine-like Seirinkan, famous for its pizza—should be explored in earnest by visiting foodies. Below are listed some of the more distinctive and pleasant cafés and bars in which to take a shopping stop-off to refuel, recover, or just soak up the stylish atmosphere.

KISSATEN VERSUS CAFÉ

One of the most highly rated places for coffee in Tokyo by aficionados of the black stuff is Sarugaku Coffee, buried in a Daikanyama brick basement. Indeed, the coffee in this *kissaten*—an old-style coffee shop with a dark interior—is only served black, and often with a considerable wait as it drips through. There are numerous other specialist coffee shops in the area that roast their own beans, like Café Façon in Nakameguro, or the Coffee Shop in Daikanyama, where you can choose between AeroPress, pour-over, or French-press brews.

Whereas drip coffee is the traditional preserve of the Japanese kissaten, espresso-based drinks are just as obsessively crafted at many of the area's cafés. Daikanyama "coffee and clothes" shop Number is one of the few places you can grab a "flat white" latte-style drink in Tokyo. Even the branch of Starbucks at Daikanyama's smart T-Site shopping and restaurant complex is good for a spot of magazine- and people-browsing if you can get a seat. The same goes for the swish Ivy Place restaurant next door. Nearly opposite is Caffé Michelangelo, a Daikanyama institution with well-heeled and well-dressed characters and their dogs often perched on the pavement seats. Sign, next to Daikanyama station, is a relaxed spot for people-watching over coffee or a cocktail.

Nakameguro has many cafés. Some are near the river, like Koop Café and Chanoma; the latter has a raised cushioned section for a relaxed seating experience. Further

Airi has just treated her mother to a Mother's Day lunch at Daikanyama institution Aso, a café whose pavement tables offer a great view of stylish passersby. Dressed up for the occasion with a Dior necklace and Louis Vuitton bag, the pair is heading out on a shopping spree in the area.

from the station are, to name but a few, Café Alaska, with its natural interior and vegetarian food; Patisserie Potager, with vegetable-based cakes and desserts; and The Works, an old factory converted to a coffee shop, restaurant, and work space with gallery. Cult boutique 1LDK's Taste AND Sense restaurant, café, and bar is also a top spot for refreshment after visiting the shop across the way.

LOUNGING AROUND

In Tokyo's hipster central, stylish loafing has given rise to a proliferation of drinking spaces with "lounge" in the title—venues that are comfier than a bar, yet somehow smarter, too. There is the cultured and sumptuous Anjin Lounge in Daikanyama T-Site; Nakameguro has the Kinfolk Lounge—a dive frequented by arty types and bicycle lovers; Lounge, at the refined Japanese restaurant Higashi-Yama, doubles as a smart café by day and cocktail bar by night. Some of the area's eateries have drink offerings that are as tempting as their edible fare: the tequila cocktails at Mexican Junkadelic and the craft beers at barbecue joint Hatos, for example. For an all-night snack and drinking session, the hole-in-the-wall Baja, a lively Nakameguro Mexican food spot, is open until 5 a.m.

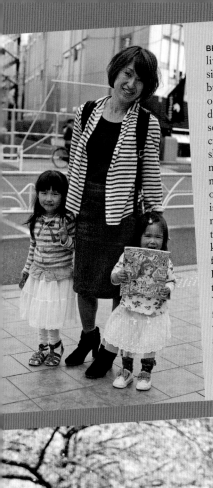

BELOW LEFT These moms live over on the northeast side of central Tokyo, but come to Nakameguro occasionally, especially during cherry-blossom season. There are several cute children's clothing shops in the area, but these moms prefer to shop at flea markets or even make their own kids' togs. Little Yura is wearing a turquoise skirt made by her mother from traditional Japanese cloths known as tenugui, known for their bold prints. **LEFT** Five-year-old Konomi and two-year-old Anna, from Yokohama, are dressed up for a Daikanyama play date with friends who live in the area. The girls are wearing clothes that their doting grandmother sends from the countryside.

LEFT Mother Madoka expertly ferries her two children, Miyabi (two) and Haruto (five), around Daikanyama on her electric mama-chari in a blur of pink and red. Haruto, with his asymmetric haircut, American Apparel hoodie, and Vans, already has the hipster thing going on. **BELOW RIGHT** The only exception to their bright color scheme is the standard-issue tartan kindergarten backpack hanging off the back of the rear child seat.

BELOW AND BELOW LEFT Fashionable local families have plenty of stylish kid shopping options for dressing their little ones.

FASHIONABLE FAMILIES
Cool Mamas & Chic Kids

Take a Sunday stroll in Nakameguro and Daikanyama, and you'll likely find yourself jostling with many young families, or with numerous gaggles of moms and kids on weekdays. These areas, already alluring with their mix of independent small businesses and well-turned-out outlets of bigger ones, are just as attractive to parents and kids, with a wealth of shops selling kids' toys, clothes, and general paraphernalia. Daikanyama in particular is a hotbed of baby and toddler activity: the chic retail complex T-Site boasts the Bornelund toy shop and Tsutaya's kids corner; La Fuente's dedicated kids, and baby floor features import and homegrown brands like Cody Coby, which offers basic casuals in quirky prints, and Dadway, which aims to make child-raising more dad-friendly; the refined and stylish British brand Caramel Baby and Child, and French favorite Petit Bateau, are in the Hillside Terrace complex and chic Bonton and Bonpoint further down the road; at designer select shop Lily's Closet, mothers can shop for clothes for themselves alongside togs for their little ones; there's also Kodomo Beams, the only baby and kids' branch of the famous Beams select shop. Daikanyama also boasts Annteana, a tasteful café geared toward moms and toddlers: it offers food and drink in its pastel interior complete with a climbing wall and soft play area. Down the road in Nakameguro, Helianthus stocks infant basics in bright prints and has an adjacent café and baby play area. And near the station is funky kids' clothing and gift select shop Chocolate Soup.

RIGHT Nakameguro's famous cherry trees bloom for just a week every year, but the abundance of parks and quiet back streets in the vicinity, like those in neighboring Daikanyama, draw little people and their parents all year round.

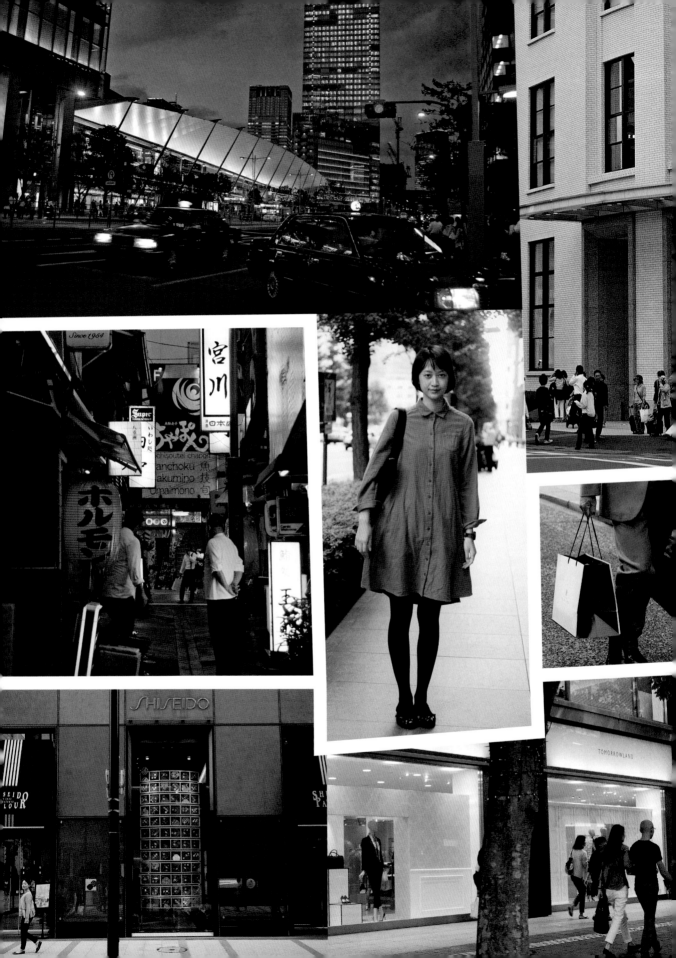

CHAPTER 6

Ginza & Marunouchi

TOKYO'S HISTORIC LUXURY SHOPPING DISTRICT

Fine Shopping Among Tokyo's Oldest Brick Buildings

A LONGSTANDING HISTORY OF FINE RETAIL

Ginza and Marunouchi stand on the east side of central Tokyo, separated from the youth-culture hubs of Shibuya and Harajuku by the Imperial Palace, an impassable oasis of green at the center of Tokyo. These areas were the earliest in Tokyo to have been given a Western-style brick-building overhaul. The redesigned Ginza was completed in 1875 following a devastating fire; the Mitsubishi Ichigokan office building, built in 1894, paved the way for Marunouchi's brick-and-mortar transformation, earning it the nickname "Iccho Rondon" (London block). Even now, both areas retain their stately grace against the diverse architectural backdrop of wider Tokyo. Fashionwise, they specialize in higher-end chic looks for the discerning Japanese shopper.

GINZA: COSMOPOLITAN LUXURY

Ginza has long been synonymous with luxury, with its glut of Japanese and foreign high-end brand shops and department stores, as well as upscale hostess bars where the "Mama-san" bosses still wear elegant silk kimono. Images of Ginza's famous Yonchome crossing—neon signs juxtaposed with the classical clock tower facade of the Wako building—represent the alluring mix of old and new, East and West, at the forefront of the Tokyo of the popular imagination. Ginza was once the most cosmopolitan area of Tokyo, with its uniform brick boulevards and grid-like street layout. Accessible by streetcar, the area drew latter-day flaneurs to stroll, shop, and refresh themselves at European-style beer halls and cafes, a pastime known as "Ginbura" (Ginza wandering) which peaked in the 1920s and 1930s. During this era, *moga* (modern gals) and *mobo* (modern boys), at the

vanguard of the transition from traditional Japanese clothing to Western fashions, favored Ginza as their stomping ground. Gradually Japanese youth gravitated to Shinjuku and Tokyo's west side, leaving Ginza to evolve into the refined shopping and leisure destination it is today.

MARUNOUCHI: HOME OF BIG BUSINESS

During the Edo period (1603–1868), Marunouchi, being nearby what was then Edo Castle, was the preserve of feudal daimyo landlord estates. Following the Meiji Restoration in 1868, the land was bought by the Mitsubishi clan, who established Marunouchi as Tokyo's first center of finance and commerce. Bridging the financial center of Otemachi to the north and the retail and leisure districts of Yurakucho and Ginza to the south, this neighborhood is still a bastion of established big business, but has also grown to become a shopping and leisure destination in its own right. Naka-dori, a pleasant, tree-lined avenue that sees little traffic, is host to a range of boutiques and chic eateries. Located around this street that runs like a backbone down through the area are various fancy dining and retail complexes, including Otemachi's Oazu; the recently renovated and reopened Marunouchi Brick Square; the adjacent towers Marunouchi Building and New Marunouchi Building (known as Maru Biru and Shin Maru Biru); and Kitte, housed in the old Japan Post headquarters. Any one of these sites offers a mix of quality fashion and lifestyle that appeals to the more monied and stylish of the area's many businessmen and -women. The middle of Naka-dori boasts an impressive open vista that stretches from the lush green outer gardens of the Imperial Palace to the red brick glory of Tokyo Station, which was restored and reopened in 2012.

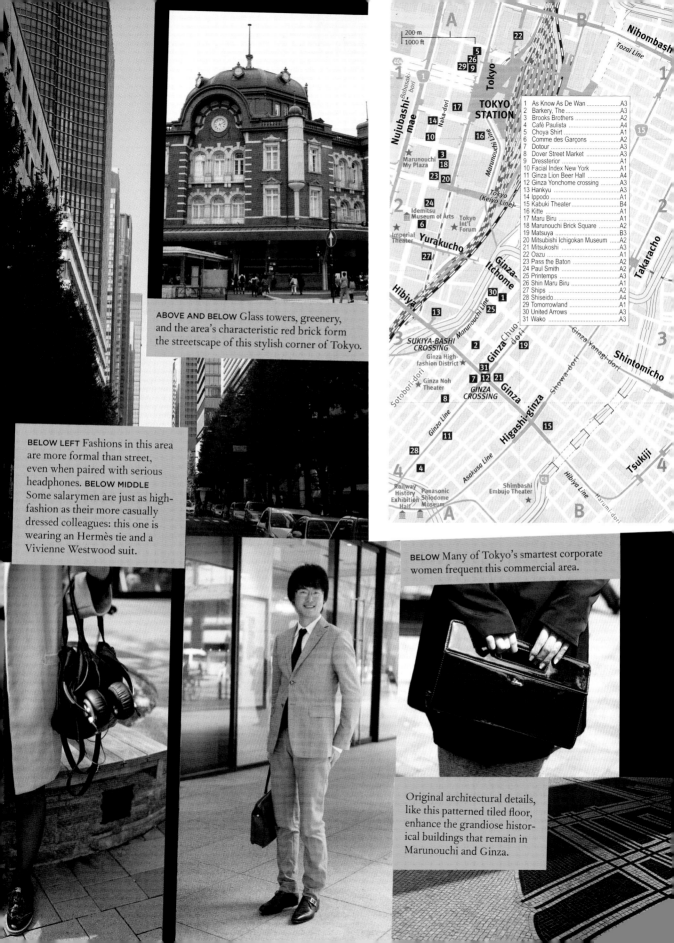

ABOVE AND BELOW Glass towers, greenery, and the area's characteristic red brick form the streetscape of this stylish corner of Tokyo.

BELOW LEFT Fashions in this area are more formal than street, even when paired with serious headphones. **BELOW MIDDLE** Some salarymen are just as high-fashion as their more casually dressed colleagues: this one is wearing an Hermès tie and a Vivienne Westwood suit.

BELOW Many of Tokyo's smartest corporate women frequent this commercial area.

Original architectural details, like this patterned tiled floor, enhance the grandiose historical buildings that remain in Marunouchi and Ginza.

1 As Know As De Wan	A3
2 Barkery, The	A3
3 Brooks Brothers	A2
4 Café Paulista	A4
5 Choya Shirt	A1
6 Comme des Garçons	A2
7 Dotour	A3
8 Dover Street Market	A3
9 Dresserior	A1
10 Facial Index New York	A1
11 Ginza Lion Beer Hall	A4
12 Ginza Yonchome crossing	A3
13 Hankyu	A3
14 Ippodo	A1
15 Kabuki Theater	B4
16 Kitte	A1
17 Maru Biru	A1
18 Marunouchi Brick Square	A2
19 Matsuya	B3
20 Mitsubishi Ichigokan Museum	A2
21 Mitsukoshi	A3
22 Oazu	A1
23 Pass the Baton	A2
24 Paul Smith	A2
25 Printemps	A3
26 Shin Maru Biru	A1
27 Ships	A2
28 Shiseido	A4
29 Tomorrowland	A1
30 United Arrows	A3
31 Wako	A3

GINZA
Lunching Ladies

There is no better spot for people-watching in Ginza than the Dotour coffee shop on the corner of the Ginza Yonchome crossing (the window seats in Mitsukoshi's Ladurée tea shop are also good). Nursing a large latte as you sit on the ground-level terrace or gaze from the upstairs window seats over the busy intersection, you can observe the modern-day version of Ginbura "Ginza wandering" in action. Since the Ginbura heyday of the 1920s and 1930s, the Ginza demographic has changed somewhat: gone are the modern boys and girls (mobo and moga) who shocked with their flagrantly European style; instead, well-heeled, chic ladies of all ages seem the most characteristic of the contemporary wanderers. Watch them in their pristine, elegant get-ups as they glide in and out of the smartly conservative Wako department store or click-clack past the majestic bronze lions of the Mitsukoshi department store opposite, navigating their way through the crowds of tourists. On Sundays, when the main thoroughfare is car-free, these elegant Ginza denizens are swamped by visitors from all walks of life—not least zealous visiting shoppers from China and Thailand.

ABOVE RIGHT Kana often comes to Ginza; here she's just heading off to lunch. She is wearing Japanese brand Aquagirl as well as Zara and Kate Spade. **ABOVE LEFT** "Ginbura" strolling around Ginza is better on Sundays, when the main street is pedestrianized.

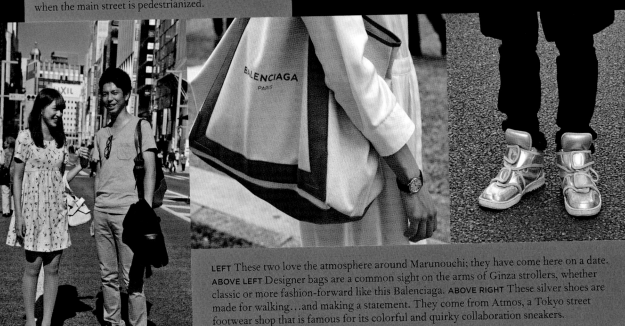

LEFT These two love the atmosphere around Marunouchi; they have come here on a date. **ABOVE LEFT** Designer bags are a common sight on the arms of Ginza strollers, whether classic or more fashion-forward like this Balenciaga. **ABOVE RIGHT** These silver shoes are made for walking…and making a statement. They come from Atmos, a Tokyo street footwear shop that is famous for its colorful and quirky collaboration sneakers.

& Weekend Strollers

GOURMET CUISINE

Ginza has always been a gourmet destination for the Japanese. Among the neighborhood's culinary institutions are the Ginza Lion beer hall, dating from the 1930s and now popular with the younger working crowd; continental-style coffee shops such as Café Paulista, from 1914; and a host of *yoshoku* (Japanese-interpreted Western cuisine) restaurants like the Shiseido Parlour restaurant in the Ginza Shiseido building (1902), where you can also sample their famous cakes and cream sodas. In addition, the top floors of Ginza's numerous department stores offer an enormous selection of Japanese and international restaurants, giving chic lunching ladies a plethora of options to choose from.

LEFT Kato-san is a nurse with a ten-year-long passion for Comme des Garçons clothes, which she is wearing today. She normally ventures to Shibuya or Aoyama rather than the Ginza and Marunouchi area, but she can feel at home here as her beloved Garçons has a shop on Marunouchi's leafy Naka-dori avenue as well as in Ginza's eclectic Dover Street Market.
ABOVE This university student loves the cheap variety offered by fast-fashion venues such as Zara, H&M, and Topshop, but brings the tone of her outfit up a notch with her Chanel handbag, a hand-me-down from her grandmother.

GINZA AND KIMONO

Wander the narrow Ginza backstreets at dusk and you may hear the shuffle of *zori* (the Japanese sandals worn with kimono) on cobblestones and catch a glimpse of kimono-clad ladies emerging from taxis on their way to work in the neighborhood's upscale hostess clubs. Although the high-class Ginza hostess clubs have been hit by the "great recession" that began in the 1990s, their longstanding businessman clients still use the opulent venues to entertain and kick back. Compared with the rest of Tokyo, kimono are a relatively common sight in Ginza—not just worn by "mama-san" hostess-club owners in the twilight, but by upper-class Japanese grannies engaged in their own Ginbura strolling. And at the Kabuki-za theater in east Ginza, you can feast on a wealth of elaborate kimono, both on the stage and throughout the audience.

BELOW LEFT Some Japanese women dress up to visit temples, strolling gardens, and other such Japanese sights. Others, like these two friends, dress up for a day of wandering the streets of Ginza, one of their favorite Tokyo spots. When not in kimono, they love the Mon Sakata label based in the chic neighborhood of Mejiro. **BELOW** A very small proportion of young Japanese women are dedicated kimono wearers, wearing them on a daily basis. Eriko, **(RIGHT)** one of these, is heading out to lunch in Ginza—one of her favorite Tokyo spots, along with Harajuku and the old-Japan-tinged Asakusa. She doesn't favor any particular kimono shop, but her shoes **(BOTTOM)** are from contemporary Japanese apparel brand SOU•SOU; she is also partial to dipping into her grandmother's kimono. **FAR RIGHT** The sumptuous traditional kimono often worn by fans of Kabuki drama can be seen on the streets surrounding the theater.

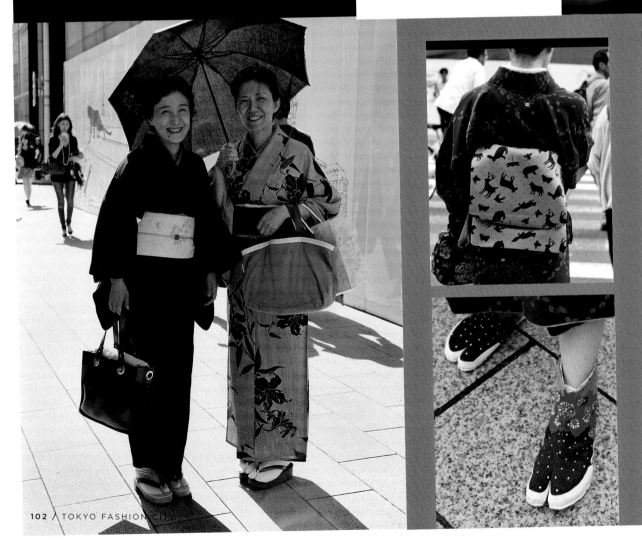

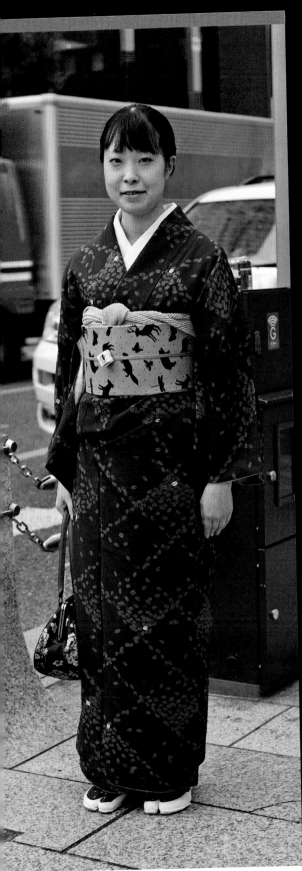
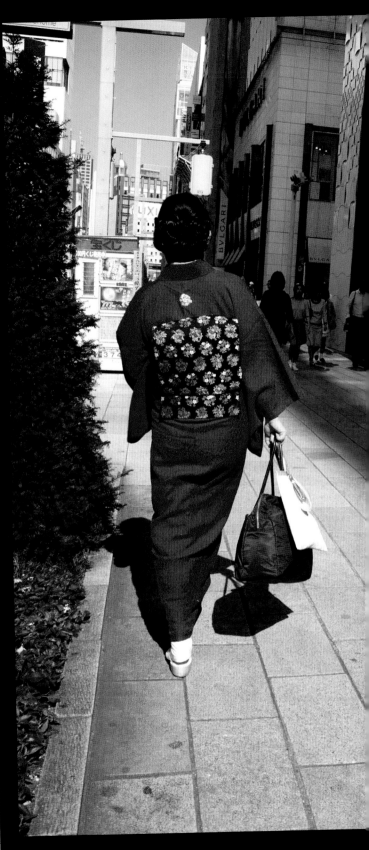

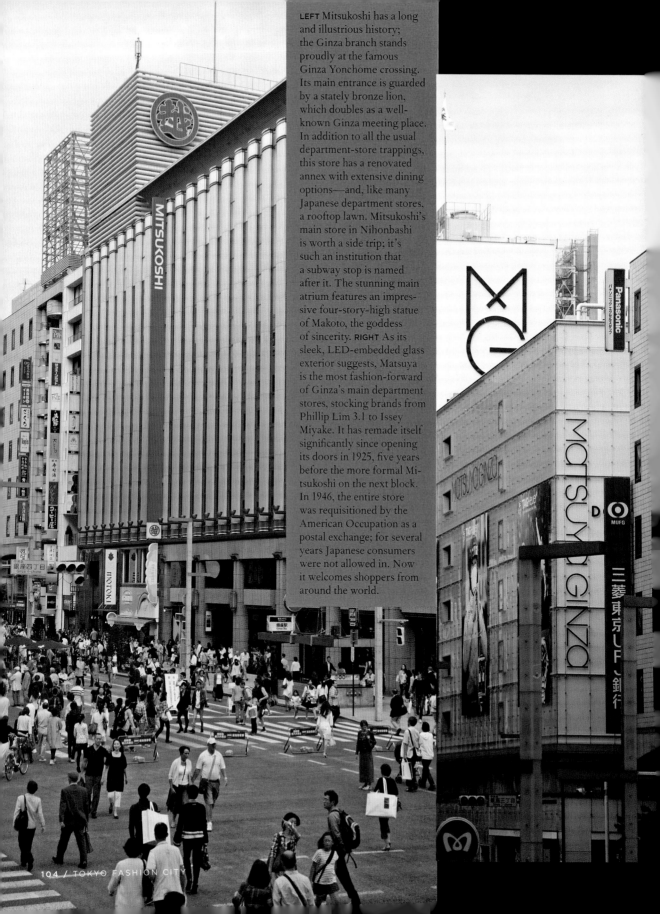

LEFT Mitsukoshi has a long and illustrious history; the Ginza branch stands proudly at the famous Ginza Yonchome crossing. Its main entrance is guarded by a stately bronze lion, which doubles as a well-known Ginza meeting place. In addition to all the usual department-store trappings, this store has a renovated annex with extensive dining options—and, like many Japanese department stores, a rooftop lawn. Mitsukoshi's main store in Nihonbashi is worth a side trip; it's such an institution that a subway stop is named after it. The stunning main atrium features an impressive four-story-high statue of Makoto, the goddess of sincerity. **RIGHT** As its sleek, LED-embedded glass exterior suggests, Matsuya is the most fashion-forward of Ginza's main department stores, stocking brands from Phillip Lim 3.1 to Issey Miyake. It has remade itself significantly since opening its doors in 1925, five years before the more formal Mitsukoshi on the next block. In 1946, the entire store was requisitioned by the American Occupation as a postal exchange; for several years Japanese consumers were not allowed in. Now it welcomes shoppers from around the world.

Historic and Cutting-edge Exclusivity

G inza is famous for being a glitzy, upmarket part of Tokyo, but what really sets the tone for the district and distinguishes it from the likes of Omotesando, Tokyo's equally smart "Champs-Élysées," are the numerous department stores that stand proud on its avenues, imparting the weight of history and a certain gravitas to the area as a whole.

PAST AND PRESENT

The most exclusive department store of the lot, presiding over the Ginza Yonchome crossing, is Wako. Its somewhat foreboding neo-Renaissance facade dates from 1932, and Westminster chimes issue on the hour from its famous clock tower. Everything in here is understated yet luxurious; it's the place for upper classes to come for their gift-giving and high-fashion needs. Opposite Wako is the upscale Mitsukoshi, which has a history dating back to 1673. This Ginza location opened in 1930, following the establishment of its first opulent branch, which is still in operation, in nearby Nihonbashi. A little further from the crossing is Ginza heavyweight Matsuya (1925); toward Yurakucho are the Tokyo outposts of Hankyu and Printemps. Even the Nishi Ginza shopping complex calls itself a department store, although it is more like a regular mall, most notable for containing the Tokyo flagship store for Sanrio, purveyor of all things cute and Hello Kitty.

Despite its grand architecture, sumptuous window displays, and prime location, the entrance to Wako, Ginza's most upmarket department store, is somewhat unassuming, and could easily go unnoticed. This helps Wako keep the riffraff out: catering to Ginza's most exclusive clientele with the most conservative taste, it displays prestigious goods that make ideal gifts for the well-to-do throughout its refined interior.

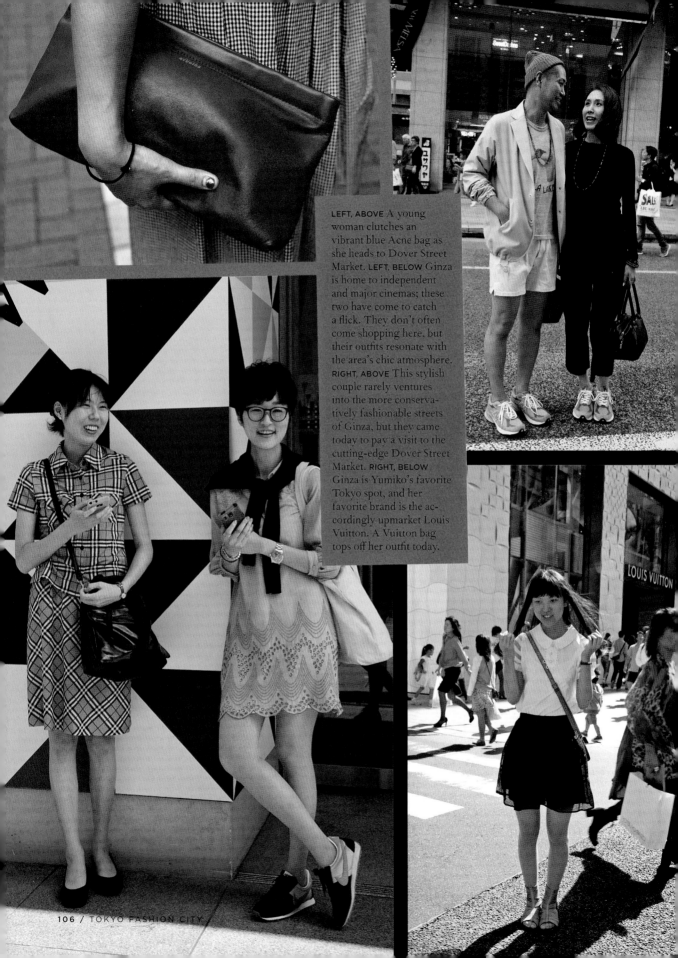

LEFT, ABOVE A young woman clutches an vibrant blue Acne bag as she heads to Dover Street Market. **LEFT, BELOW** Ginza is home to independent and major cinemas; these two have come to catch a flick. They don't often come shopping here, but their outfits resonate with the area's chic atmosphere. **RIGHT, ABOVE** This stylish couple rarely ventures into the more conservatively fashionable streets of Ginza, but they came today to pay a visit to the cutting-edge Dover Street Market. **RIGHT, BELOW** Ginza is Yumiko's favorite Tokyo spot, and her favorite brand is the accordingly upmarket Louis Vuitton. A Vuitton bag tops off her outfit today.

COMPETITION

With all these department stores clustered to-
gether so densely, there is understandably fierce
competition between them. This has led them to
attempt to differentiate themselves from one an-
other—Hankyu focuses on men, Printemps mainly
on women, Wako on exclusivity, while modern
Matsuya boasts in-store boutiques for Japan's
"big three" designers (Issey Miyake, Comme des
Garçons, Yohji Yamamoto) and a carefully curated
collection of contemporary and classic Japanese
design products on the seventh floor. Mitsukoshi
has upped its game for attracting foreign visitors
by launching the swanky Japan Duty Free Ginza
shopping lounge where travelers can peruse duty
free goods at their leisure. This competition has
also led to a spate of major renovations over the
last decade, as well as a closure: Matsuzakaya—
the oldest of the lot, having opened in 1924—
closed its doors in 2013. At the time of writing, a
huge new project is underway on its razed block,
not recreating the historic department store
but drawing on its DNA to create a new building
containing office space, retail, dining, and culture;
among other things, it will offer a Noh theater in
the basement.

DEPARTMENT STORE CULTURE

The provision of high culture has been a key role
of Japanese department stores over the last
century. The majority of classic department stores
in Japan have a gallery on their upper floors with
paid exhibitions ranging from contemporary art
to ceramics. This cultural instruction went hand
in hand with the introduction of elements of
Western fashions, cuisines, and lifestyles to early
twentieth-century Japan; indeed, Matsuzakaya
was the first store to allow the Western practice
of keeping one's shoes on when entering. Now
the Japanese are so au fait with the West that it
is, conversely, often the elements of traditional
Japanese culture that department stores must
educate their customers about: kimono, tea
ceremony, seasonal decorations, and so on. Con-
sidering that many department stores, including
Mitsukoshi, started as textile and kimono mer-
chants, they have, in a sense, come full circle.

DOVER STREET MARKET

If there were any concerns
regarding Ginza's contin-
ued relevance as a leading
fashion center, they were
swiftly assuaged when the
first international branch of
Comme des Garçons' Dover
Street Market (DSM) London
select shop opened there in
2012. The shop occupies a
wing of what was once the
Komatsuya department
store, breathing fresh life
into a long-defunct institu-
tion. The location may seem
a strange choice for such a
cutting-edge brand beloved
by the most forward of
fashionistas, but Comme
des Garçons designer Rei
Kawakubo opened the
first DSM store in 2004
on London's Dover Street,
situated in Mayfair, a simi-
larly prestigious, conserva-
tive patch of London. This
is just one of the many
juxtapositions that makes
DSM such an intriguing and
successful retail proposi-
tion. The Rose Bakery on
the seventh floor, with its
minimal decor, free Wi-Fi, and delicious healthy food, means that
the venue also has something to offer to Ginza's ladies who lunch.

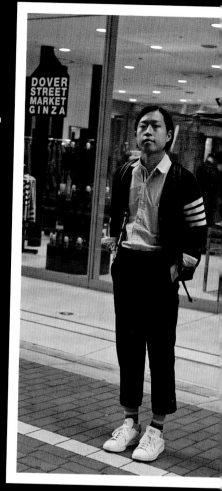

The store's interior, which is more than double the size of the
London branch, is part art gallery, part shop. Specially commis-
sioned art articuates the space on each floor, and a central white
sculptural piece by celebrated Japanese contemporary artist Ko-
hei Nawa connects all the floors around the escalator wells. DSM
Ginza is the type of concept store where the clothing racks are art-
works in themselves, as in British artist Graham Hudson's scaffold-
ing-like frames for the Junya Watanabe Man collection. Then there
is the mix of brands, carefully selected to generate unexpected
combinations: street-wear labels Supreme and Nike jostle with
the high fashion luxury of Louis Vuitton and Balenciaga. Of course,
the entire range of Comme des Garçons labels is also available
under its roof. In fact, the store itself is joined to fast-fashion giant
Uniqlo's largest shop by a couple of walkways—another surprising
juxtaposition of fast fashion and fashionista.

MARUNOUCHI

Dapper Gentlemen & Elegant Office Ladies

Tokyo, as the sight of the morning commuter trains will confirm, is rife with the corporate warriors commonly known as "salarymen." Most wear nondescript suits and comfortable shoes, but around Marunouchi a more stylish class of salaryman can be seen wandering out from the office on lunch breaks or on their way to after-work socializing. Despite the prevalence of finance and industry in the area—as opposed to more trendy and adventurous fields like advertising or media—many workers in the area have both the eye and the disposable income for natty business attire. This is true of the legions of female employees in Marunouchi as well.

RICH RETAIL OFFERINGS

Since the district has grown into a cultural and shopping destination in its own right, there are plenty of tempting opportunities for workers to browse the finest in business wear and the latest in fashion over their lunch break without even having to walk to nearby Ginza. The elegant Naka-dori boasts numerous boutiques, ranging from domestic fashionista favorites Comme des Garçons to modish "select shops" (including United Arrows, Ships, Tomorrowland, Dressterior, and a few permutations of Beams) to stylish international outfitters like Brooks Brothers and Paul Smith. There are unique offerings, too, like the made-in-Japan classic Choya Shirt, in operation from 1886; and Facial Index New York, a Japanese glasses manufacturer that draws on traditional craftsmanship to create distinctive eyewear.

Keeping company with these are traditional outposts like the Ippodo tearoom and the many design shops in the Kitte shopping complex, together with a wealth of smart eateries and the Mitsubishi Ichigokan Museum in Marunouchi Brick Square. In all, there's plenty to draw visitors to this historical business district, even on weekends.

RIGHT, ABOVE This woman's shoes are from Japanese brand Ginza Diana, whose elegant pumps and flats are favorites of the "office ladies" working in business. RIGHT Thankfully, many Japanese companies have moved on from the days when most "office ladies" wore uniforms, allowing them to choose a suit or wear smart, stylish separates.

PASS THE BATON

In a country where rampant consumerism, adherence to fads, and rapid turnover and uptake of new technologies coexist with small urban living spaces, recycling in its various forms has long been big business. From the *shichiya* pawnbrokers that go back centuries to the modern ubiquity of local bric-a-brac *risaikuru* recycle shops trading in brand bags, vintage fashion, and luxury watches, buying used goods is easy and economical for many cash-strapped Japanese.

Pass the Baton, calling itself a "New Recycle" business, has carved a distinct niche in this market by turning the pre-loved origins of an item into a selling point. Every item in its eclectic stock of jewelry, interior items, clothes, and so on comes with its own biography: a little photo and paragraph on the price tag that identifies the previous owner and some personal trivia about the item they are passing on. The regular donors—who receive 50 percent of the sales price—include famous creatives, notably Nigo of A Bathing Ape fame, whose regular consignments draw flocks of fans to the Omotesando branch of the store.

The original shop stands in Marunouchi's pleasant 2009 historical redevelopment, Marunouchi Brick Square, whose whimsical interior, featuring a haphazard layout of cabinets and dressers displaying everything from bonsai to neckties, was designed by the unfailingly trendy Wonderwall agency. Wonderwall also oversaw the store decor at the subsequent, larger Omotesando Hills shop, complete with gallery space and an equally quirky interior that is part curio museum, part bright contemporary boutique. In addition to the pre-loved treasures passed on by interesting individuals, items for sale include "remakes" of languishing B-grade goods which the company sources and buys in bulk, like the redecorated slightly imperfect Dean & DeLuca tote bags; and collaborations with designers and brands, such as Pass the Baton Rhodia notepads.

Pass the Baton has also introduced a charitable element thus far largely lacking in Japan's handling of used goods: sellers can choose to have their chunk of the proceeds donated to one of several hand-picked charities, to which the company also passes on some of its profits.

ABOVE A salaryman's bag is one of his more visible accessories. Most are some variation on this kind of smart, simple, and functional model, although all-leather bags are increasingly rare.

ABOVE A Cartier wristwatch peeks out from the sleeves of this Marunouchi salaryman's indigo blue suit. LEFT This well-groomed, well-dressed gent is an employee of renowned Italian tie makers E. Marinella; his shooting-star tie is from their shop. He is pictured standing in front of the Pass the Baton shop, around the corner from E. Marinella in Marunouchi Brick Square.

GINZA PET FASHION
Tokyo's Pampered Pets

No book on Tokyo style would be complete without a word about pet fashion. The capital's canines—especially the diminutive, less boisterous doll-like breeds such as Chihuahuas, dachshunds, and Pomeranians—seem to be dressed up by their adoring owners so frequently that going unclothed must be somewhat of a novelty to many. In a weekend stroll around the city's parks and boulevards, you might cross paths with a pair of dachshunds in matching outfits of jeans, T-shirts, sunglasses, and hats; or you could encounter a Chihuahua in a frilly skirt and diamante collar perched nervously on its owner's lap at a terrace cafe.

Pets outnumber children in Japan, leading some to suggest that the devotion to dogs in particular indicates that they may be substitutes for actual offspring. While Japan's birth rate may be perilously low, its market for pets and accessories is buoyant; indeed, it boasts many of the same categories and goods you would expect for infants.

CANINE SERVICES

There are canine classes for training and behavior; all manner of toys, many of them handmade; clothes ranging from designer to street to cute; grooming and massage services; spa treatments; dog-friendly cafes with organic dog menus; dog "daycare"; dog health food, as well as elaborate treats; even dog strollers that compete in build, function, and price with the best baby strollers. Japan's own Air Buggy premium stroller company has an Air Buggy Dog sideline. The convertible dome carry case/strollers cost around $600—more than some of their products geared to humans.

PET SHOPPING IN GINZA

Dog boutiques and other facilities exist throughout Tokyo, and indeed the nation, especially in more upmarket and leafy residential areas. Green Dog, one of the larger comprehensive shops for all things canine, offers top-of-the-line accessories, as well as grooming, classes, stroller rental, and other services. It has two locations: one in the Tokyo Midtown mini-city in central Roppongi, and one in chic Daikanyama. There is even a cool, not cutesy, grooming parlor-cum-shop called DogMan attached to the boutique Claska hotel, a perennial favorite of Tokyo's creative-class visitors that is located in expat-heavy, wealthy Meguro. While the topic of "pet fashion" could have fit in any number of sections in this book, for the extremes in pooch pampering—the crème de la crème— canine accessories are not limited to specialist dog shops, but can bought at international luxury boutiques like Hermes ($1000+ leather dog tote bag, anyone?). Ginza and Marunouchi offer many such boutiques; a selection of doggy high fashion is also available in shops such as The Barkery; Inu No Seikatsu (The Dog's Life); and As Know As De Wan ("*wan wan*" is Japanese for "woof woof"), the canine line of popular Japanese fashion brand As Know As, where owners can buy matching outfits for themselves and their pooches. But splurging on pets is not just the preserve of the wealthy; suburban and regional shopping malls throughout the country have their fair share of doggie "fast fashion" for perusal.

RIGHT Small breeds are sought after in densely populated Tokyo. Dog boutiques offer a wealth of clothes and accessories for petite pooches.

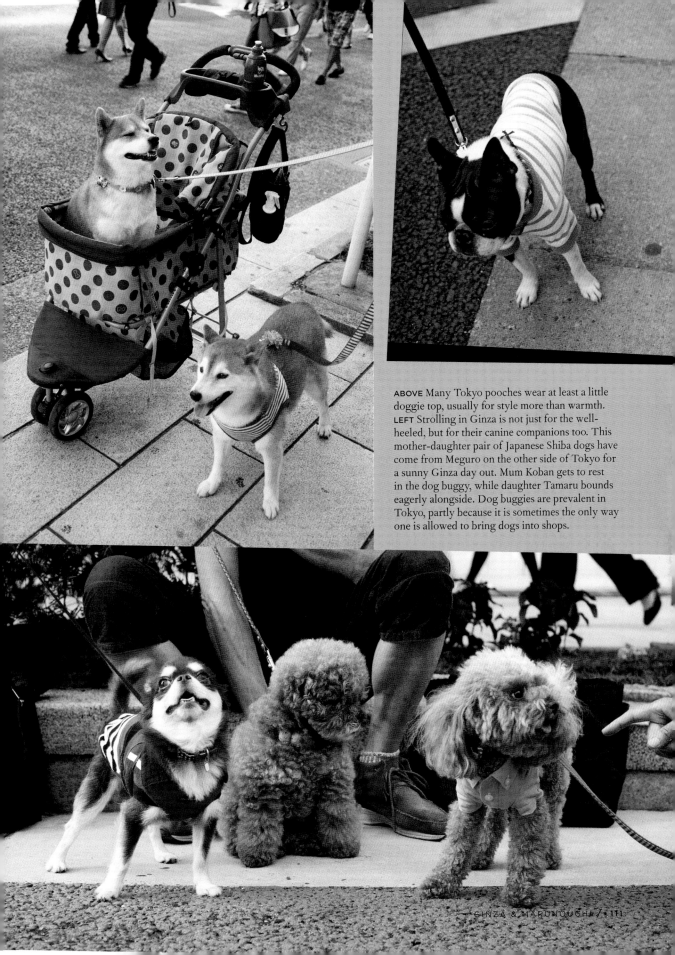

ABOVE Many Tokyo pooches wear at least a little doggie top, usually for style more than warmth.
LEFT Strolling in Ginza is not just for the well-heeled, but for their canine companions too. This mother-daughter pair of Japanese Shiba dogs have come from Meguro on the other side of Tokyo for a sunny Ginza day out. Mum Koban gets to rest in the dog buggy, while daughter Tamaru bounds eagerly alongside. Dog buggies are prevalent in Tokyo, partly because it is sometimes the only way one is allowed to bring dogs into shops.

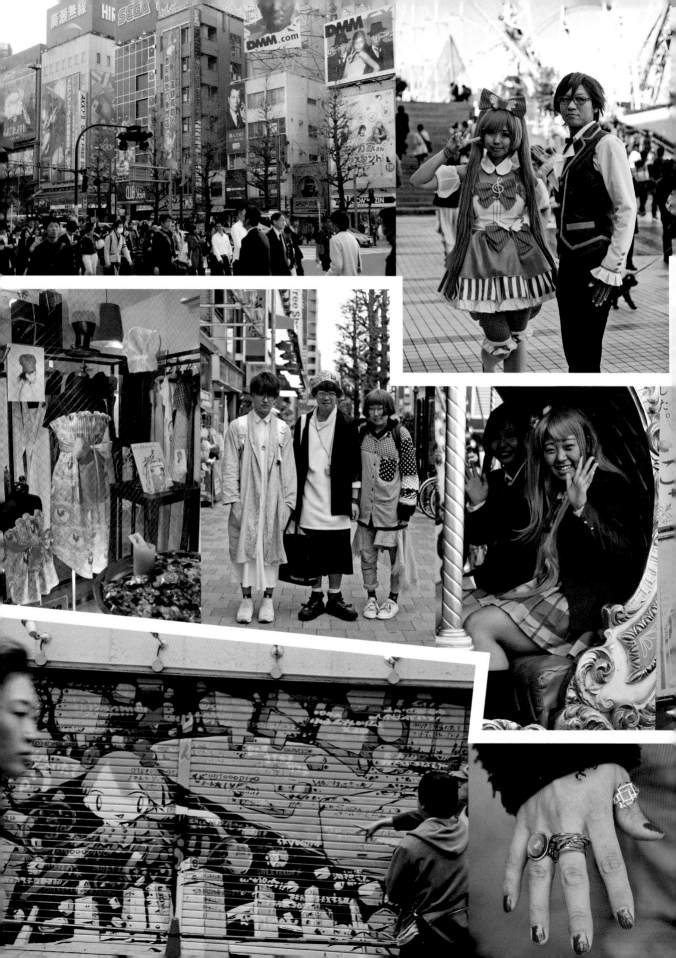

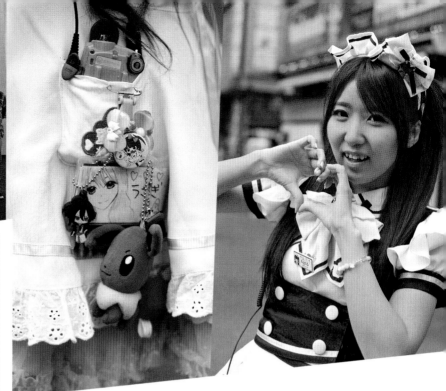

Akihabara & Okachimachi

TOKYO'S OTAKU CENTRAL

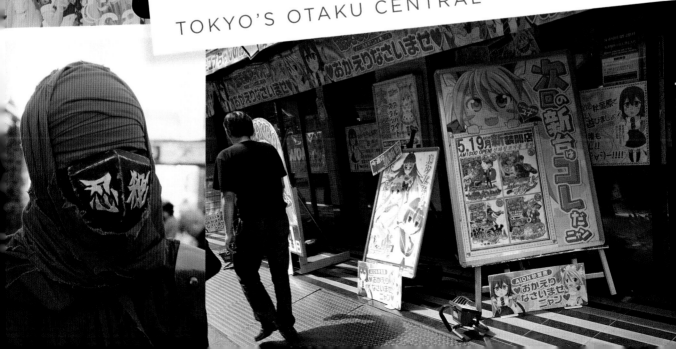

Geeks and Artists in East Central Tokyo

OTAKU CULTURE RUBS SHOULDERS WITH CRAFT AND DESIGN

These may not be most fashionable areas of Tokyo; in some ways, in fact, the opposite is true. Nevertheless, the districts in the northeast quadrant of central Tokyo have undergone a process of art- and design-heavy gentrification in the last decade. An understated, bohemian clothing sensibility has accordingly crept into the shops and clothing of people that may be encountered on certain streets in these neighborhoods, while a refreshingly resolute disinterest in fashion remains within the nerdy *otaku* strongholds.

AKIHABARA

Akihabara is Tokyo's otaku (geeky fan or collector) central. Obsessive-collector otaku are described in the section on Nakano Broadway in chapter 4. Akihabara's otaku, by comparison, started from a more specific foundation of video games. The area was originally famous for its electronics shops, particularly with the rise of the personal computer; this is still very much in evidence today. Ramshackle shops burst at the seams with cables, lighting, and other gizmos lining the backstreets of Akihabara's *denki gai* (electronic town). With the rise of the PC came PC games, and soon game designers made Akihabara their home, fuelling the boom in *bishoujo* ("pretty girl") simulated-dating games that became the foundation of the Akihabara otaku empire that exists today.

Akihabara is a bastion of anti-fashion. There are the plain, functional outfits of otaku that made their appearance in chapter 4; the elaborate costumes of the cosplayers or "maids" waiting on their "masters" in the area's many maid cafés; or the subversive slogans and in-jokes of T-shirts that simultaneously signal the wearer's otaku affiliation and position them at odds with mainstream society (check out the selection at Akihabara's Marslab).

OKACHIMACHI

Okachimachi, just north of Akihabara and one stop away on the Yamanote Line train loop, is historically a production and wholesale area for the fashion industry, with its leather foundries and jewelry wholesalers. Now it is home to an intriguing shopping site dedicated to Japanese craft and design, 2k540 Aki-Oka Artisan. Okachimachi also marks the southern end of the Ameyoko market, which runs alongside the Yamanote Line tracks to the next station north, the busy terminal of Ueno. While the name is short for Ameya Yokocho, "sweet-shop alley," the "Ame" can also refer to America: this was the site of a thriving black market during the postwar Occupation era, with some of Tokyo's first jeans outlets. It is still famous for denim; shops like Hinoya and Americaya 610 stock Lee and Levi's jeans alongside high-end domestic brands such as Samurai Jeans Co., Evisu, John Bull, Momotaro, and Sugarcane. Along with some leather accessory shops, these are the only fashion outposts in what is otherwise a fascinating, bustling open-air food market.

GEEK INSPIRATION FOR EXPERIMENTAL FASHION

The swath of Tokyo that extends east of Akihabara—including Kuramae, Higashi-Nihonbashi, and Bakurocho, discussed in the next chapter—has gone from drab business districts to art and design enclaves as young creators have moved in. There has been a knock-on effect in nearby Akihabara, whose creativity hitherto had been very much based in all things electronic and otaku. In the same way the otaku culture has long inspired Japanese artists, not least Takashi Murakami, it has now spawned its own avant-garde fashion scene. At the heart of this is the shop/collective Gokai, a riotous select-shop-cum-art-installation. The most famous name to be associated with the movement is Mikio Sakabe, who shows at Tokyo Fashion Week. The physical space (not exactly a regular shop) with its off-the-wall fashions is buried deep in Akihabara, off the map, but if you manage to find it and get in, an otaku-influenced and generally out-of-this-world sartorial wonderland awaits.

RIGHT AND MIDDLE RIGHT Like geeks all over the world, otaku, otherwise somewhat disinterested in fashion, often include ironic T-shirts in their attire. These are often printed with in-jokes and references that are only intelligible to those immersed in the immense and detailed universe of anime and manga. This T-shirt, reading *toubun* ("sugar content"), is a reference to the Gintama manga and anime series.

LEFT These two friends are cosplaying from the pages of popular manga and anime Gintama which is set in a sci-fi version of the Edo period. Their characters are a captain in the Shinsengumi police force, Okita Shogo (right) and the main female protagonist, Kagura. Invited by her friend, this is the first time for the girl in the Kagura role has tried cosplay.

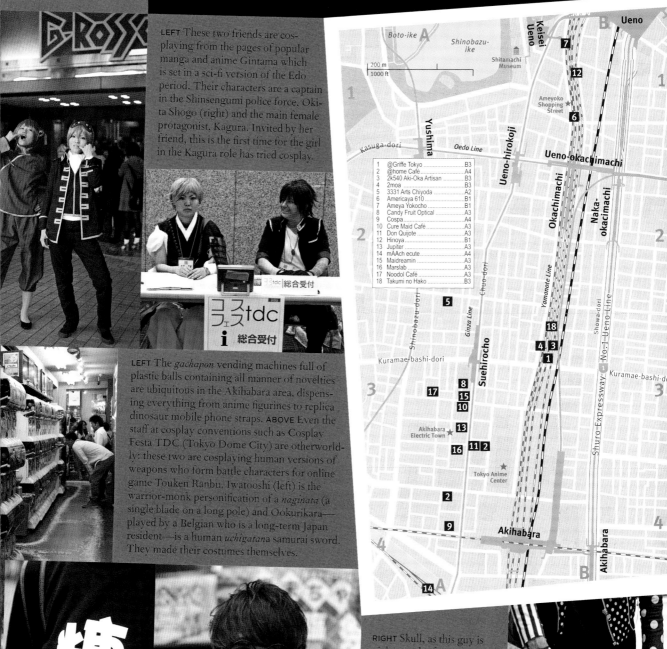

1	@Griffe Tokyo	B3
2	@home Café	A4
3	2k540 Aki-Oka Artisan	B3
4	2moa	B3
5	3331 Arts Chiyoda	A2
6	Americaya 610	B1
7	Ameya Yokocho	B1
8	Candy Fruit Optical	A3
9	Cospa	A4
10	Cure Maid Café	A3
11	Don Quijote	A3
12	Hinoya	B1
13	Jupiter	A3
14	mAAch ecute	A4
15	Maidreamin	A3
16	Marslab	A3
17	Noodol Café	A3
18	Takumi no Hako	B3

LEFT The *gachapon* vending machines full of plastic balls containing all manner of novelties are ubiquitous in the Akihabara area, dispensing everything from anime figurines to replica dinosaur mobile phone straps. **ABOVE** Even the staff at cosplay conventions such as Cosplay Festa TDC (Tokyo Dome City) are otherworldly: these two are cosplaying human versions of weapons who form battle characters for online game Touken Ranbu. Iwatooshi (left) is the warrior-monk personification of a *naginata* (a single blade on a long pole) and Ookurikara—played by a Belgian who is a long-term Japan resident—is a human *uchigatana* samurai sword. They made their costumes themselves.

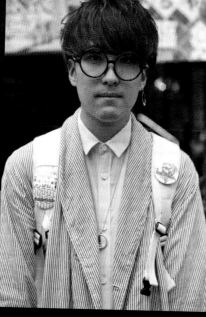

RIGHT Akihabara is a paradise for gamers of all sorts, even retro ones: this fashion student has come with his friends today to hunt for classic Nintendo 64 cartridges.

RIGHT Skull, as this guy is nicknamed, often comes to Akihabara to shop for items related not only to anime, but also to his beloved visual-*kei* music culture. Many visual-*kei* fans are also avid followers of anime and manga, and vice-versa. His outfit is like a roll-call of punk/visual-kei Japanese labels: gloves from Sex Pot Revenge Addict, jacket from Hell Cat Punks—both wonderfully named Japanese punk brands—shirt from luxury street/visual-kei brand Roen; and trousers from *gyaru* favorite Glad News.

MAID CAFÉS
At Your Service!

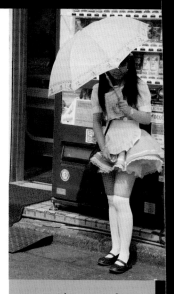

At any one time there is a small army of maids working in some 200 establishments in Tokyo. While they might resemble the domestic French maid in their choice of outfit, they are not housemaids, but glorified waitresses working in the dreamy "maid cafés" that have sprung up since the early 2000s in Tokyo and other cities (even in NYC in 2013). The first was Cure Maid Café, created by cosplay retailer Cospa in Akihabara, Tokyo's otaku central, in 2001. Otaku were the main clients then, and remain so today, although the cafés have become hot tourist spots, too. The typical experience goes something like this: Enter the warm, bright atmosphere of the café to the greeting, "*Okaeri nasaimase, goshujin-sama*" (Welcome home, Master) uttered by one of the maids. Order traditional café fare of *omuraisu* (omelette over tomato fried rice) and a cup of coffee, then request a hand-drawn cute character on it from your serving maid (maybe for an additional charge), which she will squeeze out in ketchup. Allow her to kneel down and stir the sugar and cream into your coffee. Finish off, perhaps, with a quick game of otaku vs. maid Pop-up Pirate, or request a signed and decorated Polaroid of your maid of the day (again, both with additional charges).

Now there are so many maid cafés that the optional extras have become more niche and extreme—how about a talk session, instant ramen noodles, a foot massage, a champagne call, a dance show, or a good old telling-off at establishments such as Maid-remin, @home café, Noodol Café, and Pash Café Nagomi (now closed)? These cafés offer a fantasy space directly extrapolated from the worlds of manga and dating-simulator PC games in which many otaku feel so at home. But unlike the perhaps solitary home life of many of the customers and regulars, this home away from home is all about communication, albeit commoditized.

MAID UNIFORMS

While often lumped into either the sub-cultural fashion or cosplay categories of Japanese attire, for the most part a maid uniform is just that—a uniform. It is not something that the girls wear on their days off around town, and it only becomes cosplay when one is mimicking the exact look of a specific maid from a video game or manga. Rather, a maid café may have a particular color and style of the essential "maid" elements: frilly puffed-sleeve blouse, white knee-high socks, Mary Jane shoes, pinafore, frilly apron, ribbon around the neck, and some kind of headdress. The latter is usually a lacy bonnet-esque head-piece, but is often replaced or enhanced by various cute plastic clips and/or animal (often cat) ears. While French-maid uniforms have the same risqué connotation in Japan as in other countries, the maid-café uniform is different. The aim is to create an unbearably cute look, the tantalizing flash of flesh tempered by the childish and demure behavior, high-pitched conversation, and effusive giggling of the maid. A café might go for a specifically Victorian maid look, like the original Cure Maid Café.

The maid is now such an established image in Japan that outfits can be bought anywhere from cosplay shops to cheap national general-goods chain Don Quijote. Need glasses to go with your uniform, or even with your suit? Visit Candy Fruit Optical in Akihabara, where maids wearing green-and-white costumes that give them a whiff of the medical will help you choose a pair.

ABOVE The streets of Akihabara are dotted with maids advertising their particular maid café or even a maid-guided tour of the town. **BELOW** Some of girl geek Harada-san's daily wear, including a short skirt similar to that of a maid's costume that she wears occasionally. She explains that *fujoshi* spend lots of money on their fan hobbies, so tend to skimp on their clothes. She buys hers from unobtrusive girly brands such as Samansa Mos2 and Earth Music & Ecology, as well as the cheap and cheerful Shimamura.

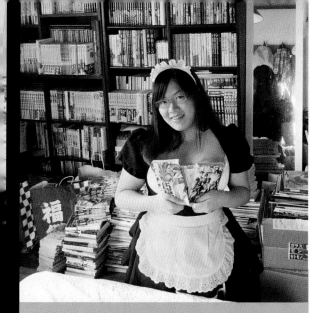

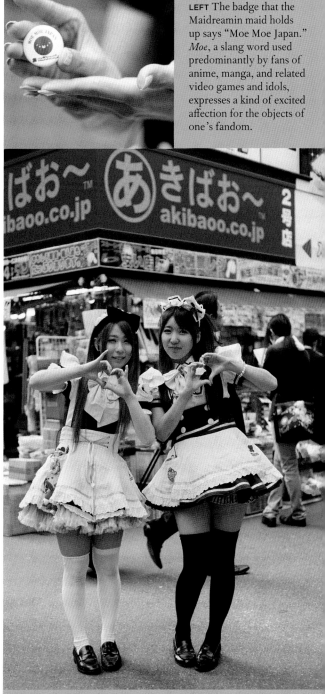

LEFT The badge that the Maidreamin maid holds up says "Moe Moe Japan." *Moe*, a slang word used predominantly by fans of anime, manga, and related video games and idols, expresses a kind of excited affection for the objects of one's fandom.

ABOVE Harada-san, a graphic designer, is also one of Japan's many fujoshi "rotten girls" (see chapter 3). This is a term that these female otaku, particularly those who enjoy the homosexual romances in the "boys' love" genre of *doujinshi* fan fiction, ironically and self-deprecatingly use for themselves. Harada-san loves visiting Ikebukuro's Otome Road, but also feels at home in Akihabara as an avid manga and anime fan. She is dressed in a maid costume that she bought online, but she doesn't put it on often, and doesn't partake in cosplay.

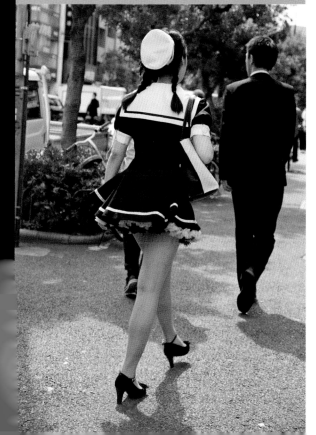

ABOVE These two maids from maid-café chain Maidreamin throw their famous heart sign as they pose. They chose to work there because "the uniforms are cute" and they "wanted to do work that surprises people." **LEFT** There's a fine line between maid uniforms for working in maid cafés, maid costumes worn for cosplaying maid characters, and maid outfits worn as a kind of fashion. And while maid and Lolita fashions look similar, there are significant differences between them—notably the provocativeness of the outfit.

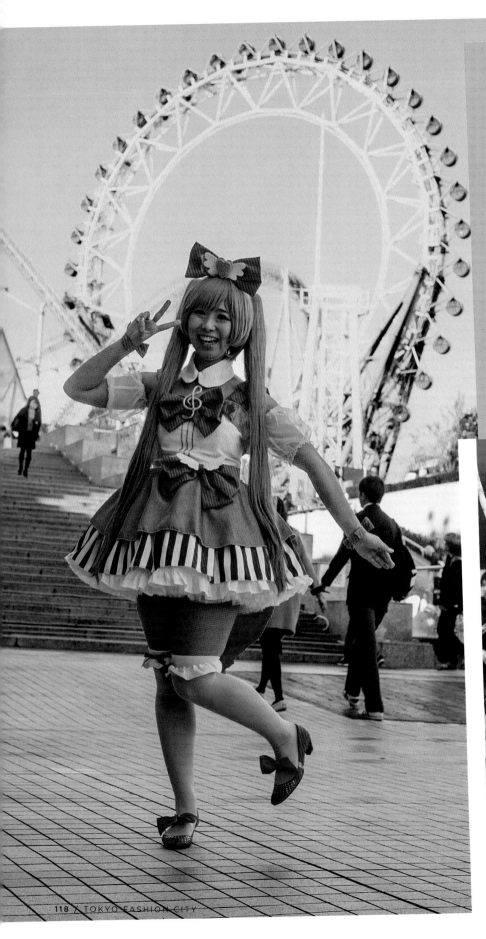

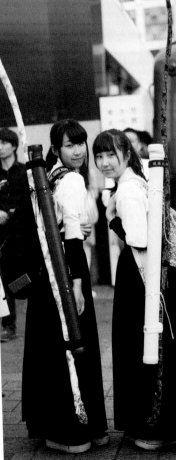

LEFT Manaka Lala is an eleven-year-old "lovely" idol. Her favorite fashion brand is Twinkle Ribbon: the pink bow with a yellow heart center that always takes pride of place atop her purple locks is from there. This is, of course, all in the realm of fantasy—in this case the world of Prism Paradise, or PriPara, an arcade game that spawned manga and anime versions. The woman cosplaying Manaka is a self-taught seamstress who made the costume herself. **BELOW** Traditional Japanese uniforms and garments are big influences on dress depicted in manga and anime, which are often set in various real or fantastical eras of Japanese history. These girls are on their way to a Japanese archery contest, although they could easily be part of a cosplay event (perhaps with the help of some wide-eye contact lenses and a colored wig).

COSPLAY
Being "In Character"

Otaku may not be interested in fashion per se, but at times they are among the most strikingly attired of all of Japan's weird and wonderful tribes. This is when they are cosplaying—dressing up in the costume of a specific fictional character while playing at actually being that character, in a situation that is clearly separate from their everyday lives. While this is by no means a solely Japanese phenomenon (Trekkies were around long before mass Japanese cosplaying) the word "cosplay" (*kosupure*), a Japanese melding of "costume" and "play," has gained global currency in recent years with the rise of "Cool Japan." The annual World Cosplay Summit, which is based in Nagoya and includes a parade and a cosplay championship, attracts hopefuls from more than twenty countries around the world.

BECOME THE CHARACTER

At the heart of cosplaying is the intention to become a real-life version of one's favorite character from a manga, PC game, or anime. The key is to be specific and to embody that character—not just through appearance, but through mannerisms, speech style, and even personality. When in costume, the successful cosplayer is always "in character." Most cosplayers, both male and female, are otaku who expend much effort and dedication to create a living, breathing homage to their chosen character or characters. But cosplay is also popular with another subculture: fans of *bijuaru-kei* ("visual-style") music, a domestic rock genre known for the spectacular fashions of the musicians. Here things get a bit "meta," with fans cosplaying the characters and looks assumed by their favorite band members, which in turn are themselves some kind of alter-ego cosplay creations of those band members.

The donning of a cosplay costume, however, does not mark as complete a transformation as it would for a someone like a stage actor: rather, it is a balancing act between expressing oneself and embodying the object of the cosplay. Much of cosplay reflects back on the wearer: the degree to which they have invested in the performance—

ABOVE *Love Live!* is one of the most popular game/manga/anime/music franchises in Japan of recent years. At this Cosplay Festa event, nine real-life high-school friends—cosplaying the nine band members of high-school idol group μ's (pronounced "muse") from *Love Live!*—enjoy a ride in character on the merry-go-round at Tokyo Dome City. BELOW There aren't many ninja cosplayers at events like this, but these two fans of the *Ninja Slayer* novel, manga, and anime series were pleased to find their costumes attracting attention from foreign visitors. Most of their garb is handmade, but some of the armor was bought from specialist cosplay shops.

Jolyne **(RIGHT)** and Josuke **(LEFT)** are both members of the Joestar family, which is at the centre of Japan's enduring serialized manga franchise *JoJo's Bizarre Adventure*. High-school student Josuke's look is characterized by his impressive pompadour, known in Japan as a "Regent." The cross-dressing fan cosplaying Josuke fashioned her impressive overhanging quiff from a wig. Cosplayers' dedication to their craft can be impressive: not only did these two spend many an hour fabricating their costumes, but Jolyne is braving the cool November weather in her skimpy, skintight getup.

whether it be spending hundreds of dollars on a top-notch outfit or dozens of hours running it up on a sewing machine—earns them cred amongst their cosplaying peers. The whole act itself is about publicly displaying personal preferences and tastes through the choice of character; it is a nuanced expression of self through the costume. This is important, as cosplaying is a fundamentally social activity: it requires an audience, and is a way to create social ties and friendships among people who might normally shy away from striking up conversations with strangers.

WHERE TO SEE AND BUY

The golden era of cosplay was perhaps in the mid-2000s in Akihabara. Back then, Showa Road, the main drag, was closed off on Sundays, providing a space where cosplayers could gather, hang out, and pose for each other and swarming hobbyist photographers. The popularity of book and movie hit *Densha Otoko* (see chapter 4) pushed the burgeoning scene to such heights that locals and authorities perceived it as a threat to public order. Following the arrest of a cosplayer under the street-performance laws, weekend cosplaying was shut down in 2008. Cosplayers have since restricted their activity to the conventions, small gatherings, and photo studios that had always been venues for their performances. The most famous of these conventions is Tokyo's biannual Comic Market (see sidebar). Sadly for tourists, the visual-kei cosplayers have also moved on from their popular weekend displays on the bridge at Harajuku station.

Now cosplaying is a big business, and costumes can be sourced online, even from abroad. A stalwart of the Akihabara cosplay scene is Cospa, with its various floors of otaku gear and new cosplay outfits that rarely retail for below $100—often for much more. For those who are pressed for cash, Jupiter trades in secondhand outfits. And there's always the hardcore fan's option: make your own.

Along with Tokyo Big Sight, Tokyo Dome City in Korakuen has become a venue for regular Cosplay Festa events. The combination of cosplayers and fairground rides makes for a fun and somewhat surreal experience.

COSPLAY CONVENTIONS

Twice a year, several hundreds of thousands of people descend upon Japan's largest convention center for one of its biggest gatherings: the three days of manga-fueled fervor known as Comic Market, or Comiket. Since its humble beginnings in 1975, the heart of the event has been the manga form known as doujinshi—comics produced by amateur fans. Devotees of this fan fiction flock to the extravaganza from all corners of Japan and further afield, seeking both comics to buy and face-to-face interactions with authors and artists at some of the event's 35,000 stalls.

While the sale of comics is the fair's raison d'être, the accompanying cosplaying activity has drawn equal numbers of manga, anime, and gaming otaku. On the ramparts of the suitably space-age structure of Tokyo Big Sight, on the futuristic reclaimed land of Tokyo's Odaiba, thousands of cosplayers strut their stuff, pose for photographs, and socialize with peers old and new. Reportedly, two-thirds of them are women, presenting a possible opportunity for the often male-heavy otaku world to do some real-life romantic chasing, away from their PC screens. If your cosplay characters fall in love in a manga, who's to say the same thing can't happen to you in real life?

When cosplaying a character, you often have a selection of characteristic looks to choose from, particularly when those characters are fictional performers themselves with multiple costume changes. Yazawa Nico and Minami Kotori, from the blockbusting *Love Live!* multimedia franchise, are not only members of the high-school idol group μ's (pronounced "muse"), but they are also its costume designers. The two friends pictured here met through their shared cosplay interests on Twitter; they bought these particular Chinese-influenced costumes for their Nico and Kotori characters online.

Japanese Design Under the Railway Tracks

One of Tokyo's most unusual shopping experiences is found in a markedly unfashionable stretch of land between the Japan Rail (JR) Yamanote Line stations of Okachimachi and Akihabara. Nestled underneath the elevated railway tracks, on what was previously a parking lot in an otherwise gloomy residential patch, is a striking black-and-white colonnaded runway of one-off shop studios and cafés collectively known as 2k540 Aki-Oka Artisan. The arcade, which opened at the end of 2010, was developed by the JR group to enliven the area, create a new pedestrian flow between the stations, and provide a space for communication. Many shops, including ones selling shoes and hats, have built-in workshop spaces that encourage interaction between customer and maker. Along with an integral event space, there are cafés, including an outpost of serious bean shop Yanaka Coffee, and Café Asan, which offers hammocks, WiFi, and iPads. These all helped the arcade to win a 2011 Good Design Award.

WHERE ARTISAN MEETS GEEK

The 2k450 in the name refers to the number of meters (2450) between the arcade and the spot in Nihonbashi in central Tokyo that functions as Japan's ground zero for distances. It also imparts a suitably geeky ring befitting a place so close to Akihabara, Tokyo's otaku central. The name "2k540 Aki-Oka Artisan," the range of shops, and the location all have a pleasing synergy, combining the artisanal spirit of the long-standing jewelry wholesalers and leather foundries of Okachimachi and the nerdiness of shops selling otaku goods. Check out UOAMU for the plastic alien figurines that have become a sort of unofficial Aki-Oka mascot, or

Jyueri Koushou (Jewelry Artisan) for jewelry produced on site. The cluster of gachapon vending machines at the northern entrance encapsulates this hybrid spirit, representing the otaku's love of collecting, but dispensing trendy design items like futuristic fluorescent assembly-ready plastic animals and packs of unusual buttons.

SOMETHING FOR EVERYONE

2K540 Aki-Oka Artisan is not only a great place to find unique knickknacks for yourself; it lends itself to gift shopping, too. You could pick up all kinds of unique items: earrings made from empty cans at 2moa; a lettuce-like umbrella from Tokyo Noble; or a one-off wallet made from old magazines at @Griffe Tokyo. Or how about a *tsuge kushi* handmade boxwood comb made by a young artisan at Takumi no Hako? The customers are an equally eclectic bunch, with Japanese grannies jostling alongside design-conscious young professionals, which—together with the artisans busy crafting their products in plain view—makes for intriguing people-watching if you're looking to take a coffee break and pick up some souvenirs while exploring the area.

Not far from 2k540 Aki-Oka Artisan, just southwest of Akihabara station, is another railway redevelopment project, mAAch ecute. The defunct Manseibashi station was renovated in 2013 to create a similarly atmospheric arcade. While there are temporary craft and design shops and events, the main focus of mAAch ecute is eating and drinking.

RIGHT Artisanal craft and tradition meet contemporary design in this collection of independent ateliers and boutiques under the train tracks. **MIDDLE RIGHT** Cominghome is one of the specialist boutiques in the arcade, selling chic yet functional aprons, some with large ribbons that tie in bows at the front.

RIGHT Shunya is visiting 2k540 Aki-Oka for the second time, particularly for its hat shop Ikhtiart, where a young artisan cuts fabric and assembles hats behind the counter. All in black, with his eye-skimming haircut, Shunya looks every part the fashionista: indeed, his bag is from legendary Japanese designer Issey Miyake's Bao Bao line, and his coat is from Final Home, set up by Kousuke Tsumura, a former Issey Miyake protege. Further, Shunya produces art and design shows.

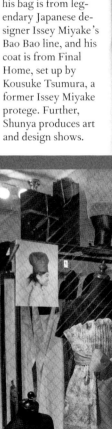

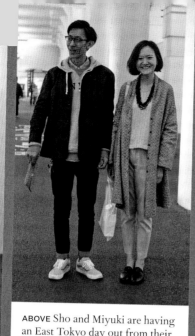

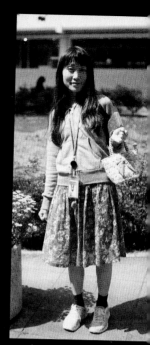

3331 ARTS CHIYODA

Just a five-minute walk east of 2k540 Aki-Oka Artisan is 3331 Arts Chiyoda. Besides being named in the same fashion, these enterprises share the goal of building community alongside their respective functions as artisan shops and an art gallery / event space that also offers international residencies. The 3331 of Arts Chiyoda's name connects it the surrounding area, a bastion of Edo culture with many traditional festivals, shops that have been established for generations (*shinise*), and traditional artisans. It refers to the rousing or congratulatory call-and-response clapping rhythm in which the leader yells "Yoh!" to which the respondents clap, "da-da-da, da-da-da, da-da-da, DA" (3-3-3-1). Dating from the Edo period, this rhythm can still be heard at shrine markets and festivals today.

Like 2k540, 3331 Arts Chiyoda renovated a disused space—in this case, a school building. There is now a large gallery space on the ground floor; other rooms house small studios, event spaces, offices, and small businesses, as well as the Food Lab café. There's always something to see, whether it's an artist's open studio or the main exhibition of contemporary, often community-based art.

The Kuramae area west of 2k540 Aki-Oka Artisan is also a hotbed of young artist and designer activity, with a few galleries and quaint shops. Between the two is the Taito Designers Village, another artistic conclave that has appropriated an empty school building to support emerging design businesses. It is occasionally open to the public.

ABOVE Sho and Miyuki are having an East Tokyo day out from their home near Kichijoji in western Tokyo. After visiting the shops and cafés of nearby arty Kuramae in the morning, they are returning to this artisan collective, heading for Hacoa, one of the many woodcraft shops under the tracks, which even offers wooden keyboards and computer mice. They have "normal," non-design-oriented jobs, but take an interest in fashion. They usually do their clothes shopping in the secondhand shops of Kichijoji or nearby Shinjuku, seeking unusual finds rather than brand items.

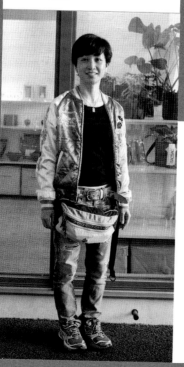

LEFT Pop-culture icon Mickey Mouse replaces the usual traditional Japanese imagery on Risa's *suka-jyan* (short for Yokosuka jumper), a type of silky jacket originally produced as souvenirs for American Occupation forces. Risa, a housewife who recently moved to Tokyo, bought this one in Harajuku, whose Takeshita-dori is now equally famous for souvenir trinkets. Her leather belt is printed with a pattern reminiscent of kimono fabric. In exploring the city, she was drawn to the collection of artisan shops at 2k540 Aki-Oka, as she loves making things. "It's definitely made me want to make more stuff myself," she says. **RIGHT** These gachapon novelty vending machines, geared toward the design crowd, dispense translucent neon creatures at around $5 a pop.

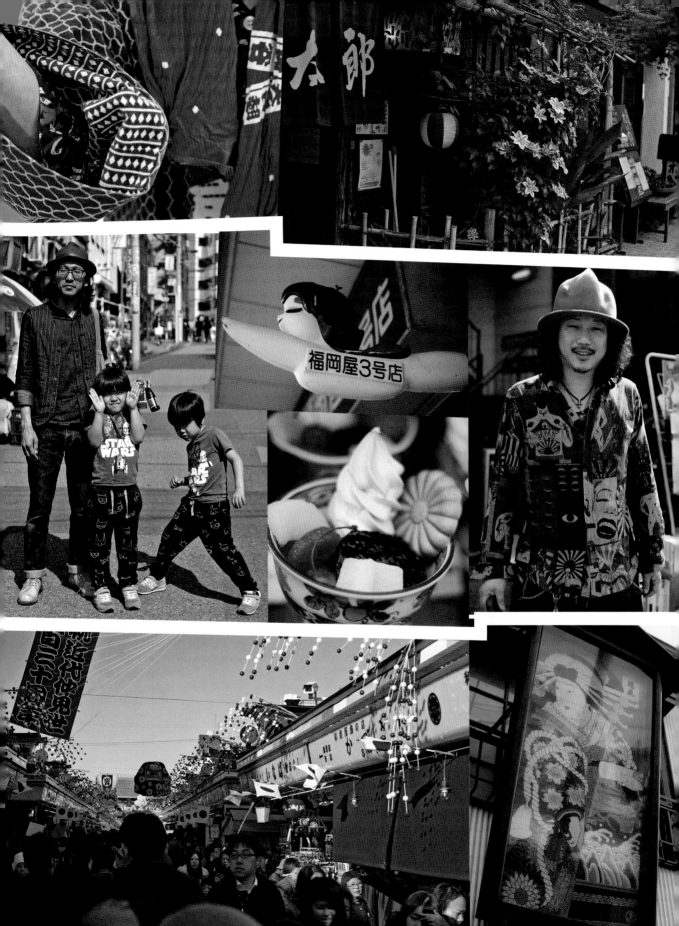

CHAPTER 8
East Tokyo
ECHOES OF TRADITIONAL EDO

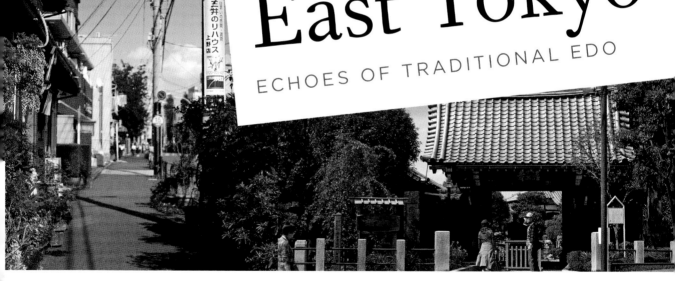

A Trip Down Memory Lane

ASAKUSA, KURAMAE, AND BEYOND

East Tokyo, the area east of the JR Yamanote Line train loop, stretching out to the Sumida River and beyond, is the *shitamachi* (low city) counterpart of the *yamate* upper-class foothills to the west of the city, a distinction that has prevailed since the seventeenth century. This area, best known for the historic district of Asakusa, is the preserve of the Edokko "children of Edo"—families who have lived in Tokyo for generations. Some of them still live in the cramped rows of wooden houses that have stood for generations in the area, which largely escaped the wartime bombings. Alongside the long-term residents are the traditional artisans, albeit in diminishing numbers, whose crafts have been handed down for generations, sometimes centuries. East Tokyo also has many *shinise*, long-established restaurants and shops that have been passed down through numerous family heads.

THE RISE OF THE EAST

The traditional is a strong presence in the area's fashion, too: the kimono worn by Asakusa geisha and hostesses; the *yukata* summer kimono donned for fireworks celebrations and by the sumo wrestlers who live and train there; and the various kinds of special garb worn specifically for the many festivals that are held in the area. But in some areas you are increasingly just as likely to come across young people flaunting their hip outfits as you are to stumble across grandpas tottering along in *geta* clogs. East Tokyo has been rising in recent years, literally and figuratively: 2012 saw the opening of the Tokyo Skytree broadcasting tower in Oshiage, Sumida ward. The tallest broadcasting tower in the world, with a viewing deck and attached shopping mall, it is a huge tourist attraction, pulling enormous numbers of visitors beyond Asakusa for the first time. Also contributing to the East Tokyo makeover is the influx of a new generation of artisans: young designers, artists, and craftspeople who are taking advantage of the low rents and existing small-scale production industries and networks. Often stylishly clothed themselves, their small businesses also draw the young and fashionably attired design crowd.

Asakusa and its surroundings are packed with visual reminders of traditional Japan, such as *chiyogami* papers (TOP LEFT), kabuki (ABOVE LEFT), pottery (ABOVE RIGHT), narrow streetscapes of wooden houses (RIGHT), and rickshaws (RIGHT MIDDLE).

ABOVE Figures from the popular Yo-Kai Watch game, manga, and anime series. East Tokyo is home to some of Japan's legendary *yokai* ghosts and ghouls.

ABOVE AND LEFT East Tokyo has a thriving art scene, including unusual gems such as SCAI the Bathhouse, a gallery in a renovated 200-year-old bathhouse in Yanaka. This couple stands in front of its entrance wearing playful Japanese label Frapbois.

BELOW Kappabashi, near Asakusa, sells the replica food that is displayed outside many restaurants in Japan.

1	Agata Takezawa Building (Art-Eat, Gallery αM ,Taro Nasu Gallery)B3
2	CashiB3
3	ClassicoA1
4	Ink StandB2
5	Is MyB3
6	IsetatsuA1
7	KakimonB2
8	KappabashiB2
9	KoncentB2
10	MirrorB2
11	Nui HostelB2
12	One Drop CafeA3
13	SCAI the BathhouseA1
14	Tokyobike GalleryA1

500 m
2000 ft

Local Neighborhoods, Local Styles

East Tokyo's sprawl is packed with distinctive neighborhoods. Often charmingly rough around the edges, they are characterized by a down-to-earth friendliness and an altogether more humble experience of the city of Tokyo.

UENO AND ASAKUSA: CULTURAL AND RELIGIOUS HOT SPOTS

Ueno and Asakusa are the two major hubs of downtown East Tokyo, the former with its large park, zoo, and numerous national museums; the latter with Sensoji temple and the lattice of roads surrounding it, where shops selling traditional crafts as well as tourist tat jostle up against long-established eating and drinking venues and even some remaining geisha houses. But alongside these tourist spots are altogether more intimate and surprising neighborhoods.

YANESEN: NOSTALGIC WANDERINGS

For a glimpse of what Tokyo may have felt like in the earlier years of the 20th century, the Yanesen area makes a good excursion. The name combines three areas—Sendagi, Yanaka, and Nezu—situated to the south and west of Nippori station on the JR Yamanote Line. Nippori is famous for its textile wholesalers in the area north of the station—worth a visit for those partial to creating their own clothes and accessories. But to the south stretches Yanaka cemetery, where cherry trees—whose short-lived flowers are a reminder of the ephemerality of life—provide a contemplative and beautiful backdrop to the several thousand graves every spring. The area offers up many quaint long-running craft stores, like Isetatsu, whose tiny shop near Sendagi station is chock full of traditional Japanese paper and paper products in vibrant patterns. But there are also more contemporary style offerings, such as "antiques, clothes, crafts, and life" from the charming boutique Classico. This

area—where there seems to be a temple around every corner, a cat on every wall, a gallery on every street (check out the SCAI the Bathhouse), and plenty of cute cafés and Japanese sweet shops to provide sustenance—is perfect for a day's exploratory strolling.

ELSEWHERE IN THE EAST

Further south along Tokyo's central east side is Ningyocho, like a smaller-scale, slightly more upmarket Asakusa. Known particularly for its traditional sweet shops and eateries, it is well worth a wander at dusk along the lantern-lit roads. Hop further east from Ningyocho over the Sumida River and you'll arrive at Kiyosumi Shirakawa, a hotbed of grassroots artistic activity surrounding the striking Museum of Contemporary Art Tokyo (MOT) built in 1995.

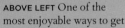

ABOVE LEFT One of the most enjoyable ways to get around Asakusa and its environs is by rickshaw. This rickshaw runner wears a traditional bamboo *sandogasa* hat that allows air to circulate and cool the head while sheltering it from the summer sun's unforgiving rays. **ABOVE RIGHT** This fashion student has come fabric shopping to nearby Nippori. The collar of her Minä Perhonen (a famous Finland-inspired Japanese textile designer) print dress is just visible.

LEFT Tree peonies and festival participants are seasonal presences on the streets of venerable East Tokyo neighborhoods. BELOW The older areas are increasingly drawing a young crowd, including this couple, who have started to come to Yanesen quite frequently to stroll and explore. The neighborhoods offer an exciting mix of artisanal young businesses and traditional charm, like the udon noodle shop Kamachiku, housed in an old *kura* storehouse, which is a favorite with these two.

TRADITIONAL SHOPKEEPER FASHION

East Tokyo is the domain of the "shinise," which literally means "old shop," but refers to traditional businesses—whether they be restaurants or shops—that are long running and typically have had their particular recipes or skills passed down from one family head to another across the generations. Living up to their moniker, shinise are a steadfastly unfashionable bunch. They tend to deal in traditional crafts, food, and drink (such as Japanese sweets and sake); their involvement in "fashion" was limited to draperies selling cloth by the length for kimono. Now these draperies, going back as far as the Edo period, have either disappeared or been transformed into department stores, of which Mitsukoshi is the most famous example.

But some of the shinise, and other local family-run business besides, do have a worthwhile take on Japanese clothing, if it is not exactly fashion. You may be greeted by ladies in kimono at more exclusive shinise eateries; by staff in old-fashioned white overalls at traditional *wagashiya* sweet shops; by a variety of aprons, ranging from indigo-dyed with business logos printed on to the practical brown apron of the *shokunin* craftsman. And there are the shop owners who don Japanese garments of bygone years, such as geta clogs and cool summer pajama-like *jinbei*, adding a charmingly eccentric touch to the otherwise (post)modern and Western fashion backdrop of Tokyo.

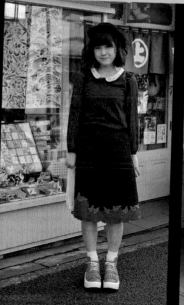

BELOW LEFT This vintage-lover has just bought goodies from Japanese decorative chiyogami paper institution Ise-tatsu. A Yanaka convert, she vows to bring her friends next time. BELOW RIGHT The owner of Florentine bakery Atelier de Florentina stands in his minimal shop interior.

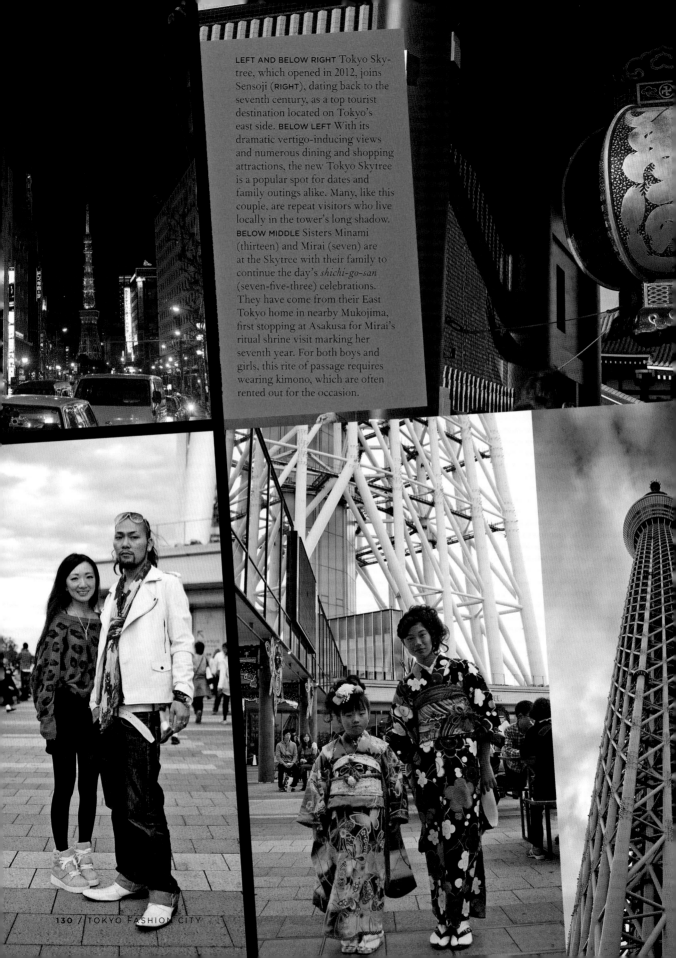

LEFT AND BELOW RIGHT Tokyo Skytree, which opened in 2012, joins Sensoji (**RIGHT**), dating back to the seventh century, as a top tourist destination located on Tokyo's east side. **BELOW LEFT** With its dramatic vertigo-inducing views and numerous dining and shopping attractions, the new Tokyo Skytree is a popular spot for dates and family outings alike. Many, like this couple, are repeat visitors who live locally in the tower's long shadow. **BELOW MIDDLE** Sisters Minami (thirteen) and Mirai (seven) are at the Skytree with their family to continue the day's *shichi-go-san* (seven-five-three) celebrations. They have come from their East Tokyo home in nearby Mukojima, first stopping at Asakusa for Mirai's ritual shrine visit marking her seventh year. For both boys and girls, this rite of passage requires wearing kimono, which are often rented out for the occasion.

Tourist Spots Old & New

East Tokyo has hitherto been somewhat of a sartorial wasteland. Although you'll find more people in traditional garb in these neighborhoods, the daily outfits of the long-term residents are largely unremarkable and dowdy compared to those in the style hot spots on Tokyo's west side. But there are always opportunities for dressing up smartly for a day out, or putting on one's trendiest togs for a date: donning one's Sunday best, as it were. East Tokyo now has two world-class attractions, with Sensoji temple in Asakusa—Tokyo's most popular tourist spot—being joined by the Tokyo Skytree in 2012. These two Eastern landmarks, old and new, high and low, religious and secular, offer contrasting excursions for everyone, from those living in their neighborhoods to visitors from the other side of the globe.

TOKYO SKYTREE

The iconic construction that's heralding a new era for East Tokyo is the Tokyo Skytree, a broadcasting communications tower with an observation deck open to the public and an attached shopping and restaurant complex. Stretching 634 meters upwards, it is the second-tallest building in the world (after Dubai's Burj), positively dwarfing the original Tokyo Tower. The promise of the stomach-churning view, which reveals the scale of Tokyo in all its glory, attracts some 6 million visitors a year from all over the world.

The tower itself has a sort of clothing in the form of the thousands of LED lights that grace its exterior. As befits as a symbol for Tokyo, the high-tech lights are programmed to alternate daily between two "outfits" that draw on differing traditional aesthetic concepts: *iki* (similar to "chic") and *miyabi* (something like "elegant"), represented by blue and purple colors respectively.

SENSOJI TEMPLE

Year after year, the biggest visitor crowds in the capital are drawn to Sensoji temple, lured by the mixture of impressive architecture on a grand scale, historical significance, promise of wishes to be granted at its altar, and the opportunity to shop for traditional trinkets and delicious street snacks along Nakamise-dori at its entrance. The gigantic red lantern that dangles imposingly from the temple's main Kaminari (thunder) gate is surely one of the most popular backdrops for tourist group photos in the whole of Tokyo. So expect to see people dressed for dates, babies wrapped in frilly white blankets for blessings at the attached shrine, and visitors in kimono for their *wa* (Japanese) day out.

OTHER EAST TOKYO EXCURSIONS

While the Skytree has put the Tokyo that lurks beyond the Sumida River firmly on the tourist map, there are, of course, many other well-established tourist attractions in East Tokyo. These include the Edo-Tokyo Museum and the National Sumo Stadium at Ryogoku; the Museum of Contemporary Art Tokyo at Kiyosumi Shirakawa; the wholesale cookware street Kappabashi; and all the quaint shops and businesses surrounding Sensoji in Asakusa.

New Art and Design Enclaves

J ust south of Asakusa is a sprawling area whose patchy rumblings of art and design activity have grown into something altogether more substantial. The neighborhoods of Kuramae and adjacent Bakurocho form a strip between the traditional Asakusa and business-oriented Nihonbashi. The cityscape in these areas is unremarkable; bland office buildings on wide streets prevail, but some of the older constructions have been saved from demolition, preserving and enhancing their character, by some creative renovation and repurposing by young new businesses.

NEW STYLE, OLD INDUSTRY

Among the bleak urban blocks are pockets of unpretentious hip. Kuramae was once the center of toy production, and toy wholesalers, with their gaudy plastic wares bursting forth onto the sidewalks, are still charmingly scattered around. But the new kids on the block are establishments that build on the artisanal ethic of the traditional shitamachi area but offer products that appeal to the young art and design crowd. These are not fashion hot spots per se, but there are numerous ateliers crafting accessories, and the clientele are typically an artfully attired bunch.

TOP MIDDLE These two work at Kakimori, specialist stationers to the design crowd. She's borrowed her husband's Frapbois shirt; his apron lends him an artisanal air. BELOW MIDDLE This area is popular with artists and designers: this woman came to buy supplies for art workshops. The sheep pin (INSET RIGHT) holding her scarf together was made by her friend, the metal artist Seiko Kajiura.

RIGHT Tomo is a designer who comes to Kuramae occasionally, today to visit a client—a rice shop—in the area. He has taken the opportunity to make another one-off notebook at Kakimori. Carrying a Freitag bag, he wears

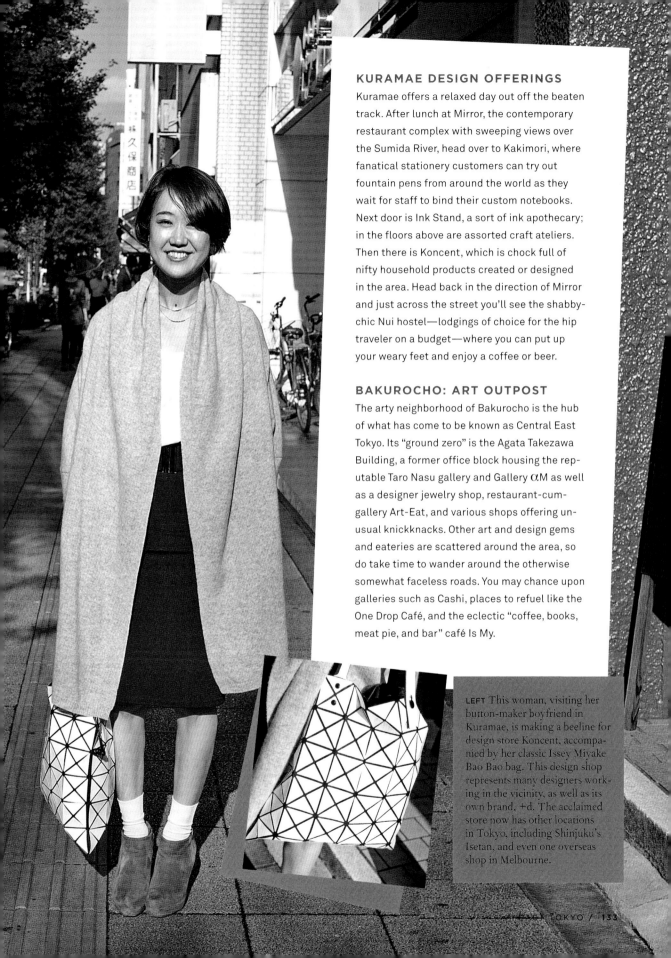

KURAMAE DESIGN OFFERINGS

Kuramae offers a relaxed day out off the beaten track. After lunch at Mirror, the contemporary restaurant complex with sweeping views over the Sumida River, head over to Kakimori, where fanatical stationery customers can try out fountain pens from around the world as they wait for staff to bind their custom notebooks. Next door is Ink Stand, a sort of ink apothecary; in the floors above are assorted craft ateliers. Then there is Koncent, which is chock full of nifty household products created or designed in the area. Head back in the direction of Mirror and just across the street you'll see the shabby-chic Nui hostel—lodgings of choice for the hip traveler on a budget—where you can put up your weary feet and enjoy a coffee or beer.

BAKUROCHO: ART OUTPOST

The arty neighborhood of Bakurocho is the hub of what has come to be known as Central East Tokyo. Its "ground zero" is the Agata Takezawa Building, a former office block housing the reputable Taro Nasu gallery and Gallery αM as well as a designer jewelry shop, restaurant-cum-gallery Art-Eat, and various shops offering unusual knickknacks. Other art and design gems and eateries are scattered around the area, so do take time to wander around the otherwise somewhat faceless roads. You may chance upon galleries such as Cashi, places to refuel like the One Drop Café, and the eclectic "coffee, books, meat pie, and bar" café Is My.

LEFT This woman, visiting her button-maker boyfriend in Kuramae, is making a beeline for design store Koncent, accompanied by her classic Issey Miyake Bao Bao bag. This design shop represents many designers working in the vicinity, as well as its own brand, +d. The acclaimed store now has other locations in Tokyo, including Shinjuku's Isetan, and even one overseas shop in Melbourne.

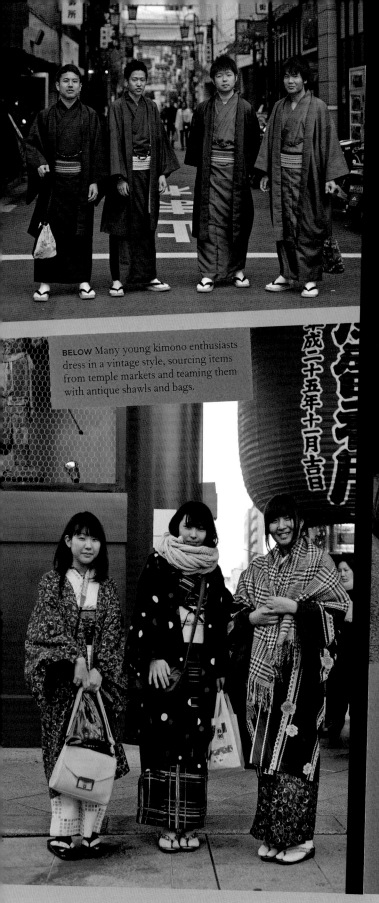

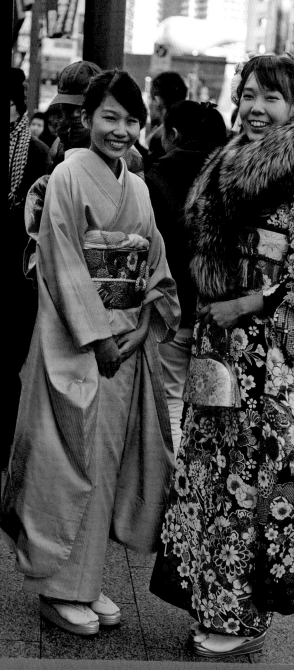

BELOW Many young kimono enthusiasts dress in a vintage style, sourcing items from temple markets and teaming them with antique shawls and bags.

LEFT, ABOVE Wearing kimono for a day out is more unusual for men than for women, but these four friends have come sightseeing to Asakusa in full Japanese regalia. Their *haori* coats, held partly shut by a beaded string, keep them warm on this chilly day. Men tend to wear kimono in more muted colors; patterns, if any, are subtle, though blue denim can lend a modern twist to the traditional garb. Though the four make a striking ensemble, they're quite new to the experience, claiming to still feel somewhat uneasy in their outfits. **ABOVE** This elaborate formal style of long-sleeved kimono, known as a *furisode*, is worn by women in coming-of-age ceremonies to mark their arrival to adulthood at twenty. A huge industry of kimono sales and rentals has arisen just for this occasion. Most women book appointments at salons to help them dress and set their hair and makeup for the day.

Making a Statement

The kimono has evolved (or perhaps regressed?) from an item of daily wear—it literally means "thing to wear"—to a statement garment that can come across as formal, ceremonial, anti-establishment, playful, or relaxing, depending on how it is worn. The garment itself is a simple construction of straight lengths of cloth—usually cotton or silk—forming a T-shaped long robe with wide sleeves. It is a one-size-fits-all piece of clothing (although the length can vary) that is tailored to the wearer by being wrapped tightly around the body and fastened just above the waist with multiple circuits of a wide "obi" sash. The body inside is therefore pushed and squeezed into submission to achieve a straight-up-and-down silhouette that de-emphasizes any natural curves, bumps, or lumps—quite the opposite of the corsets and bustles that were its nineteenth-century European equivalents. Since the kimono has a fixed shape, its colors and patterns take on particular significance.

THE MODERN-DAY KIMONO

The kimono, in one form or another, was everyday wear for over a thousand years until the twentieth century, when Western clothing gradually became prevalent. But the kimono has remained as ceremonial formal wear in events such as weddings and funerals and as elaborate ritualistic attire for life-stage ceremonies like the shrine visits for seven-, five-, and three-year-olds and the *seijinshiki* coming-of-age ceremony at age twenty.

In contrast to the sometimes elaborate and expensive silk kimono worn on such occasions, the lightweight, informal yukata is a colorful presence at summer festivals and fireworks displays in villages, towns, and cities all around Japan. Yukata are also used like dressing gowns at *ryokan* hotels. A kind of "off-duty" relaxing robe, they show that the wearer is having fun or letting their hair down.

SUMO AND KIMONO

Contemporary kimono and yukata are mostly associated with women. Of course, men wear them, too—and one class of men in particular: sumo wrestlers. These lumbering giants must wear one or the other when out and about, and yukata-wearing sumo are not an uncommon sight on trains and in other public spots, especially in east Tokyo. The dozens of sumo stables in Tokyo are concentrated in the east; the national sumo stadium is at Ryogoku, just over the river from Asakusa.

A CONTEMPORARY REVIVAL

While kimono have long been available in elaborate and vibrant patterns, a recent kimono revival has inspired prints depicting everything from playing cards to bananas; these are often worn with vintage accessories. The kimono magazine *Nanao* documents the rise of the scene, which includes indie brands like Mamechiyo with their bold and whimsical designs. There are all sorts of ways that kimono now cross over with "fashion," like the tongue-in-cheek monotone yukata prints of Tsukikage, sold every year at Harajuku's Laforet; denim kimonos—some of which, like those made by cult Japanese denim maker FullCount, even feature jeans labels and rivets; and the high-fashion runway kimono creations of Jotaro Saito.

EAST TOKYO KIMONOS

Of course, kimono are not restricted to East Tokyo in particular, but they find a particularly fitting Tokyo home here. They are worn at the many traditional festivals held on the east side, like the Sanja Matsuri and Sumida River fireworks. The sumo wrestlers concentrated here and the Asakusa geisha in many upscale traditional restaurants in the area also wear them; you are more likely to see kimono and yukata being worn as everyday clothing here than in many other parts of Tokyo, whether by aging "Edokko" stuck stubbornly in a sartorial time warp or in new reinterpretations by denizens of the East Tokyo design crowd.

Matsuri Mode

The year in Japan is punctuated by dates, occasions, and seasons that require some ritualistic commemoration—like *hatsumode*, the first shrine visit of the New Year—or just an opportunity to have some fun and do something out of the ordinary, as in the *hanabi taikai* summer firework festivals. All these *matsuri* (festivals) are just as ingrained in Japanese life as they are bracketed off from it. They are enjoyed by those from all walks of life—the major ones are attended by many as a matter of course—and they provide all these people with an escape from day-to-day banalities and a place for revelry and contemplation.

Many matsuri have their roots in the Buddhist or Shinto religions, and take place in or around local temples and shrines respectively. Others are secular, like the festivals celebrating the various flower blooms throughout the year, most famously the cherry-blossom viewing festival in the spring. Whatever the occasion, matsuri are kept separate from daily life, often symbolically, through the music, drinking, dance, food, and, of course, the dress of their participants.

TRADITIONAL FESTIVAL GEAR

All sorts of traditional outfits are worn at matsuri, from the reenactment of historical costumes in the grand parade of Kyoto's Festival of the Ages (Jidai Matsuri) to the *fundoshi* loincloth-like underwear—worn with little else—on men. The most typical festival garment is perhaps the waist-length *happi* cotton jacket, which provides more symbolic function than warmth (it has no fastening and is just one thin layer); emblazoned on the back is a crest or logo, often indicating a neighborhood affiliation. Another form of dress found in festivals of all descriptions is the kimono, perhaps that of the traditional music player or the spectator participant. And the yukata cotton kimono gets its yearly outing at the summer festivals if nowhere else.

The Sanja Matsuri, one of the famous big three Shinto festivals in Tokyo, is held every May in Asakusa. Participants from local homes and business are decked out in traditional festival gear as they parade heavy "portable" shrines through the streets on their shoulders, chanting and heaving as they go.

LEFT These matsuri revellers are wearing a classic, simple outfit of *hanten* jackets bearing their town association name, momohiki pants, black split-toed tabi boots, and obi sashes. Their accessories include *sensu* folding fans, *kinchaku* drawstring cotton bags fastened onto their obi, and the *hachimaki* headbands that hold their hair down. The hachimaki are made from versatile *tenugui* long cotton cloths tied in the *kuwagata kaburi* stag-beetle style that is typically favored by women. Many matsuri garments—like obi sash belts, *waraji* rope sandals, and donburi apron strings—require specific ways of folding, tucking, and tying, echoing the emphasis placed on these principles in Japanese material culture, from kimono to *furoshiki* carrying cloths to origami. **RIGHT** Festivals in Japan are inclusive events that bring the whole community together, young and old. Younger participants in the Sanja Matsuri can bang drums, hold ropes, or just walk in the procession looking very cute. Of course, they need to wear their own proper festival gear inscribed with the name of their neighborhood association. This boy is a symbolic continuation between old and new, elderly and young: dressed in his traditional attire, he carries a bag knitted by his granny.

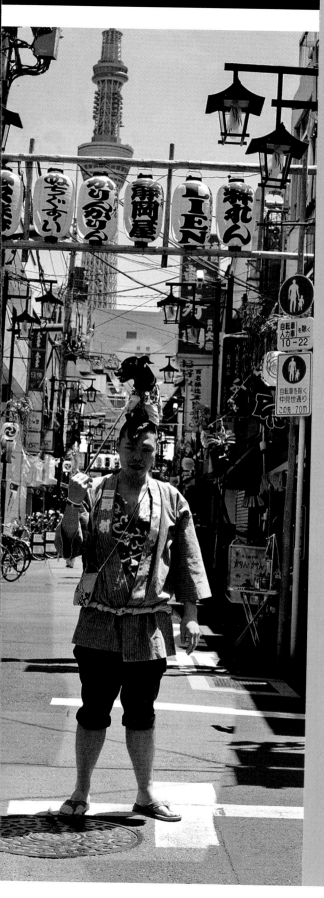

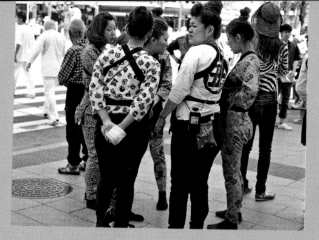

ABOVE These girls have gathered to talk about the upcoming day's festivities in front of Asakusa's famous Kaminarimon, the "Thunder Gate" that leads to Sensoji temple. It won't be the sound of thunder that will be heard on the street, but cries of "*Wasshoi! Wasshoi!*" as participants bump the huge *mikoshi* floats on their shoulders through the crowds. These girls, too, will be pulling—or carrying—their weight at some point in the day. Despite their relatively young age, some of them have been doing this for ten years or more. They are kitted out in traditional festival gear—the matching suits of *koikuchi* "carp mouth" (for the shape of the neck) shirts and *momohiki* farming pants under a *haragake* or *donburi* cotton apron. Accessories include their split-toed *tabi* boots and the wooden engraved *namae fuda* name tags around their necks. But these are clearly *gyaru* underneath all the traditional attire: they're given away by some fluorescent-yellow nail polish here, a Chanel mini-bag there, their makeup, and their properly coiffed and set hair.

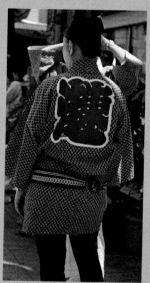

ABOVE Hanten jackets are decorated on the back with characters representing the neighborhood, or—as on this blue jacket—the name of the festival, Sanja Matsuri. **LEFT** Today Yuya carries not a mikoshi float on his shoulders, but his dog Mabu. Yuya, from Okinawa, is temporarily part of the Asakusa Sanchome Higashi Chokai neighborhood team. Mabu (meaning "soul" in the Okinawan dialect) is resplendent in his own festival gear: a canine koikuchi shirt made by Yuya's friend from traditional tenugui cloths and fundoshi underwear, and his own wooden name tag.

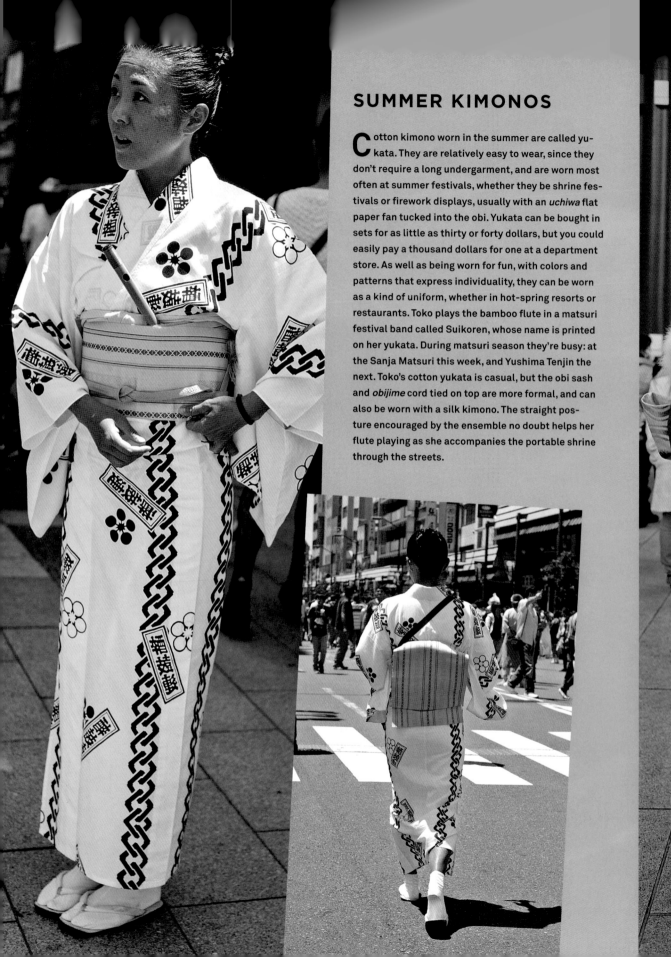

SUMMER KIMONOS

Cotton kimono worn in the summer are called yukata. They are relatively easy to wear, since they don't require a long undergarment, and are worn most often at summer festivals, whether they be shrine festivals or firework displays, usually with an *uchiwa* flat paper fan tucked into the obi. Yukata can be bought in sets for as little as thirty or forty dollars, but you could easily pay a thousand dollars for one at a department store. As well as being worn for fun, with colors and patterns that express individuality, they can be worn as a kind of uniform, whether in hot-spring resorts or restaurants. Toko plays the bamboo flute in a matsuri festival band called Suikoren, whose name is printed on her yukata. During matsuri season they're busy: at the Sanja Matsuri this week, and Yushima Tenjin the next. Toko's cotton yukata is casual, but the obi sash and *obijime* cord tied on top are more formal, and can also be worn with a silk kimono. The straight posture encouraged by the ensemble no doubt helps her flute playing as she accompanies the portable shrine through the streets.

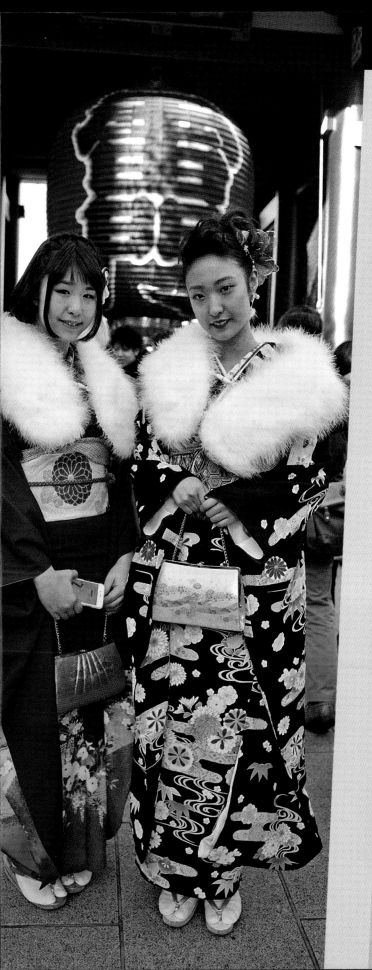

WINTER KIMONOS

Yukata are only for summer: in winter, far fewer women take to the streets in kimono. More formal kimono, often made from silk as opposed to the cotton yukata, are more expensive and more involved to put on: they require a long undergarment called a *nagajuban*, and must be folded above the waist and tied just so before the obi sash can be wrapped around. They are also not terribly weatherproof; the open-toed *zori* sandals worn with them require special plastic toe-covers in wet weather, and haori coats offer scant protection from the cold. One occasion on which many young women don kimono in winter is the coming-of-age ceremony held at age twenty. Women like these two can't help but look somewhat festive in their long-sleeved formal furisode kimono with white fake-fur collars draped around their shoulders, as is the current trend.

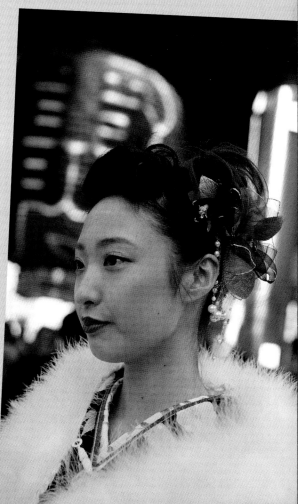

Tips and Resources

CONSUMPTION TAX

Carry your passport with you! Japanese consumption tax is currently 8 percent; much of that can be claimed back by foreign shoppers through various ways, depending on the shop. There's even an entire airport-style duty-free shop for travelers in Ginza's Mitsukoshi department store. While the usual system of taking receipts to tax-return counters still exists, many major Japanese retailers now offer a tax-free service at the point of purchase. All you need to do is show your passport for a 5 to 10 percent discount to be put through at the till. A receipt document will be attached to your passport; the item should be taken out of Japan with you as you depart.

CREDIT CARDS

While most shops and services accept credit cards, there are still many cash-only businesses. Furthermore, some independent retailers may have a minimum charge for credit cards. When paying with cards, PIN entry is common in Tokyo, but signatures (sometimes digital ones on a touch screen) are still used a lot. Occasionally, for small amounts, no form of validation is required at all.

When receiving a credit card, a sales assistant may ask you whether you would like to pay all in one go (*ikkatsu barai*) or in installments. This is a function attached to Japanese credit cards that you need not worry about; just answer, "*Ikkatsu de onegaishimasu*" (or say "one" while sticking up your index finger for clarification).

CASH AND TRAVELER'S CHECKS

Cash can be withdrawn 24 hours a day from ATMs in convenience stores, particularly the 7-Bank ATMs that are found in 7–11 convenience stores as well as other locations. International cards can also be used to withdraw cash at Post Office ATMs and branches of Shinsei Bank. Withdrawal fees at the Japan end are usually minimal, but of course you may be charged by your home bank.

Cash can be exchanged at banks and post offices as well as numerous counters at the airports. Traveler's checks are best exchanged at hotels, airports, or big retailers such as department stores. Changing them at banks can be a lengthy process and is best avoided.

TIPPING

There is no tipping system in cafés, restaurants, or bars in Japan; do not leave tips, as they cannot be processed by most places. Sometimes a table charge will be added for each person in the group.

IN THE SHOPS

Japanese customer service is typically very polite but enthusiastic. On entering a shop you will likely be greeted by a shouted chorus of *Irasshaimase* (welcome). Depending on the retailer, you may be closely attended by a sales assistant as you move around the shop, and offered superfluous advice like, "You can try this on if you like."

When trying on clothes in Japanese changing rooms, don't forget to remove your shoes at the appropriate place (usually outside the individual cubicle); leave them there. Inside the cubicle there may be something like a tissue box containing disposable face covers. Use these to keep makeup from getting on clothes as you try them on.

AT THE TILL

Domestic retailers in particular can have strict return policies, so check them before buying something you are not sure about.

The clerk may ask whether the purchase is a present (*Gojitaku-you desu ka?*). Generally, anything you indicate is a present will be wrapped in paper or a bag featuring the shop's logo, typically with a ribbon. Retailers also tend to give you a separate carrier bag for each present they wrap, which they will put together with the purchases in the main bag. Let them know if you don't need the extra bags. Carrier bags can quickly pile up when shopping in Japan; some sales clerks might offer to consolidate your bags at the till if they see you are holding a lot.

It is common shop policy to secure the carrier bag containing your purchases with tape across the top or around the handles before handing it over to you. If you don't want a bag, they may insist on putting a small strip of tape on each item to show that it has been bought.

The shop assistant will usually hand you the bag personally, sometimes coming out from behind the counter to do so. Some may walk with you to the shop's threshold,

standing in the door and bowing until you are out of sight. As the customer, a slight nod of the head back in their direction is an adequate response.

SIZES

Women's shoes in Japan typically stop at 24.5/25cm (US 8/8.5, UK 5.5/6); men's at 28cm (US 10, UK 9). Cheaper shoes often only come in S, M, and L sizes. Some popular brands like Tsumori Chisato and Margaret Howell are available in large sizes at Tobu's Ikebukuro department store and larger branches of Marui. Japanese shoe brands Diana, Washington, and Oriental Traffic all make shoes up to 26cm (US 9.5, UK 7).

Japanese brands also do not typically stock bigger clothing sizes. "Large" sizes fit around a US 10 or UK 12, but even then may be short in the sleeves or skirt/trouser length. Kimono and yukata, which wrap around the body, are the ultimate one-size-fits-all clothing souvenir, though it may be difficult to find lengths sufficient for taller builds.

GETTING HOME

After a successful day of shopping, if you find yourself weary and weighed down with bags on each arm, fear not! Hail a taxi and the back passenger door will open for you as if by magic. Remember that the driver will also close it from the front seat when you get out at your destination.

SELECTED TOKYO FASHION BLOGS AND WEBSITES

Incisive and illuminating English-language blogs:
- TokyoFashionDiaries.com
- TokyoTelephone.com
- Neojaponisme.com

Street snaps and fashion event info:
- TokyoDandy.com
- Reishito.com
- TokyoFashion.com
- JapaneseStreets.com
- Style-Arena.jp/en

Tokyo shop guides:
- http://superfuture.com/supertravel/tokyo
- http://www.timeout.com/tokyo/shopping-style

ACKNOWLEDGMENTS

I could not have compiled this book from my own knowledge of the city alone: thank you to all those who made suggestions and rallied to my calls for information on various neighborhoods, particularly those who gave me guided tours, like Patrick Galbraith in Akihabara and Andrew Lee in Daikanyama. I am grateful, too, to the many fellow Tokyo denizens who assisted me with other aspects of the project, whether by helping look after my boys, reviewing the text, putting me in touch with people, or just ladling out encouragement. So thank you, in no particular order, to: Elizabeth Tinsley, Emiko Ota-Boylan, Shai Ohayon, Danielle Demetriou, Colleen Sheils, Satchie Raudzus, Cheryl Mori, Rachel Ferguson, Fuyuri Kobayashi, Kai Satake, Anna Farrier, Sarah Everitt Furuya, Victoria Kwee, all the staff at Ryozan Park, and any other friends whose small kindnesses regarding the book I may have forgotten. Thank you also to those who produce the websites listed under Tips and Resources; these were a rich source of inspiration, particularly Misha Janette's Tokyo Fashion Diaries, David Marx's Neojaponisme, and Tokyo Telephone, all of which offer invaluable information and commentary on aspects of Tokyo fashion and its history.

I would like to thank Cathy Layne, my editor (who unfortunately could not see this project through to the end), for getting it off the ground and guiding me through the bulk of the groundwork. And thank you to all those at Tuttle, the book's publisher, for their input and diligence.

Most importantly, I would like to thank photographer Yuri Manabe for her wonderful images and for being such a good and chipper companion, once again, throughout the duration of this project.

Finally, thank you to my family: my encouraging parents; my husband for his unswerving support and patience; and my two boys, particularly the smallest, my little assistant, who accompanied Yuri and me to the majority of photo shoots for this project, both inside my growing belly and, once he was born, strapped to my front. I'm sure he charmed more people into having their photo taken than Yuri and I could have achieved alone.

And thank you, Tokyo, for being so endlessly fascinating.

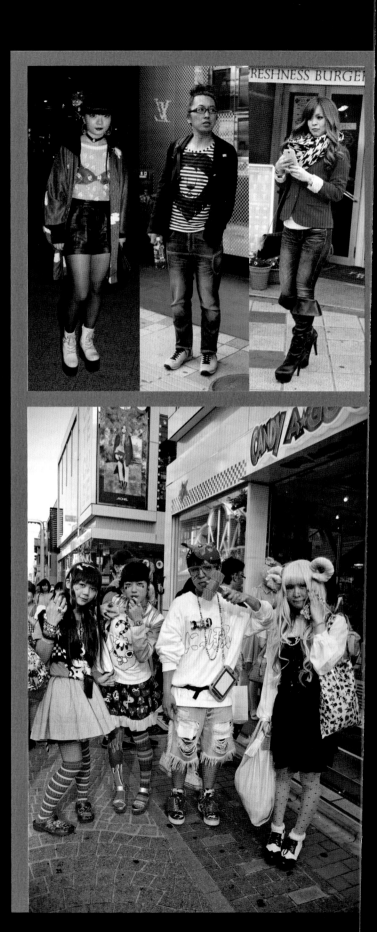

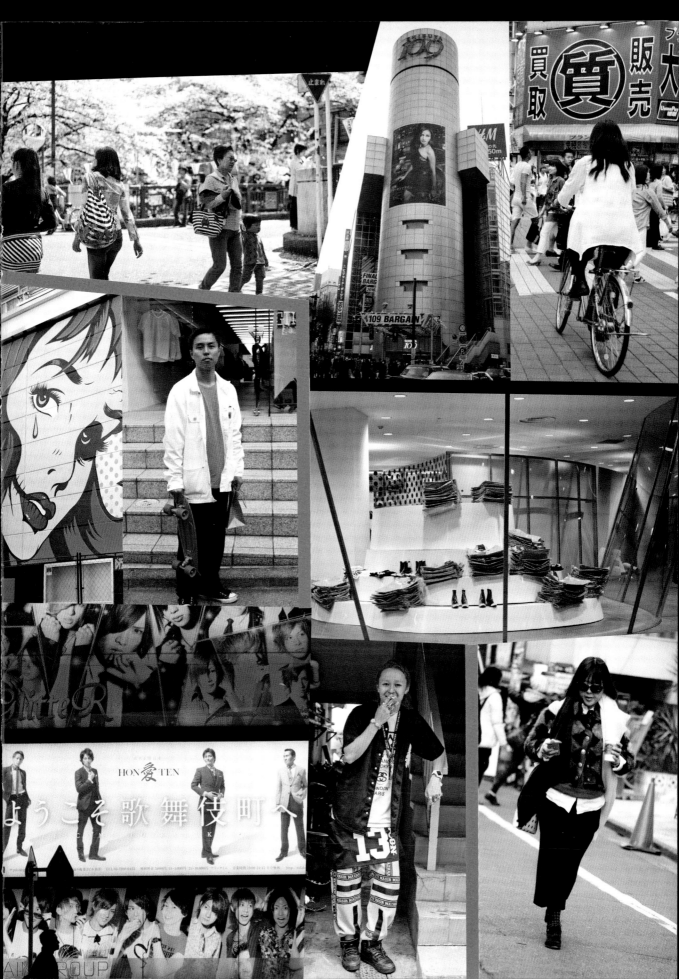

Published by Tuttle Publishing, an imprint of
Periplus Editions (HK) Ltd

www.tuttlepublishing.com

Copyright © 2016 Periplus Editions (Hong Kong) Ltd

ISBN: 978-4-8053-1339-8

Library of Congress Cataloging-in-Publication Data

Names: Keet, Philomena. | Manabe, Yuri.
Title: Tokyo fashion city : a detailed guide to Tokyo's
trendiest fashion
 districts / Philomena Keet ; photography by Yuri Manabe.
Description: Tokyo : Tuttle Publishing, [2016]
Identifiers: LCCN 2016003190 | ISBN 9784805313398
(pbk.)
Subjects: LCSH: Fashion design--Japan. | Fashion--Japan.
| Tokyo
 (Japan)--Guidebooks.
Classification: LCC TT507 .K3588 2016 | DDC
746.9/20952135--dc23 LC record available at http://lccn.
loc.gov/2016003190

Distributed by

North America, Latin America & Europe
Tuttle Publishing
364 Innovation Drive
North Clarendon, VT 05759-9436 U.S.A.
Tel: 1 (802) 773-8930; Fax: 1 (802) 773-6993
info@tuttlepublishing.com
www.tuttlepublishing.com

Japan
Tuttle Publishing
Yaekari Building, 3rd Floor
5-4-12 Osaki, Shinagawa-ku, Tokyo 141-0032
Tel: (81) 3 5437-0171; Fax: (81) 3 5437-0755
sales@tuttle.co.jp
www.tuttle.co.jp

Asia Pacific
Berkeley Books Pte. Ltd.
61 Tai Seng Avenue, #02-12
Singapore 534167
Tel: (65) 6280-1330; Fax: (65) 6280-6290
inquiries@periplus.com.sg
www.periplus.com

20 19 18 17 16 10 9 8 7 6 5 4 3 2 1
Printed in Malaysia 1605TW

TUTTLE PUBLISHING® is a registered trademark of
Tuttle Publishing, a division of Periplus Editions (HK) Ltd.

ABOUT TUTTLE:
"BOOKS TO SPAN THE EAST AND WEST"

Our core mission at Tuttle Publishing is to create books
which bring people together one page at a time. Tuttle
was founded in 1832 in the small New England town of
Rutland, Vermont (USA). Our fundamental values remain
as strong today as they were then—to publish best-in-
class books informing the English-speaking world about
the countries and peoples of Asia. The world has become
a smaller place today and Asia's economic, cultural
and political influence has expanded, yet the need for
meaningful dialogue and information about this diverse
region has never been greater. Since 1948, Tuttle has
been a leader in publishing books on the cultures, arts,
cuisines, languages and literatures of Asia. Our authors
and photographers have won numerous awards and
Tuttle has published thousands of books on subjects
ranging from martial arts to paper crafts. We welcome
you to explore the wealth of information available on
Asia at **www.tuttlepublishing.com**.